6.00
Aqu. 16

John Pike Paints Watercolors

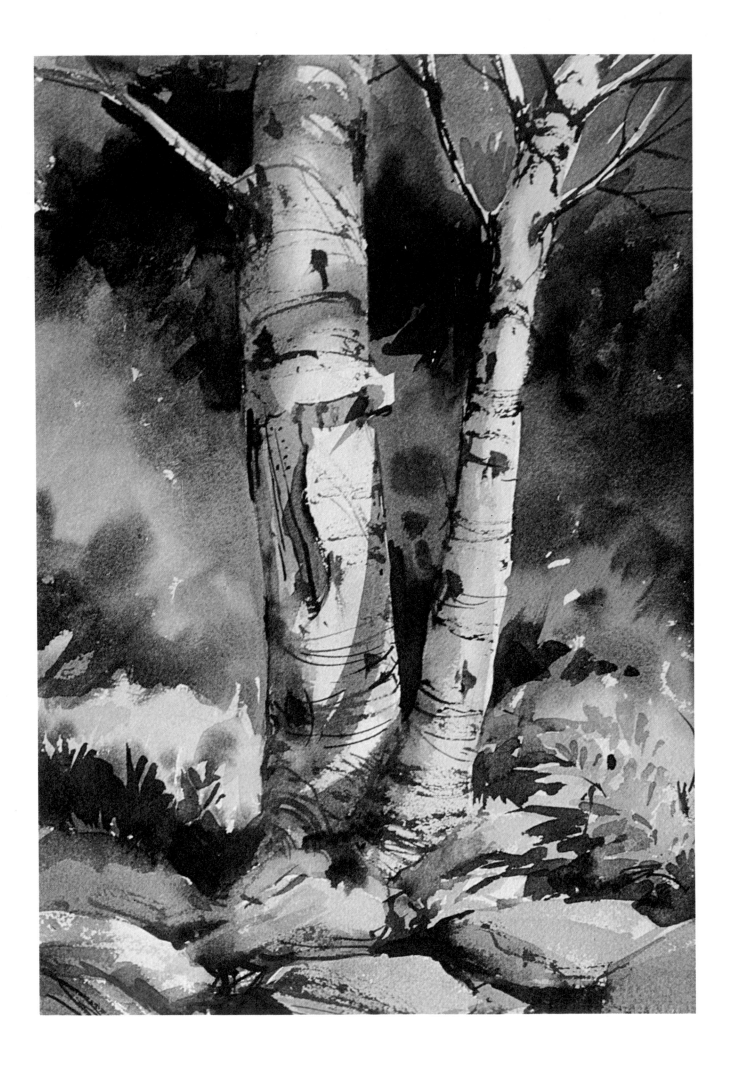

John Pike
Paints
Watercolors

BY JOHN PIKE

WATSON-GUPTILL PUBLICATIONS/NEW YORK
PITMAN PUBLISHING/LONDON

First published 1978 in the United States and Canada
by Watson-Guptill Publications,
a division of Billboard Publications, Inc.,
1515 Broadway, New York, N.Y. 10036

Published in Great Britain by Pitman Publishing Ltd.,
39 Parker Street, London WC2B 5PB
ISBN 273-01284-3

Library of Congress Cataloging in Publication Data
Pike, John, 1911 –
 John Pike paints watercolors.
 Includes index.
 1. Water-color painting—Technique. I. Title.
ND2430.P54 1978 751.4'22 78-17139
ISBN 0-8230-2577-2

Manufactured in Japan

First Printing, 1978

Dedication

To old friend Don Selchow—geologist, explorer, naturalist, photographer, and watercolorist—who took all the color photographs for the "Demonstrations" section of the book. He is also the only man I have ever known who *walked* 12,000 miles through Africa.

And of course, to my Zelha, who knows.

Acknowledgments, with Gratitude

To that "boy genius," Don Holden, who took time out from his heavy work schedule to write a most flattering introduction to this effort.

To the lovely, charming Senior Editor, Marsha Melnick, for her patience with a rather opinionated, tough old watercolorist, his struggles with many languages, and his silly, age-old stories and poems—but mainly for the fact that she was the gal who planned and pulled it all together.

To Connie Buckley, who edited the book and carefully saw it through the various stages of refinement.

To Bob Fillie, who designed a beautiful, visually integrated book.

John Pike

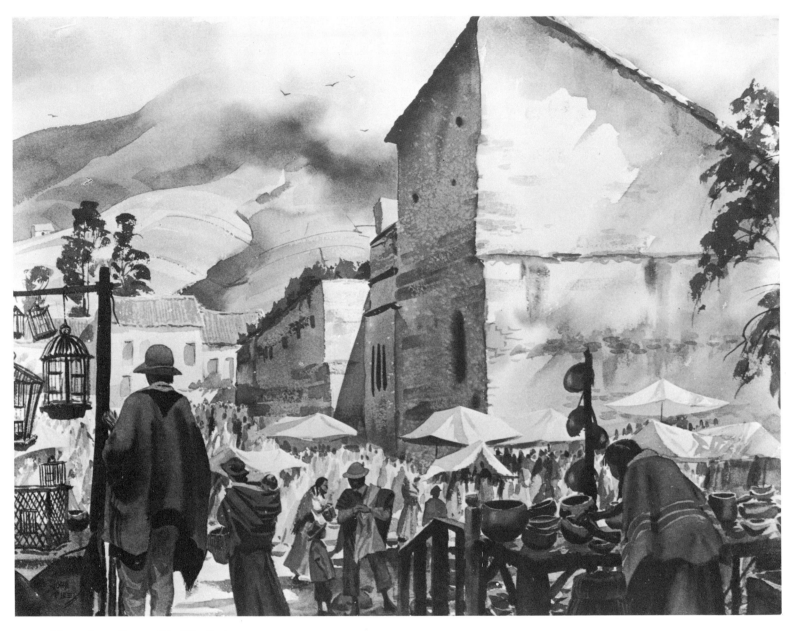

Ecuador, Open Air Market
22" × 30" (56 × 76 cm).

This market is in a town that's about 10,000 feet above sea level, while the mountains in the background go up another 8,000 or 9,000 feet. Thus, there are always a few clouds hanging over the mountain tops.

I'm including this painting because the mountains and sky are executed in an interesting way. First, the pale grays of the clouds were brushed in. While the surface was still wet, the undertones of the mountains were added. All these tones blurred together, wet-in-wet. When the paper was completely dry, clear water was washed over the entire area; then some shadow darks were dropped in and allowed to take their own action. When all these soft, diffused tones were dry, the mountains were modeled right on top of them. That's how I got the effect of the mountains melting away into the sky. Notice how the lower slopes of the mountains were painted with strokes that follow the curving shapes.

CONTENTS

FOREWORD

Like most art students in the 1930s and 1940s, I saw my first art in the pages of illustrated magazines such as *Life, Collier's,* and *The Saturday Evening Post.* And one day I turned a page and stopped dead before an illustration that made my head spin. The picture was nothing like the other illustrations in that magazine. No Hollywood couple with liquid *eyes* and toothpaste smiles, clinching in the moonlight. No smooth-shaven good guys and stubble-faced bad guys shooting it out at high noon, with blue smoke curling from their sixguns. What I saw was an atmospheric landscape with trees and snow and figures—figures that looked natural because they blended into their natural surroundings.

Looking back three decades, what I must have discovered on that momentous day was the difference between an illustration and a *painting.*

I looked for a long time at that picture. (I think it was in *Collier's.*) The snow seemed to glow from within. The forest had a magical feeling of space. A marvelous, cool, pearly light seeped through the trees. The picture was signed by someone named John Pike. He had a funny way of making the final E in Pike: just three parallel lines.

After that first discovery, I watched the magazines for paintings with that peculiar signature. (I still had no idea that I might be lucky enough to see his paintings in an art gallery.) Whenever I found a John Pike, I studied the magazine page day after day, hoping to figure out how he did it. I found it hard to believe that these miraculous images were watercolors, painted with the same humble tubes and brushes I was struggling to master. How could anybody do so much with tinted water?

At some point in my teens, I made the electrifying discovery that a nickel subway ride would take me to 57th Street, where all the New York art galleries were lined up side by side, filled with pictures that I could look at for seven solid hours every Saturday, when the tedious school week was over. I lived for those enchanted Saturdays, when I could look at real paintings—not little images in magazines, but "lifesize" pictures, "originals" big enough for me to see every stroke.

One of these galleries turned out to have some watercolors by John Pike, with that funny signature in the corner. (I wondered if he knew how to make an E.) Now I had the chance to study these treasures with my nose so close that I left a mist on the glass. I was still hoping to figure out how he did it. What was his secret?

Pike could paint *anything*! His clouds were as subtle as smoke, yet solid and three-dimensional. His blue skies were filled with sunlight, while his gray skies were never a dead "battleship gray," but just as full of color as the sunny ones. He could paint a tree that looked as if it had a million leaves, with golden sunlight around the edges and patches of brilliant sky

breaking through—but it was hard to find a single leaf! The whole thing was done with broad brushstrokes that suggested infinite detail without actually *rendering* the details. He could give you the side of a rock, with all its cracks and craggy textures, with just a few sweeps of the brush that made the texture of the paper suggest the detail of the rock.

Like most art students, I was convinced that John Pike's "secret" was all a matter of technique. For it was obvious that he had an uncanny ability to make the brush and that ornery tinted water do what he told them to do. But he painted so simply—just strokes and washes and no obvious technical tricks—that mere skill didn't seem to explain everything. I had the feeling that there was something more.

Well, the years went by and I looked at thousands of paintings. Gradually, it dawned on me that the key isn't how well an artist slings paint, but how well he *sees*. It's the eye, not just the hand. By now, I've looked at hundreds of John Pike's pictures, and I think John would agree that his special magic is his phenomenal eye for values. He's looked long and hard at nature, from the shadowy forest outside his studio window in Woodstock, New York, to the brilliant sunlight on the beaches of his beloved Jamaica. He knows how to simplify and redesign the values of nature to create a haunting illusion of space and atmosphere. Like every outstanding watercolorist throughout history, he's a master of light.

In a way, I knew John Pike the *artist* before I knew John Pike the *man*. But what about the man?

One of the great delights of the publishing business is that you sometimes get to meet the idols of your youth. One Saturday morning more than a decade ago, I drove up the winding road through John Pike's woods. I must confess that I was a little worried. When you've put a man on a pedestal, you want to keep him there—you're not sure how you're going to feel when he steps off the pedestal to shake your hand. But the smiling man who met me at the door of the John Pike Watercolor School lived up to all my expectations.

He *was* the John Pike I'd hoped to meet for all those years. And then some. For John Pike's prodigious talent expresses itself not only in painting, but in everything he touches. He seems to be good at everything he tries. He can design buildings and oversee their construction. He can fly a plane. He can play any musical instrument that has a keyboard. He's a highly successful entrepreneur, the designer and manufacturer of the best watercolor palette I've ever seen, as well as a pocket-sized "perspective machine." He's an artist who moves with great finesse in the "real world" of business, selling everything he paints. He's a raconteur who can hypnotize a room full of people for hours. And he's a brilliant teacher, whose wisdom, generosity, and sheer charm are legendary among watercolorists.

Wherever you go in the world of watercolor, you meet those who've fallen under John Pike's spell. The man is as memorable as his art.

Donald Holden
Irvington-on-Hudson, New York
1978

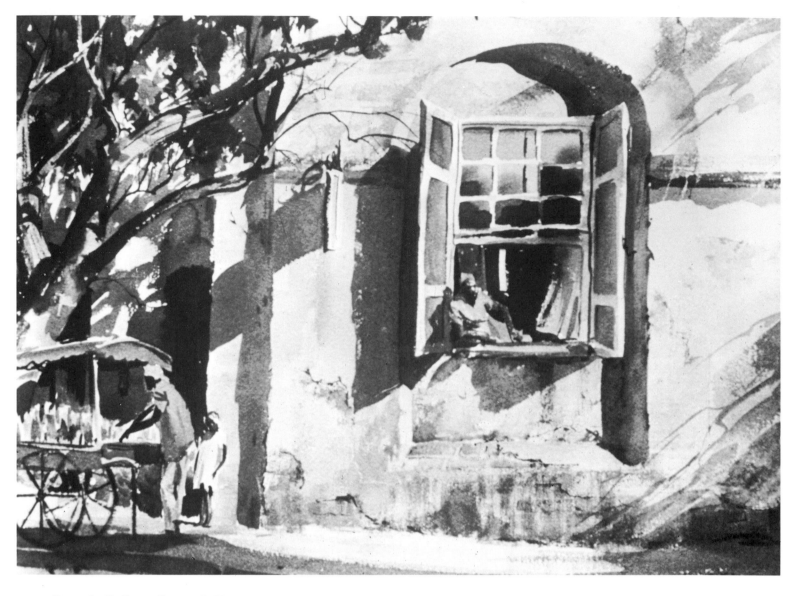

Snowball Cart, Spanish Town
22" × 30" (56 × 76 cm).

Spanish Town was the first capital of the island of Jamaica, and this old building was probably built by the Spanish before they were relieved of its responsibility by the British. Many people think of Jamaica as a little island located someplace in the Bahamas, when it actually has the same square mileage as the state of Connecticut and has the highest mountains of any island in the Caribbean— over 7,300 feet. It's a beautiful country. I love the place and its people.

I think this painting is a particularly good example of the different textures you can get if you take advantage of the roughness of the paper and exploit all the things your brush can do. For example, a round brush will make big, ragged drybrush strokes if you work with the side, rather than the tip. You can see these strokes in the lower righthand corner. If you sweep the brush swiftly across the sheet, not pressing down too hard, your strokes will have rough, broken edges such as the strip of shadow at the bottom of the picture or the patches of shadow on the wall. The side of the brush was also used for those subtle, broken textures that appear all over the wall. Don't doodle too much. Decide exactly where you want some texture, make a few decisive strokes, and stop.

INTRODUCTION

A fine part-time painter friend of mine told me, "People write books on watercolor and painting. They also write books on sketching and seeing—learning to see beyond the obvious—but nobody writes follow-through books on how you carry that first excitement of your sketch in black and white through to the point where you've translated into color and paint that Gold Medal winner." As a professional for over forty years, it never occurred to me that these were not all one single objective; but after much questioning of my artist friends and students, I've found that learning the various stages of follow-through is a problem. So this book includes not only my approach to painting with transparent watercolor, but also my approach to following through from preliminary sketch to final painting, as well as many other things that have been a help to me.

When I talk about methods or approaches, I am really saying, "This is the way I have done it and the way I have found it easiest to arrive at what I hoped to get down as an impression of a place or thing." I never say this is *the* way; each painter must approach his subject in all the different ways that are best suited and most interesting to him. I am only giving you my way. So whatever you read from here on is only what old Pike has managed to chisel out of that granite wall around the perimeter of the unknown in this delicious medium.

In the opening section of the book I'll tell you a few things about how I feel about art and painting in general, about my painting in particular, and what it has meant to me to have actually earned my living from my painting for many years. Then a question-and-answer section will focus in on subjects such as specific techniques and materials I prefer, how I start a painting, the importance of establishing correct values, how I go about making various kinds of value sketches for my work, and what I feel are the advantages and disadvantages of using photography as an aid in painting. A "Portfolio of Sketches" ends this first section.

A series of thirteen different step-by-step demonstrations will show you in detail how I start a painting with a value sketch and how I follow through to bring these paintings to completion. Finally, I have included a gallery section of thirty-seven of my paintings that I particularly like. Some of the things I'll tell you I've gleaned from the "masters" I have had the honor to know in the past, but most are my own tin-horn conclusions and experiences.

How I Began to Paint

Before I make the great splash with both feet and hands into this noble effort (effort, yes—noble, we shall judge later), there are a few points I would like to make. First off, I never studied watercolor. At sixteen I went to Provincetown and studied with Charles Hawthorne. From him I gained

a great deal from the standpoint of color and values. At the same time I also worked under Richard Miller in portraiture. That is the extent of my formal art study, although I have really been a student on my own all my life. I do not think that the art school has anything to offer a student after the fundamentals have been learned, except to teach discipline and the development of the working instinct.

But when I started painting, no one taught what fun and mad things you could do with this beautiful form of artistic expression. In the past, watercolor was always used as a sketching medium—to get down shapes and forms with their basic colors—usually on a pad 8″ × 10″ (20 × 25 cm) or smaller, only to be worked into an oil in the studio later. It is probably difficult for some younger watercolorists to realize that watercolor was recognized only in 1940 or 1941 as a major medium by the great National Academy and other art institutions.

I began experimenting in watercolor in an attempt to gain greater richness without losing the feeling of spontaneity that, of course, is watercolor's principal charm. I wanted to reach a quality that would force watercolor out of the sketcher's medium rating and place it definitely beside the major painting mediums. Any watercolorist, be he abstractionist or academician, will agree that from the standpoint of sheer technical skill and manipulation, there is no more difficult medium.

There are two men who had a great impact on the importance of representational watercolor painting, particularly in the United States— Winslow Homer and John Singer Sargent. Both men worked through the latter part of the nineteenth century and well into the twentieth. They were both primarily *oil* men. However, I think the greatest sparkle and brilliance of both Homer and Sargent, two wonderful artists, was in their watercolors. Watercolor is my real love too.

My personal inspiration was a great Bostonian "boy genius" named John Whorf, who carried through in the Homer-Sargent tradition. At the age of twenty-one he was the great man. I was only eight or nine. Who, at Whorf's age, wanted a runny-nosed kid padding in his footsteps? Happily, his wonderful mother, Sarah, was a close family friend as well as my Sunday School teacher. Occasionally the class met at her house for milk and cookies, which is when I sneaked in and *saw*. And that's when I started painting watercolors some fifty-five or more years ago.

Knowing Your Craft

I'm talking about the great need for a thorough knowledge of your subject, the tools necessary to do it well, and the ability to use those tools when the time arrives. Each individual who chooses to work in any of the arts, whether it be painting, sculpture, theatre, music, dance, or writing, must have a driving desire to learn his or her craft. Craftsmanship means a complete and thorough knowledge of the art form that you have embraced. So where do you go once you've got the tools? That's the beginning of the exciting part; it depends on you and on how hard you are willing to work—what dreams of wonderful things you are capable of putting into action. The world of watercolor is a rough one, like all the other arts I have mentioned, but what glorious fun! Remember: an academic degree only shows you where the tools are. Recognition by your peers says you are learning how to use them.

Once you have learned the basics of your craft, you know enough not to walk in front of the leading man when he's in the middle of his greatest

lines, or push that beautiful Swedish chisel against the walnut grain, or write a great symphony before you know the scales. As a watercolorist you know how to throw in that big, fat, slick wash and toss in a few clouds on the way. You know you have to take off the excess water along the edges of your paper with tissue or sponge so the "flowers" won't come in when it's dry. You know that when you want a crisp or hard edge, the basic or underneath painting must be dry; or for a soft edge, it must be wet (you have to work fast!). These, along with a dozen other pointers are just a few of the things that make up this crazy, happy way of painting.

I often use the word *mechanics,* and some painters find it somewhat offensive. But if you stop to think, transparent watercolor is about the only form of painting where a thorough knowledge of mechanics and how they affect your painting is necessary. Oil, acrylic, gouache—these are all opaque mediums, and if something goes wrong, you can scrape it out and start over. Unhappily you can't do this with transparent water-color. *It must be preplanned.* To me it's a business, and as a professional, I know. But most happily, it is the thing I love to do most—paint water-color. What more could a person ask?

Become Your Own Type of Painter

Always remember that anyone in the arts must try to grasp all the fundamentals available to him—the *fundamentals* are really only an awareness of the tools with which he will work. The use of those tools and the skill in handling them are his alone. So each artist really goes his own way, arriving at his own conclusions by whatever means he finds easiest and most satisfying to him. Actually, beyond learning the fundamentals or mechanics, it is really up to you and only you. I don't feel there is any right or wrong way to paint a watercolor. Here I am only talking about my way, the way that has eased my path. If there are some suggestions that look good, grab them—but then do it your way.

Find out many different artists' approaches. Pick and choose what you like and dislike—gain experience, then become *you!* Don't make the dreadful mistake of becoming the professional student, waiting and hoping for that magic word, color, or brush to come along some day. I'm sorry to say, "There ain't none." There is just plain old wonderful hard work. A great deal of that work has to do with your own mental attitude. How much do you want to get out of your painting adventures? If a beautiful set of juicy washes or charming design thoughts satisfy your needs, then stay with them. It's possible they are your answers. I was one of those nauseatingly flashy kids at sixteen or seventeen who turned out splashy watercolors that sold (don't ask at what price). Also, in those Depression years, *barter* was not beneath one's dignity. Thanks to a fine young dentist who had no patients but liked my efforts, I still have a mouthful of my own teeth.

For all the splashy watercolors, it's hard to remember (considering what I have been involved in during the last fifty years) that I was once a very shy lad. As time went by I felt something was missing, at least for my needs, and I wanted to think deeper than just the surface of that beautiful white sheet of paper. I had to learn the whys and wherefores of what I was painting. I wanted to go deeper and get behind the surface appearances of nature. As every man must at some time, I had to step back from fixed thoughts and take a good long look.

In your education as a painter, you must have a greater awareness of

the world around you than most people. You must learn to think around and far beyond the simple structure and color of that charming red barn. Seeing the same subject can sometimes take several views. For example, you *drive* down a wooded road, and the beautiful tree patterns are silhouetted against the sky—then a rabbit darts across your path and disappears. You *walk* down that same road, and the beautiful tree patterns are there; but in addition, you see the bark textures of the treetrunks with their moss and lichen, the soft, subtle undergrowth, the leaves and pine needles nestled among the rocks—*and* you have the fun of seeing where the little rabbit went.

Seeing is not only looking but also knowing what you are looking at. The more you know the less insecure (the middle name of transparent watercolor) you will feel about the beautiful painting you visualize. Get it all down in your sketchbook for future reference. You think you'll remember it, but you won't. Draw all kinds of things. Develop your own drawing ''shorthand'' so you can make quick records. This will also help you develop your pictorial memory, just as writing down a person's name will help you remember it (at least in theory).

Anything can be sketched or photographed, but that doesn't necessarily mean that all your information has to go into any one painting. However, find out all you can about your subject. Learn why a tree leans, a roof sags, a ground mist rises—the cause and effect of things. A knowledge of these will help you in making a convincing, believable painting. Your thorough understanding of the construction—the way and why it happens—will allow you to take the liberties with nature and manmade structures that will make you a truly creative painter.

Teachers Who Paint and Painters Who Teach

I am of the opinion that anyone in the arts should start handing on his experiences when he is at the very *peak* of whatever little ''hill'' he has built for himself. This was done through the Middle Ages and the Renaissance by apprenticeship systems. In those days (after the kid had cleaned his palette, washed the brushes, and swept up to the joint), the Great Master said, ''Work and study hard so you may take into the future my accumulated knowledge and that of the Masters.'' Sounds terribly pompous and precious, doesn't it? But actually, it is the *only* way an art form may be thoroughly passed on to the up-and-comers. The dance, the theatre, the works! In another book I wrote, I spoke of how one could *read* forever how to ride a bicycle. It's only in riding the monster yourself that you learn. Or as David R. Locke, Abraham Lincoln's friend, writing under the *nom-de-plume* of Petroleum V. Nasby, put it: ''Yew Jist Caint Ketch Tha Larnin' Proper Without The Doin'.''

There are teachers who paint, and there are painters who teach. Actually the distinction between the two is quite broad. After some thirty years as a producing painter (which I still am), I belong in the latter group, since during the last few years I've started teaching six to eight weeks a year—four weeks at my summer school and usually two two-week sessions abroad. Both of these two types of teachers are of equal importance. The teacher who paints is greatly needed for his fine education in the whys and wherefores, his ability to completely convey to the neophyte the basic technicalities of drawing, perspective, composition, shape, mass, and form, as well as proven techniques. He has been taught how to put across these ideas. He opens the wondrous door and says, ''Go to work.''

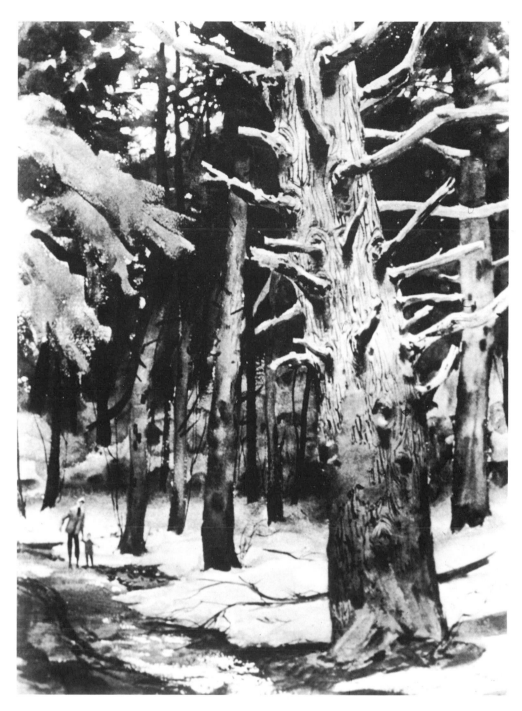

Old List
30" × 22" (76 × 56 cm).

This is the base of the old tree I spoke of in the caption for the painting *Untouched Forest,* page 134. Practically the entire picture was kept in a low key to emphasize a few bright spots: the brilliance of the sky, the sparkle on the wet road, and the luminous snow in the foreground. Notice how the big tree starts out dark at the base and gradually grows lighter as your eye moves upward. The lighter parts of the tree are emphasized by the darkness of the surrounding forest. As I worked, I kept in mind the fact that the light was coming from above. Thus, each branch on the old tree has a dark shadow on its underside. The texture of the trunk was suggested with wandering strokes of a rigger—a lovely, springy brush used by signpainters. Because the rigger is long, slender, and slightly unpredictable, it can give you lines that look precise and spontaneous at the same time.

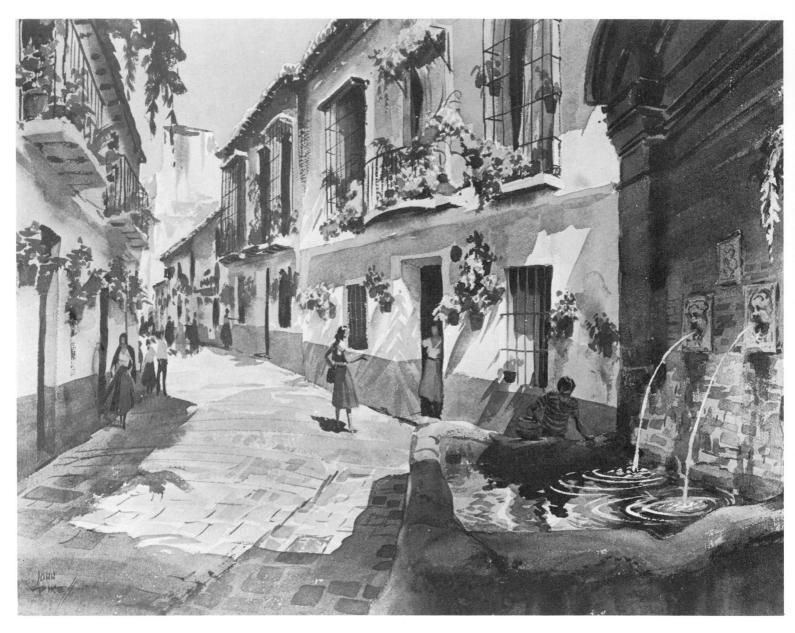

Málaga, Spain
22" × 30" (56 × 76 cm).

After spending many days in the Rif Mountains of Morocco, we took a large steamship-ferry from Tangier through the straits of Gibraltar to Málaga. When we checked into our charming hotel, all our luggage was delivered to the room except my painting gear. Also missing were five paintings I'd done in Morocco—paintings that were already sold. (If I sound mercenary, I *am;* after all, painting is my *business.*) My equipment and the five paintings had stayed on deck and traveled back-and-forth between Tangier and Málaga for five days until they were spotted and returned to me at last.

Spain is a land of strong lights and shadows. I emphasized the contrast between the sunlit areas and the cast shadows on the walls and on the street. Notice how I "framed" the sunlit focal point of the picture. The bright center of the street is surrounded by the shadowy fountain on the right, the shadowy walls of the houses, and strips of shadow on the street itself. The picture *looks* bright, but if you squint at it, you'll see that it's mostly in shadow. That's what makes the street look so sunny. As always, the secret is to plan your lights and shadows before you start.

Now the painter who teaches is a different kettle of fish (and I hope there is a *Pike* in the pot—even a wall-eyed one). He, in a sense, approaches teaching from the other direction. He comes in from the outside world of rough daily competition and says, "Here are some of the do's and don'ts and pitfalls I have learned the hard way. Maybe I can help you avoid them." And that's what I'll be trying to do in this book as I relate to you my own experience.

Getting Perspective on Yourself

My life has been, and is, a very happy one, even though I had to make it almost entirely on my own. I am one of those fortunate people who has been able to do whatever he has done in the area he loved most. I have always taken my work most seriously, but not necessarily myself—perhaps subconsciously just to avoid those bruises that come to every artist who identifies too strongly with his public image—good or bad.

My father once told me an ego-leveling story when I was about seventeen. I was preparing for my first one-man show and was perhaps feeling rather important. I have never forgotten the story.

It was about the bright young western farm boy who kicked over the plow and headed for the university. His brilliance took him through his schooling on various grants. Then a Rhodes scholarship. As time went by, he went on to great financial success, his philosophies were far-reaching, and he became known throughout the world as a great thinker and philanthropist. Then came the honor of his appointment as Ambassador to the Court of St. James—a position he handled with wisdom and great skill. However, along with this came a little smugness and considerable satisfaction with his accomplishments. But one night as he sat alone in his private chambers at the Embassy in London, an overwhelming desire to see his old home town again swept over him. He would go home. Six days by steamship, another five by train, and he arrived at his little town in the western prairieland. The train chuffed off into the night, leaving him standing alone on the station platform peering through the drizzle in an effort to see some form of transportation that might take him to the town's one hotel. Just then, into the pale circle of light cast by the single bulb with the corrugated tin shade shuffled the old station master. A gnarled hand shaded his eyes as he peered up into the great man's face. He said, "Why, hello, Georgie. See you got your satchels—y'goin' someplace?"

The point here is: don't in all your life begin to believe your own publicity—or perhaps don't take too seriously your successes and failures within your own little art group. There is a tough world of real competition out there. Take a chance. Face it. But keep splashing. Observe everything. And aim high!

INTERVIEW WITH JOHN PIKE

The editors of Watson-Guptill have asked me a series of questions about such things as my working methods, my techniques, my studio setup, and the materials I prefer to work with. There are also questions here that reflect the kinds of things students have often asked me over the years. Hopefully the answers will help you understand better how I work and why I paint.

What do you look for in a subject?

Learning what makes a good painting subject comes mainly from experience as well as the type of thing you enjoy doing. I personally look for subjects that will give me three distinct main values—light, middletone, and dark. Of course a subject may also be chosen because of its physical interest—a carved door, a decorative cathedral, interesting tree or rock formations, and so on. However, as a representational painter, it is these three values that count most to me.

Do any subjects especially interest you?

Yes, I like atmospheric things, subjects with a mood, be it sad or happy. In my old illustration days I was known as a "wind and rain" boy. I have a tendency to lean toward the theatrical, which allows for a little drama with a bit of feeling beyond the rather cold, factual still life of a barn, tree, mountain, or rock. Also, I like to feel that there is some sort of *life*, be it human or animal, living within that atmosphere.

Are there any subjects you really dislike?

Not really—just a few subjects that I do not feel come off too successfully in transparent watercolor, such as direct portraits for likeness of a particular person. You have to noodle too much, and the watercolor loses its freshness. Semi-caricature and splashy character studies are great! I don't like to paint rainbows, alizarin crimson sunsets, and fields of waving grain (although I like the products—the pots of gold, red sails, and the bread).

Do you find ready-made compositions in nature?

Ready-made compositions in nature are everywhere if you know how to see them and where to look. Nature actually is the ultimate source, but it is how you interpret what you see that gives you your own individual style of painting.

Do you prefer to paint at any special time of day?

I have always been fascinated by early evening light, when the subtlety of colors and values, enhanced by the scent of wood smoke from kitchen fires, lends curiosity about the activity within warmly lighted rooms. In building your atmosphere, think in terms of the sharp bite of the icy air, the squeal of dry snow under your boots, the knowledge that when you reach the kitchen door nice people often ask you in by the fire and place a stimulating mug in your hand.

Do you ever use a special device—a view-finder or a reducing glass?

Yes. I devised a small blue plastic view-finder with grid and movable steel strips that will stay at any angle you place them due to a magnetic rubber border. It is called, "John Pike's Wonderful Perspective Machine" and may be purchased from your art store or by writing to me in Woodstock, N. Y. 12498. It really works. I use a reducing glass very seldom, unless I am working for reproduction and know the art work will be printed considerably smaller than the original. However, it is an excellent way to look at your painting from a distance without having to move your feet.

Do you prefer special colors or color schemes?

Not particularly. My color is usually dictated by the subject matter, the kind of day (sunshiny, gray, rainy, etc.), and the time of day. Unless I am doing a purely decorative piece, I generally gray down or slightly neutralize the pure color.

Do you have any favorite compositional devices— geometric shapes, spirals, etc.?

No. My approach to composition is somewhat instinctive. I doodle with small thumbnail sketches until it *looks right* to me and hope that it is. Long experience helps, but if you want more definite instruction, many fine books have been written on the subject over many years.

Once you discover what you want to paint, what do you do next?

I start playing around with quick compositional and value sketches. Most all of the black-and-white compositional and value sketches in this book were done on the spot or had their inspiration from some particular area. However, even though most of my paintings have a factual look, I actually only use any given place as the starting point. Then I rearrange, design, and do a half-dozen thumbnail sketches. After deciding what I want to say, I go into the final sketch with full values indicated, as well as light sources and mood. I must admit that those many side-line years as an illustrator did great things to develop a mental filing system slotted in the back of my head. It never leaves you and is always on tap. Endlessly go back to your fundamental source, nature. Study it, and then rearrange it to suit yourself for the particular thing you wish to say.

What kind of sketch do you make? What's its purpose?

To me, the sketch is of tremendous importance because it is the complete guide to your finished work. It is your blueprint or road-map. In it goes all your planning of composition, values, and your entire thinking about what you wish to accomplish. In the more plastic mediums such as oil and acrylic—those that can be manipulated, scraped off, or painted over—it is not always necessary, but in transparent watercolor it is a *must*. I do predominantly two kinds of sketches. One for proper value relationships and large mass tones, using either black and middletone gray chalks or 6B graphite pencils—a "carpenter's" flat and standard round. If the subject is complicated with a lot of little detail, I will also do a so-called technical drawing in line, with a sharp felt-tip pen or pencil. If some colors are most unusual, I will write them in my own shorthand to be remembered later when I am going to work back in the studio. I'll give you a more detailed description of the kinds of sketches I make, plus many examples, in the "Portfolio of Sketches" following these questions.

Why are values so important?

Because for a representational painter, they are the one move that takes you from the actual two dimensions—*height* and *width*—into the illusion of the third dimension—*depth*. Of all that I learned in the late 1920s from Charles Hawthorne, the *value* lesson was, by far, the most important.

How do you arrive at effective value distribution?

I stick to the three basic values—black (or darkest), middletone, and light. The patterning and arrangement of these are entirely influenced by your subject matter. All the little values and tones in between are only contributors to the big three.

Do you use these sketches in the studio and on location?

I do sketches when working in the field as well as in the studio. Perhaps they are broader when I'm working on location, but the values and light patterns are there. These are done quickly, usually with chalk, because the light changes very rapidly. In doing the watercolor, I follow this original design. Combining sketches is done by most painters. Even when on location, I will swing a full 360 degrees and steal a tree, a rock, or anything that will improve my compositional sketch.

How do you transfer the sketch to the watercolor paper?

By a very simple square-up method: three lines vertically and three lines horizontally, sketched lightly with about a #2 pencil on both sketch and watercolor paper. In this way the same proportions as in your sketch may be gained very quickly. Otherwise you may find your drawing leaves about a quarter sheet blank; or conversely, you may not be able to get it all in.

How much detail do you include?

How much detail to include in the big sheet drawings is completely dictated by the subject. A complicated architectural idea or figures will be drawn in with great care, whereas a broad landscape may have only what I think of as large wash stopping lines. Very often I will use figures and animals in my watercolors (I like to think something is moving around out there in the world). If these are complicated, I will do separate drawings in proper scale, then trace them on the painting paper. This eliminates the chance of damaging the watercolor paper's surface by any erasing changes.

Do you ever take photographs to help you?

The purist painters of an earlier period would, no doubt, pop a gasket at the very word *photography*, and there are still a few contemporaries I know who might have a mild attack of the vapors at the idea. But, being realistic, since the day Daguerre was first able to freeze an image on silver-coated copper in the 1830s, painters have been using photography. And why not? I like to think of it as an instantaneous form of sketching: and there are many ways of using it to your advantage.

What are the pitfalls of painting from photographs?

Complete dependence upon your color shots will lead you down a lane to utter mediocrity and more and more subdue your own creativity. For example, if detail is in a background on your slide, the great tendency is to put it in where it is not really needed. The camera did it better. So learn to see only the salient points or centers of interest in your slide that are important to your eventual painting. Then put the slide away and get to work with your *own* thinking. After all, a copy of a Kodachrome is only a copy of a Kodachrome—and not quite as good.

Assume you have traveled to Spain, Hong Kong, or Ashtabula and have taken a thousand photographs because there wasn't time to sketch and put down your own notes. This can be most rewarding material from which you can glean much in the way of atmosphere, architectural design, and types of people. But these crutches would serve only as a jumping

off place for you, the creative person. They are the factual language—*you* are the interpreter! Think back and try to remember the mood, the feel of the place, how it smelled. All are contributing factors to your eventual painting, just as much as the physical structures. *You* take it from there.

How do you use the photographs?

I have purposely avoided photography over the years so I wouldn't get stuck. But with the advent of the black-and-white Polaroid, I think I've found the perfect sketcher's camera. For example, dashing down one of our miserable, highspeed highways, you see that beautifully grotesque Victorian "gingerbread" house. You say, "I *want* it." Then you ask yourself the question, "Should I get out my sketchpad or the Polaroid?" The answer is obvious—the Polaroid (black and white, not color). After permission is granted that you may trespass, go all around the house taking shots so that you will know the layout and structure. Then, when you get back to that warm studio, start analyzing what you have—good photos of all sides. Now you know how the place is built, and you can work in any direction from there. Think in these terms:

1. I have a *light source*. It might be the direct sun or it could be a high, soft overcast.

2. I have an *object*, which is the funny old house.

3. I can see the *cast shadows*. In my direct sun, they will take obvious sharp shapes.

Light source, object, cast shadow. To understand this for yourself, set up a few objects on the kitchen table and put a light bulb in a lamp to one side and *look*. Ask yourself, "Where does the light come from? On what areas does it fall? What patterns do the shadows make?" Shadows from a soft, overcast, or gray day are from the entire dome of the sky above. There are no sharp-line shadows. They too are soft, but they are definitely there.

In thinking and working in this way, using your sketch notes and black-and-white Polaroid shots, you can become independent of the physical subject itself. Your notes or memory give you the color; and your black-and-white Polaroids give you the texture, the architectural eccentricities, and the reasons why you liked it in the first place. Now, you have all your theatrical props offstage and are ready to decide where and how each will fit into your final production. Since you now have a knowledge of how this old place was built, how do you wish to present it in your painting? Here are some possibilities:

1. A *bird's-eye view*. This means you have had to understand the roof and other basic construction. This is why I keep saying "know the reasons why."

2. *Head-on view* With this approach you'll have to decide whether it will be to the left or right or to the rear.

3. A *worm's-eye view*. This may sound silly, but if you *know* what you are working with, mental projections are not difficult. How, for instance, does the artist who does a visualization from a blueprint come up with a beautiful painting?

Do you paint from the photograph or do you make sketches first and then paint?

My friend Don Selchow came up with a very nice answer for the *color slide blues.* His method is to project one of his photos on the wall, then sketch from it what he wants. He projects another and maybe borrows a small area from that one, and possibly even from a third one. He does his black-and-white value sketch, plans his composition and painting, and then puts away the slides and works entirely from the black-and-white sketch. This really is an excellent way of utilizing slides without becoming a slave to them. It is actually the same as sketching on the spot—you can pick and choose what you want. The painter must be in tune with himself. Does he wish to be a free spirit or does he wish to use crutches to go along his particular path? Both are perfectly honorable, but I hazard a guess that much would depend upon what he wishes to find at the end of that path.

Why do you feel it is so important to paint outdoors?

I think it's most important to paint on the spot whenever possible. It's the endless return to nature to find out one more little secret, one more subtlety you had not known, or pehaps to rediscover some long-forgotten shape or mood.

What if direct painting is impossible?

Many times when poor weather conditions or darkness make direct painting impractical, it becomes necessary to develop the art of *seeing* and to retain what you observe. While notations and quick sketches help greatly, there will be some situations where the entire thought must be carried in your head until you can put down your notes. At such times I do small black-and-white sketches on the spot, while thinking in color and aiding my memory with written color abbreviations. All watercolorists are most aware that the inherent problems of the medium are great enough without having to break the ice in their water containers. But one should never fall so completely in love with the comforts of the studio that he forgets to return to the source of all things—nature.

Do you ever work from a car in inclement weather?

Only for sketching, not painting. However, I have seen great rigs that artist friends have worked out for cross-country painting trips. These are veritable studio homes on wheels, complete with drawing tables, side glass panels, skylights, storage bins for paper and paints, plus a bunk. This necessitates a van type vehicle. Some people feel they need a changing scene for inspiration. I am of the school that thinks you can kick over a rock in your own backyard and find something interesting to paint.

How do you arrive at your color scheme?

I plan my color almost entirely from memory, as we are now into the creative end of the business. Make those colors anything *you* want to help create what you wish to get across. That's the fun. A barn is red, the trees are green. Okay, make the barn green or blue and the trees red, orange, or some other color. Enjoy the fun of the doing—the experimentation. It's most rewarding because it's you!

What brushes do you use, and what do you use them for?

I am sure most serious transparent watercolorists will tell you that of the three major tools used in this medium (paper, paint, and brushes), the brush is the least important. The quality and texture of your paper (to suit your particular style or approach) and that of your paints must be absolutely of the *finest.* About my brushes. I was a flashy, smarty-pants young

painter in the very depths of the early Depression years, and for the price of a two-inch sable, even in those days, I could live for six months. So, in desperation, I discovered ox-hair—beautiful, and at a tenth of the price! I still use them for my largest brushes. They range from ⅝″, 1″, 1½″ to 2″ for large washes. These are the flat, or sign-painters' type, with squared ends and quite long hair. You can learn to scumble around so that you don't get a mechanical, squared-off look if you don't want that effect. In addition, a #8 or #10 round, a #5 round, plus #4 and #6 riggers or script brushes for free-swinging fine lines.

How do you store your brushes?

Brushes to be stored for long periods may be placed in any kind of box that can be closed. Lay them flat, and remember brush hairs are peaches and cream to Mr. Moth, so toss in a moth ball or flakes and spoil his appetite.

What kind of watercolor paper do you like best?

For my particular method of painting, I enjoy working on a hand-made, 300 lb. cold pressed paper. It doesn't have to be tacked down or stretched. It is rough enough to texture well but smooth enough to take a large wash rapidly. However, if the paper is a little thinner, as in the 300 lb. double elephant size, and is going to be dry-mounted on backing board before painting, I would use the rough. The mounting process slightly flattens out the hills and valleys, so the result is about the same as cold pressed. Double elephant is large, about 25″ × 40″ (64 × 102 cm), while the so-called full sheet, or Imperial size is 22″ × 30″ (56 × 76 cm). That big fellow takes courage, but there is great sport in the trying.

Do you prefer to work flat or at an angle?

I usually work flat, as I like to stand to paint. But I do tilt the paper to better control large washes.

What's your working surface?

Any place I can set down a board with my paper on it. I like the water bucket and palette on a table or stools on my right. For teaching-demonstrations in the field, here and abroad, I had to have some gear that would carry about ten *full* sheets, but would also be a working surface and side table. So, by trial and error, I developed one. Please don't write me, it can't be done twice.

Do you work on full-size sheets, or half-sheets or both?

Both. I use full sheets for gallery and exhibition paintings, as well as most class demonstrations at the school. Half-sheets for fast exercises in medium control, such as washes and various textures, as well as value understanding. I seldom exhibit a half-sheet watercolor, although there are a few in this book.

Do you prepare the paper in any way before working?

With most of the fine heavy papers, there is a slight sizing on the surface. I have never known why—possibly for protection. But years ago I found that if you wash down the painting surface very gently, with clear water, your paint will "bite" far better and retain a truer color. This is the simple process of using a regular plain commercial kitchen sponge (no soaps). Wet the sponge in clean water and wash it over the paper surface gently. Squeeze out the sponge and take up the excess water and and allow the paper to dry. Now, go on to paint that masterpiece!

What kind of watercolor palette do you use?

You have to be kidding! Of course it's that Rolls Royce of all palettes, designed and test-hopped all over the world for many years by the author. Naturally, like all better mouse traps, it has had a couple of unfortunate imitations. Try them—you will be back.

This palette design grew over many years from my desire to have a large flat mixing area where I could stir up a lot of juicy color and still not foul up the pure color around the edge. Butcher trays were a mess after the first or second mixing, so I used the shallow dam idea. I made a

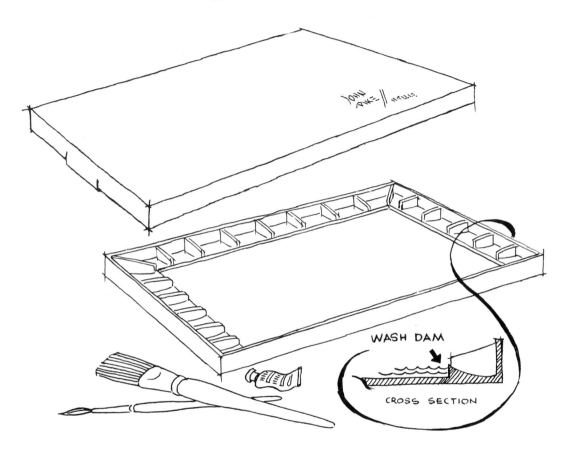

WASH DAM

CROSS SECTION

prototype out of aluminum, just for myself, with no idea of ever putting it on the market, but friends urged me to have it manufactured. I did, and its success has been phenomenal!

Specifications: size—15″ × 10½″ × ⅝″ (38 × 27 × 2 cm). On the inside of the snap-on top is an additional working surface. The palette is injection molded of rugged, stain-resistant ABS plastic, a very expensive process, but well worth the cost in quality. It's the same plastic as in your Princess telephones. If you are unable to find one at your local art store, write to me, John Pike, Woodstock, N.Y. 12498.

What are the colors on your palette?

Perhaps a diagram of my colors and the palette would better explain my approach to this part of the over-all picture (no pun intended). The fervent hope of painters around the world (I have covered a lot of it) is that the many paint manufacturers would come to terms on basic terminology. For instance, the phthalocyanine colors. Grumbacher came up with and copyrighted the name Thalo. This is by far the best solution to a word you can't pronounce, let alone spell, but that at the same time indicates the contents. They don't like it, but the word Thalo has come into common usage by artists in many countries, regardless of who manufactured

the paint. (Mr. G., that's the price of brilliant thinking). For similar colors, Winsor and Newton prefix their color names with Winsor. Another difference in terminology is Gamboge Hue by Grumbacher and New Gamboge by Winsor and Newton. If these were tricky studentbait colors such as "Hawaiian Sunset Pink" or "Over the Moors at Dawn Mauve," okay, but those I have mentioned have become standards; so hopefully, let's standardize someday. Ultramarine, the siennas, the cadmiums and others made out all right. The colors shown on my palette are the only ones I need.

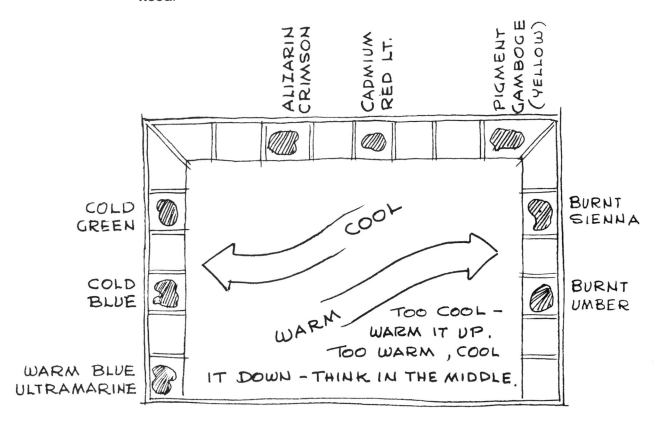

Where do you keep your water?

I shall refrain from being facetious on this one. Actually you can find water most anywhere. I have fished it out of the Tiber, the Seine, the Danube and other polluted rivers, as well as sitting on a closed commode in a Paris hotel bathroom using the water from the adjoining bidet so I might paint, through a round window, Sacre Coeur at sunset. Once I even used a jugfull from a Holy Font, along with the blessings of the good Father. Unhappily, it didn't improve my painting a bit. When in doubt, take along a jug of water, and perhaps another kind of jug as well—you just might get thirsty, not dirty!

What other things do you paint with?

About the only tricks I have are the occasional use of a liquid masking agent, plus masking tape when I wish to block out large areas. I can then swing a broad wash over a tricky area and still keep the freshness of the white paper in the blocked-out spots. I also use a sharp knife or razor blade once in a while to scratch little sparkles here and there. To me, too many tricks can become a crutch; so in these later years, I have become more and more curious about just what my moderately educated brushes can do. But play with anything you wish to gain your desired effect. Goodness knows, this toughest of all mediums can use every bit of help it can get!

What kind of light do you have in your studio?

In my small winter studio, I have a 7 foot by 7 foot north light window and, on one side, hanging vertically, a two-tube fluorescent fixture that is on all day. When daylight fades, the changeover is hardly noticeable. A word of caution about fluorescent lights. Great strides have been made in recent years in the development of *true* white, or daylight, tubes by several large companies. These are not usually found at your local hardware or electrical store. At this writing they may be purchased only through commercial electrical dealers. They cost a little more than the standard tubes, but the difference is well worth it. They snap into the standard fixtures.

In my big studio, where I have my summer school, I have eight 8-foot double fixtures (16 tubes) running the full length of the cathedral ceiling. The north window is 20 feet wide by 16 feet high. I like lots of light.

How do you arrange the materials around your work surface?

Perhaps, it's best if I show you this drawing.

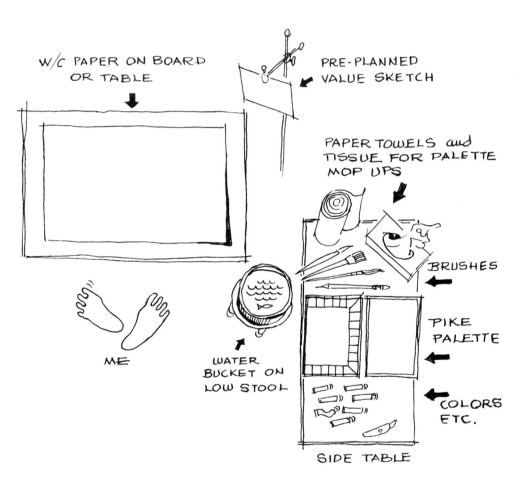

For my method of working, this layout is pretty much ideal. The sketch and stand can be most any place for easy referral. Again let me say, this is only *my* way. Lay things out in a manner that is most comfortable for you—if you are left-handed, naturally the set-up would be reversed.

See the tiny fish in the bucket? One morning at school, while holding forth with my preliminary talk on the up-coming demonstration, I glanced down, and there, swimming gaily in the water pail, were three baby trout. A couple of my students had scooped them out of the stream. For a moment, and only for a moment, I almost took the pledge!

Can you mentally see the entire picture before you start painting?

Pretty much so. And doing a careful black-and-white sketch beforehand helps greatly to solidify my thoughts. But oh, how wonderful it would be to sometime have the final painting come even close to that beautiful image I see in my mind's eye! (I think I would set fire to my brushes and, in the iridescent smoke, slowly ascend or descend as the higher judge might dictate.)

Do you have any special gadgets for drying paper?

Yes, I have a gadget of my own design, affectionately called the "Monster," as it had the dubious distinction of blowing all the fuses at the National Academy while four fine watercolorists were doing demonstrations for record crowds. But that much power is unnecessary. There are excellent hair driers that do the trick beautifully; and, of course, when you are in the field, you always have old *sol!*

How much time do you spend planning your painting?

It depends on the subject and how quickly the overall picture jells in my mind. Sometimes I may come to a conclusion at once, do a fast sketch, and swing right into the painting, which will take considerably longer than the planning. But on other subjects, when only the vague idea is there, I will doodle around with a dozen or more thumbnail sketches for a day or two until I find exactly what I am looking for. Then I'll do the finished watercolor in two or three hours. Here again, there really are no rules. I once got expansive and said, "For every ten minutes of painting, think and plan for twenty." Now that I think of it, it's not a bad thought.

Do you generally work from light to dark?

Usually, yes, because in transparent watercolor you can always make a wash *darker*, but not *lighter*. However, many exceptions will come up. As an example see "Burano at Night" in the step-by-step demonstrations section, page 56.

Do you start with big brushes and work toward smaller ones?

Yes, because I like to establish my large areas very quickly, both in values and shapes. Smaller brushes are for greater detail, textures, and close-up interest right down to swinging that tiny rigger or script brush for the little fancies. Caution: it is very easy to get "rigger happy" and overdo it.

How do you decide how much detail to add?

This answer depends on the type of painting I'm doing. A large, dark, mass picture of careful design will obviously not need a great deal of detail, as its impact lies in its patterning and values. But a delicate leafless tree silhouetted against a light sky will need considerable detail. So think between the two, and when you feel you have enough detail for interest, let it alone!

When a painting goes wrong, do you try to save it?

On my school wall I lettered: *"Trying to fix a watercolor is like telling a lie—the more you work on it, the worse it gets!"* This isn't original—a student said it years ago—but how true it is. There is one great comforting thing about painting on heavy paper: you have a clean side on the back, and when you goof, you can always turn it over and start anew.

The bathtub treatment for me is out; however I have seen some very interesting ethereal effects gained by students. I'm too lazy. I want a clean sheet. I will admit that in small areas that are not just what I want, I will scrub out and repaint. This is done with a clean oil bristle brush with pigment and water dabbed up with a tissue. But if you try this, don't scrub through your paper, and try not to harm its surface.

How many drying periods do you usually have?

Any time I want to paint a hard or sharp edge of an object over an existing wash, I will dry that underwash thoroughly. So the drying times may be anywhere from two to ten, depending on the problems and the complexity of the painting.

Do you ever look at the painting in a mat while you're working?

Yes, once or twice during the painting process. It tends to give a sharper confinement to your watercolor than the rather irregular edge of your paper. Another old trick I use is to view it in reverse with a mirror. I use an old distress signal mirror I brought back from my "Government-Sponsored Cook's Tour" of the early 1940s. This allows you to view a whole new painting, and you can immediately see flaws in your composition, drawing, and values. I guess everyone knows that one.

Do you ever put a painting aside and then go back to it?

Once in a while I do this, and it's not a bad idea. We all sometimes get into the "can't see the forest for the trees" frame of mind, and a fresh eye a few days later can sometimes work wonders. I did overdo this with a painting some years ago, however. I had painted the background and water and masked out the figures and foreground foliage. I wasn't deliriously happy, so I set it aside (I keep all my sketches). I forgot it, and five or six years went by. I came across it in an obscure bin, liked what I had, went on and finished it, and it is in an earlier book. Its title is *Fishermen,* and shows two lads, one standing, one sitting, in a dugout canoe in a tropical lagoon with a small fish breaking water in the right foreground.

How do you know when a painting is finished?

Ah, here, you have asked me one of the most difficult questions to answer, and one that needs answering the most. Perhaps a parable will be the best answer.

Three Roman citizens sidled up to the buffet lunch bar (Carrara marble, of course). They were Maximus Max, Normalus Tempo, and Particulus. After a time of feasting, Max groaned and said, "By Jove, it was so good I think I have eaten *ad nauseum,*" while Particulus complained there was nothing he really liked and was still hungry. "How odd," said Normalus Tempo. "I have partaken of just enough and feel excellentus! Shall we leave?"

How do you like to frame your watercolors?

I like the simplest kind of frame—simple, but with quality. All of the fancy framing in the world will not save a bad watercolor. To me, if it is a good watercolor, a garish frame accomplishes nothing beyond pulling the eye away from the painting. The mat and frame are really eye stoppers, something like a window that helps to concentrate your view into that particular part of the world the artist has seen and liked well enough to put down; so don't spoil it by hanging a piece of furniture on the wall.

The following sketch shows one type of mat that I like to use; it goes with any type of decor. (Your decorator will agree unless she is also a framer.) I do not like colored mats for my type of painting. Warm and cool grays and white are all right. There can be some color in the narrow frame, but with discretion.

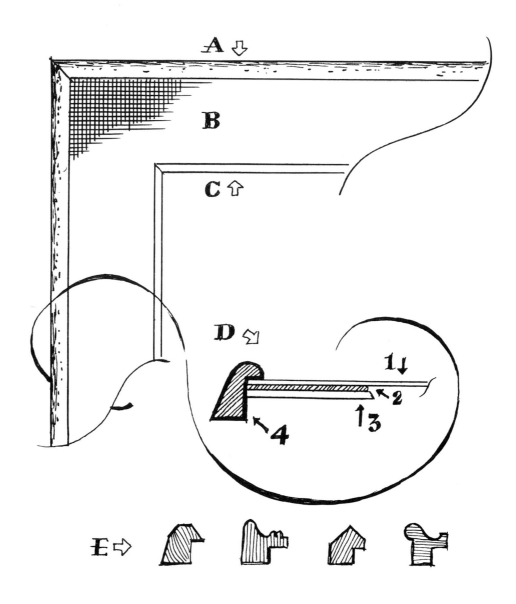

A. This is a strong but narrow frame of neutral color. Color may be added to suit the individual taste (some of the new metal frames are good).

B. I like a light-toned linen overlay in warm or cool grays, depending on what goes best with the watercolor. This overlay is done by stretching the linen over a standard-weight mat, turning over the edges, and gluing.

C. One-quarter-inch Upson, or beaver board, cut at about 45-degree angle, and sanded and painted dead white. The linen mat is then glued on the top of the white-edged mat, exposing the bevel.

D. cross section
 1. Glass or plexiglass. Note: If you are shipping the painting, use plexiglass, as most shippers will not handle regular glass.
 2. Linen overmat.
 3. White-edged undermat.
 4. One type of molding I use quite often is wire brushed, grayish, and sort of wormy. Sweets to the sweet?

E. There are innumerable types of moldings available in colors, grays, gold, silver, etc.

What is your criteria for a successful painting?

A universal notion has always been that the artist is the poorest judge of his own work. What nonsense, at least up to a point. Every artist feels his painting is a very personal thing, and in judging a finished effort, some of these personal preferences may creep up and possibly influence his eyes and mind a bit. Criteria? None beyond the joy and warmth of doing the best I can in that given place in time.

What is your setup for doing demonstrations?

I think this can best be shown by a drawing, some explanations, and some variations on my setup.

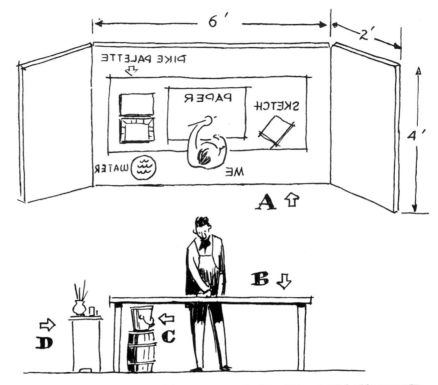

MY SCHOOL-STUDIO DEMONSTRATION SETUP

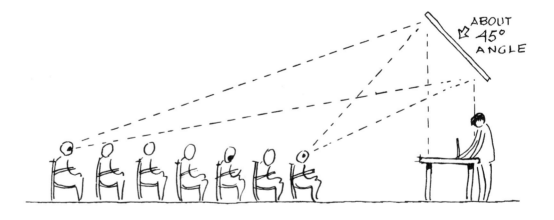

A. Overhead mirror with side adjustable wings.

B. Working surface table. (See layout in central mirror reflection, reversed, of course).

C. Plastic pail of water sitting on an old nail keg.

D. Small side table for miscellaneous things—brushes, pencils, masking materials, tissues, paper towels, etc.

In the lower side view drawing, I have left off the side wings of the mirror for simplification. In a demonstration setup, all reflective surfaces should be adjustable to accommodate the size and distribution of an audience.

Some time ago a friend introduced me to a great product named "Mirrorlite." It is a *glassless* mirror that, to me, is the ultimate perfection for display or demonstrations. It is extremely lightweight, which makes it easy to handle, hang, and store, and it is also *optically* as good or better than the finest of glass mirrors. I don't often plug a product, but this is something special, and you should know about it. Write for information: Mirrorlite, Kamar Products, Inc., Irvington-on-Hudson, New York 10533.

Why do you paint?

Every once in a while, I stand back and ask myself this question. Why? What is a big, strong man doing splashing around with water or oil and pigments, when possibly his greatest contribution to his immediate environment would be to help dig that ditch for the completion of a new sewage system. Is it ego, financial gain (even the paint boys have to eat, drink, and be sheltered), or is it simply that deep down one has to react to the ugly or beautiful world and *say something*—even if it is only to oneself?

Ego? Sure, it pleases me and encourages me greatly when someone says, "I like what you do." Financial? Yes, it's been rewarding: a kid through college, travel, and a lot of good eating and drinking (and my waistline shows it). But let's dig back underneath for the *real* answer to *why* I or any other artist does it.

I think most people who have made one of the arts their profession have had the joy and sometimes the terror of inner thoughts, thoughts beyond the obvious two plus two make four. I think that way back in early childhood there was a definite shyness in these people, leading perhaps to a greater or lesser degree of introversion. Happily, most of them, with a little ego shove due to acceptance, came roaring out of that dark cave and became some of our most outgoing, creative people.

For the creative person in any art form, there is a time for fun and exposure and a time for work; the latter comprises about 95% of that time. In other words, he is of necessity a loner. He must go his own way. And I am one of these people—a loner who must go my own way, reacting to the world around me in my own way, trying to get down on a white piece of paper, with some water and pigment, a response to the world that is my own.

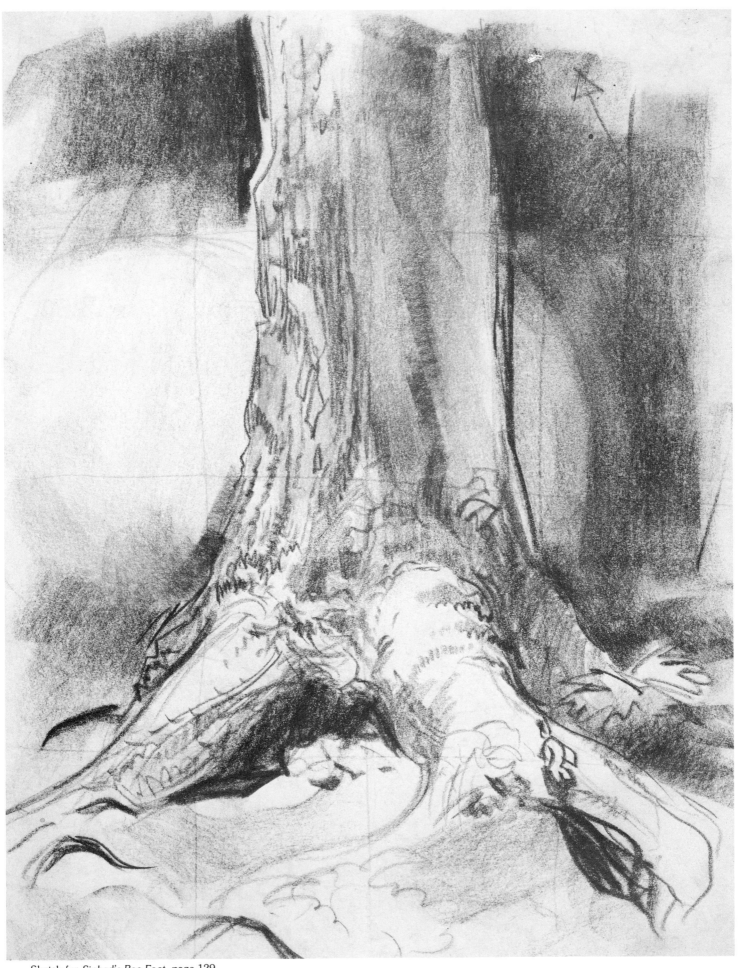

Sketch for *Sinbad's Roc Foot*, page 129.

PORTFOLIO OF SKETCHES

Some of these black-and-white sketches go back thirty years. I have tried to keep as many as I could, just as I do the hundreds of watercolors that didn't make it. They allow me to look back on many experiences, attempt to say something that I wasn't able to pull off at a particular time. I hope these sketches demonstrate what I feel are important points.

As an "impressionist," "realist," "representational painter," "square," or whatever other names the critics may dream up to try to pigeonhole me, I think the ability to really see values is by far the single most important factor in watercolor painting. What do we have to start with? A blank piece of paper or canvas that has two dimensions—width and heighth. What do we hope to achieve? The illusion of the third dimension—depth—which is gained only by thinking through value relationships. This was hammered home to me by the great Charles Hawthorne and his gentle but strict Number One disciple, Henry Henche, back in the years from 1927 to 1930. I was just sixteen the first summer I studied with Hawthorne, and it wasn't until a few years later that I really understood the great wealth I had received.

I have divided this sketch section roughly into three parts:

1. Graphite sketches done with pencil and graphite sticks
2. Chalk sketches done in middle grays and black chalks
3. Preliminary pencil drawings that are traced full-size onto the watercolor paper (usually figures and animals)

These are the three I have used most, but you can use almost anything. Some of the sketches were done in felt pen, Conté, India ink—anything that was at hand to put down a thought. I've even used burnt cork years ago when corks were readily available.

Graphite (sticks or pencils). It's a good idea to leave a blank sheet between your sketches if you are going to keep them in your pad or book. A good bond paper pad about 9″ × 12″ (23 × 30 cm) is excellent for your wanderings. It has enough tooth to make good dark lines, yet is smooth enough so you can lay in large gray values with the side of your pencil or graphite stick. The sticks are numbered the same as pencils. I like the softer one in both—4B and 6B. They allow for finger rubbing, which is very nice since a certain subtleness can't be accomplished by just putting the pencil to the paper. You'll also need a spray fixative along with you.

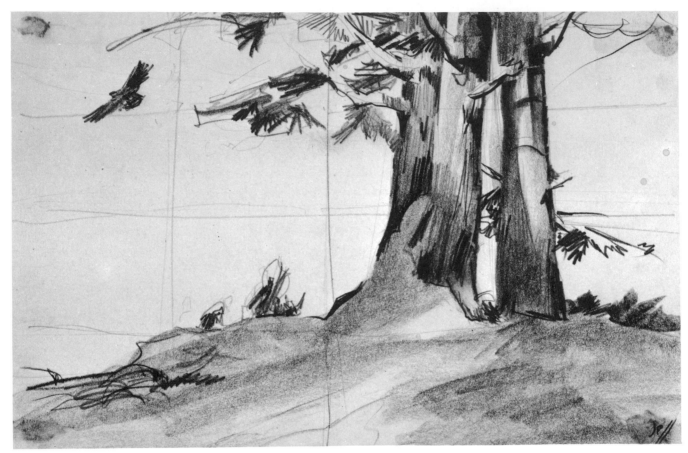

Sketch for *Castle Invaded,* page 135.

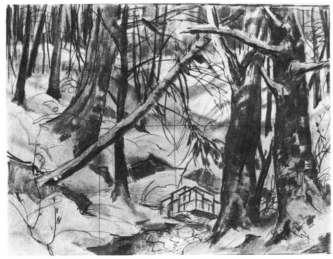

Sketch for *Untouched Forest,* page 134.

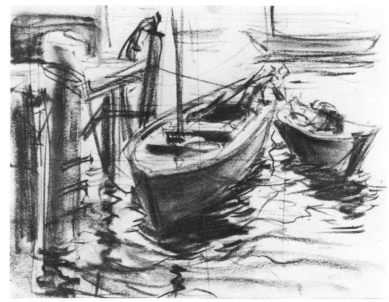

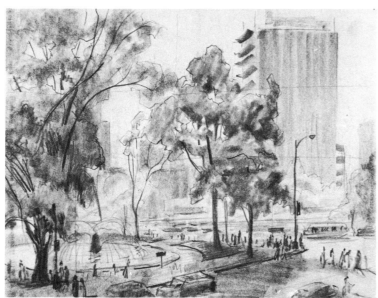

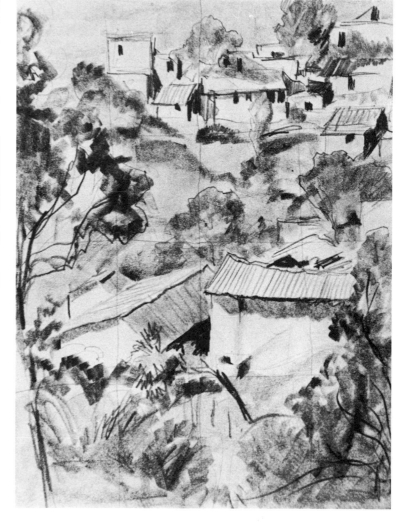

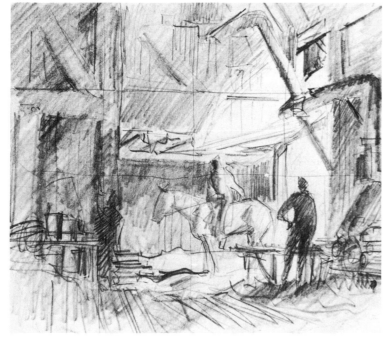

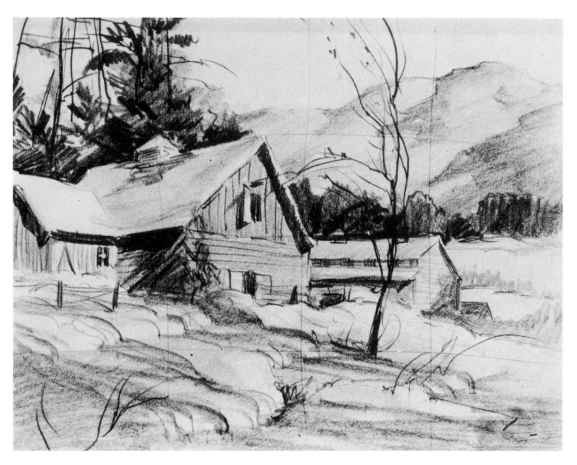

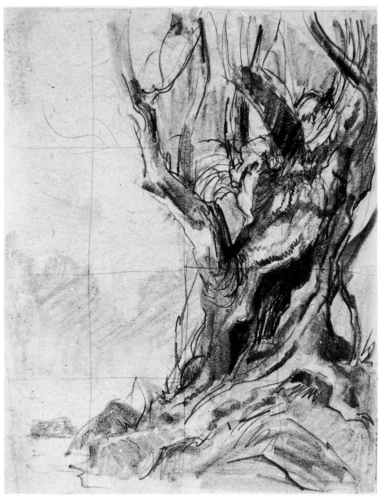

Sketch for *Shooting Fish on the Rio Carrao, Venezuela*, page 147.

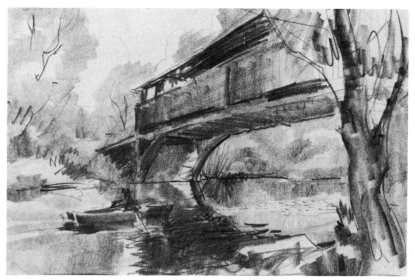

Sketch for *Perrine's Bridge*, page 150.

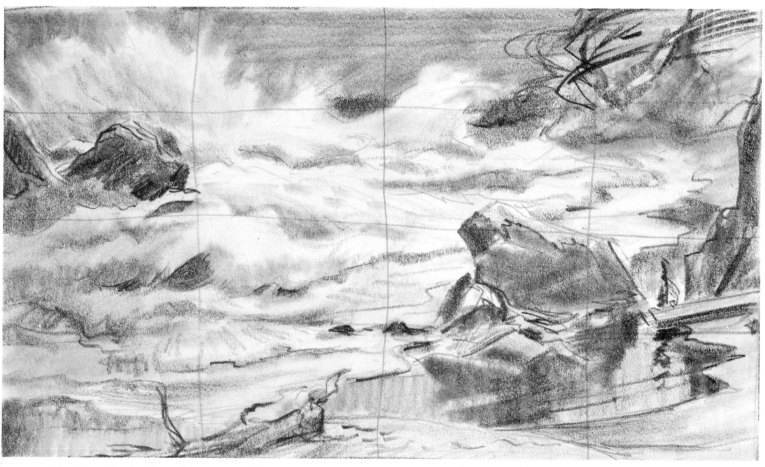

Sketch for *Brewing Storm, Jamaica*, page 140.

Chalk. This is very messy, but its messiness is offset by the rapidity with which you can get down a large value area. The same bond paper that is good for graphite sketches is also workable for chalk, but the chalk can take a more toothy paper than graphite and still give you a nice, solid tone. In the chalks, I usually use a couple of middle grays and a black, using the white of my paper as the white or highest value. But there are no pat methods. Try everything that you want until you find the way that is most comfortable for you. For instance, try a middletone gray paper and work up and down your value scale, using only a black and white chalk. This can be fun. Also remember that in your sketch you are mixing, changing, stealing from behind you, erasing, and composing until you find the combination for that great Gold Medal winner.

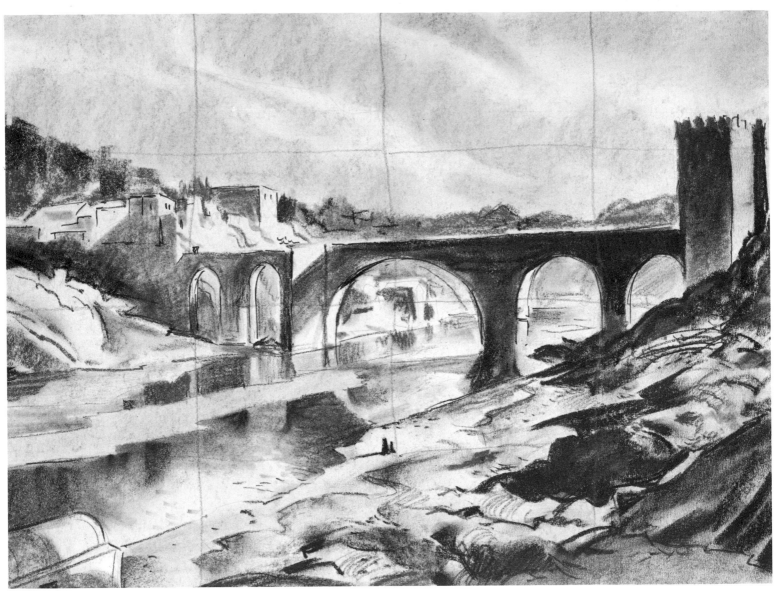

Sketch for *Old Bridge, Toledo, Spain*, page 156.

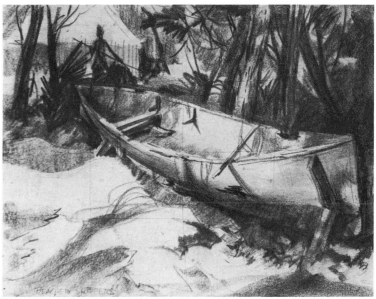

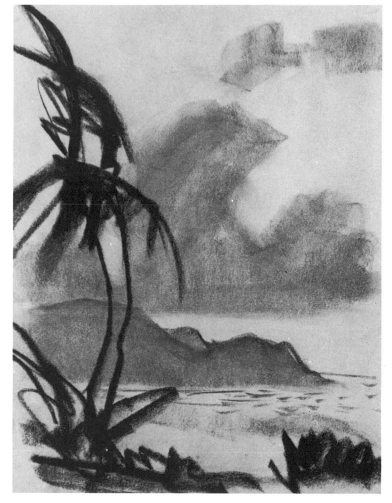

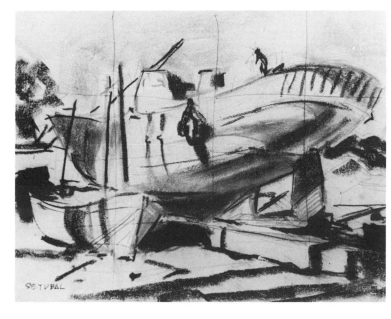

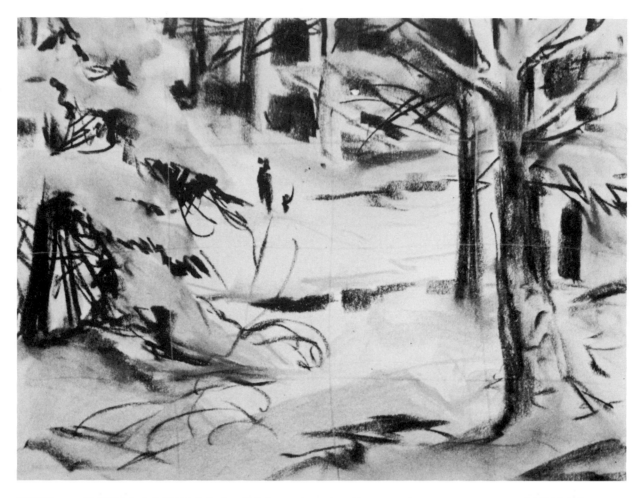

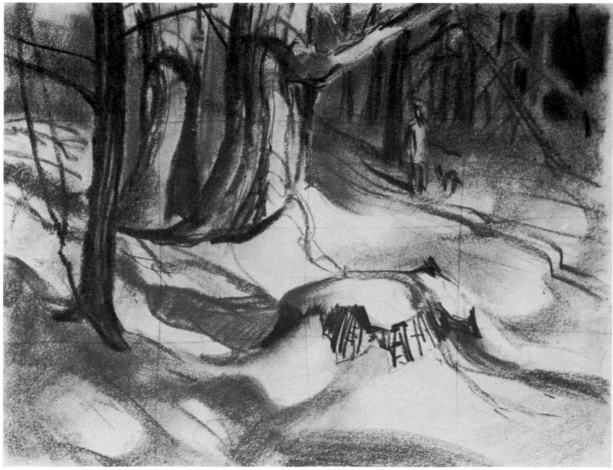

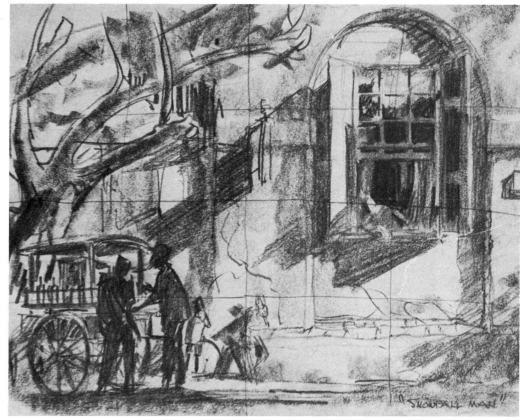

Sketch for *Snowball Cart, Spanish Town*, page 10.

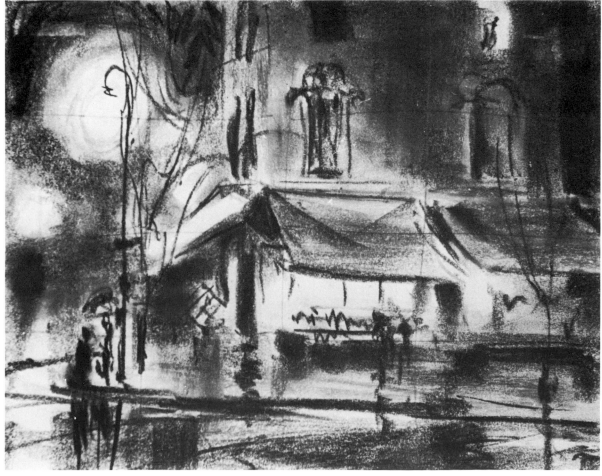

Sketch for *Snow Cascades*, page 142.

Preliminary Pencil Drawings. These can be traced onto your paper after you've decided on the pose or anatomical part your going to focus on in the final watercolor. By working on a separate sketch pad, you avoid roughing up the surface of that beautiful expensive sheet of paper with changes and erasures. Plan! Plan! The goofs are so easy to make if you don't. I suppose my caution comes from working so many years as a magazine illustrator. There were always deadlines, and if you wanted to stay in that lucrative part of the art game, you had to have your painting in on time. There was seldom a second chance, so you planned most carefully.

Above, Upper right, Lower right: *Sketches for Jungle Beasts Gather for a Refreshing Pause, Africa, page 141.*

Sketch for *Atlas Mountains, Morocco, page 152.*

Sketch for *Shooting Fish on the Rio Carrao, Venezuela, page 147.*

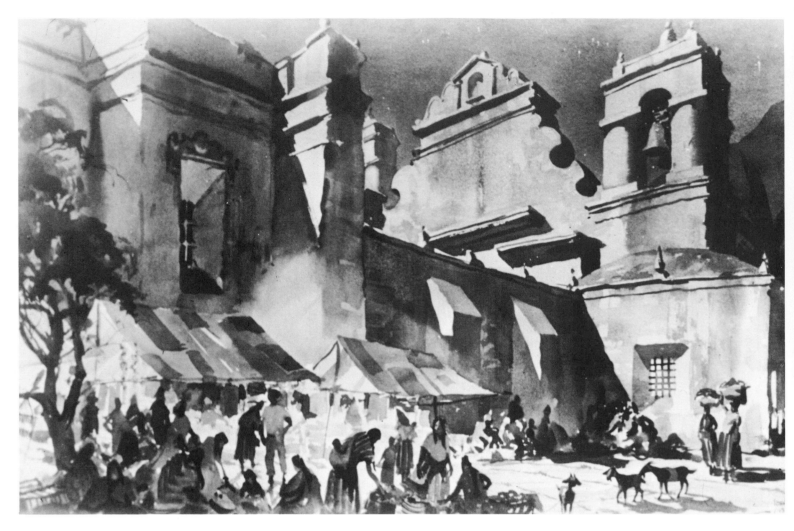

Night Market, Guatemala
24" × 40" (60 × 100 cm).

This delicately designed but massively structured church stands in the middle of a forlorn little village high in the mountains of Guatemala. Not many people speak Spanish here. In fact, the inhabitants of one town can't always understand the people of the next town. Their figures are small, but they have rugged, beautiful Mayan features.

Although I did the sketch in bright sunlight, I decided to switch to moonlight when I painted the picture. I wanted to play the cool tone of the night sky and the moon against the warmth of the lanterns hung under the patched canopies. On a clear night, moonlight can be surprisingly bright—a lot brighter than you might think. Here, the moonlight gave a clear, crisp distinction between the light and shadow planes of the building, emphasizing the stark beauty of the architectural shapes. But I saved my strongest light and dark contrasts for the market in the lower left, where the dark figures are silhouetted against the glowing light under the canopies. Notice that the strongest darks in the picture are not in the moonlit sky—which beginners tend to paint too dark—but the shadows on the building and the dark figures in the foreground.

DEMONSTRATIONS

As always, for every watercolor I do, I have a carefully prepared black-and-white sketch to work from. It may have been done on location or worked up back in the studio, possibly combining several thumbnail sketches to gain the composition and general feel of what I wanted to say. In these demonstrations, we photographed the watercolor directly as it proceeded through its various stages to the final painting—and all in full color. How was it done? Everyone likes an inside story, so here it is.

We set up one of the side storerooms in my school as a photo studio. The moment I completed demonstrating one stage of the painting, Don Selchow and his assistant Dick Frisbee whisked the painting through the side door and photographed it while students in my summer school grabbed another cup of coffee and seemed happy to have a break.

Allow me to reiterate. Each watercolorist has his own approach and methods. What is shown here are simple procedures that I have found simplest for me. If you like them, help yourself; but remember, no two subjects are just alike. It's up to you to select and analyze the procedure that is correct for the subject you're painting.

1
SUMMER WOODLAND

15″ × 22″ (38 × 55 cm)
Collection of James Flowers.

I'm going to paint this watercolor to demonstrate how to take a very confusing mass of ''woods trash'' and break down all that detail into a very simple form—a form that's painted cleanly and freshly, and yet still gives the illusion of that charming stuff out there in the woods. The raw material of this painting may not *look* beautiful at first glance, nor can anyone hold your hand and say, ''This is beautiful.'' You've got to discover the beauty of an unlikely subject all by yourself. You must live with painting and with nature long enough to be able to see beauty where others might not see it.

Sketch. This chalk sketch is done in three values: a dark tone, a middletone, and bare paper for the white. The in-between values are only contributors to the ''big three,'' as you know. Here, the trees and other shapes in the foreground are the darks, while the more distant trees are the middletones. Vertical and horizontal lines make a kind of checkerboard that allows me to look at the composition piece by piece when I enlarge this drawing on the sheet of watercolor paper. When I make my pencil drawing on the watercolor paper, I look at the sketch one square at a time. It's easier that way. This process is called ''squaring up'' and goes back to the old masters.

Step 1. When I'm finished with the free, simple pencil drawing, I paint in the most distant tree silhouettes, working around the shapes of the bigger, closer trees on the left, which I leave untouched. Since things tend to go cooler or grayer as they go into the distance, I start with a subdued mixture of ultramarine blue and burnt sienna. This makes much lovelier grays than a simple mixture of water and ivory black, which isn't even on my palette. In fact, any blue-gray mixture will produce a variety of warm and cool grays. Don't hesitate to exaggerate the coolness and paleness of these tones if this creates a greater feeling of distance.

Step 2. When this first wash is dry, I make my second move forward into the ''far middleground''—the darker trees and the underbrush on the ground—painting right over the tone that I put down in Step 1. These darks are a stronger combination of ultramarine blue and burnt sienna than the first wash. I've also indicated a few patches of foliage colors: a mixture of new gamboge and a hint of ultramarine blue at the center; alizarin crimson, burnt sienna, and new gamboge to the left. I'm still leaving white paper for the foreground trees in sunlight.

Chalk on bond paper, 9″ × 12″ (23 × 30 cm).

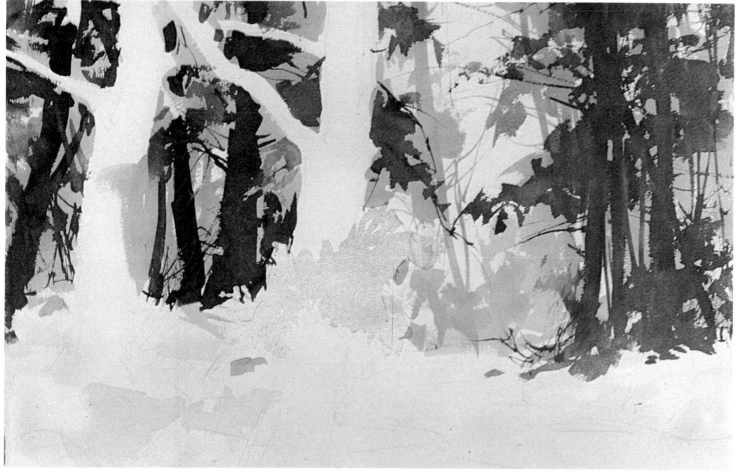

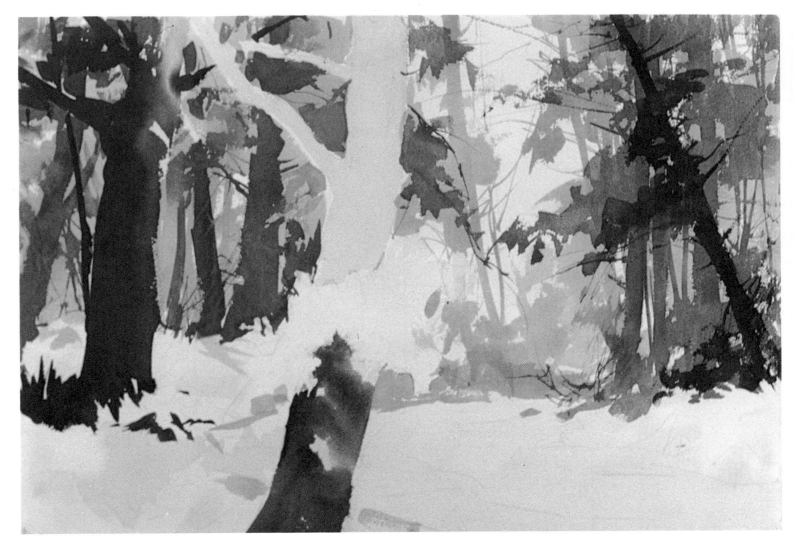

Step 3. Now I go to work on a few of the darker tree shapes, superimposed over the first two passes. You can actually see two tones on the big central trunk and the one to the left. I begin with a pale wash of burnt sienna, new gamboge, and just a touch of alizarin crimson. While this is still partly wet, I go back in with a much darker mixture of burnt sienna and ultramarine blue. Where the underlying wash is still damp, the dark tone blends wet-in-wet into the undertone, as you can see on the lower part of the central trunk or toward the top of the trunk on the left side. I'm saving the upper part of the central trunk for the final stage, when I'll do my most detailed work. That's why the lower part of the sheet is still bare, since that's where I'll do the intricate brushwork for the ground.

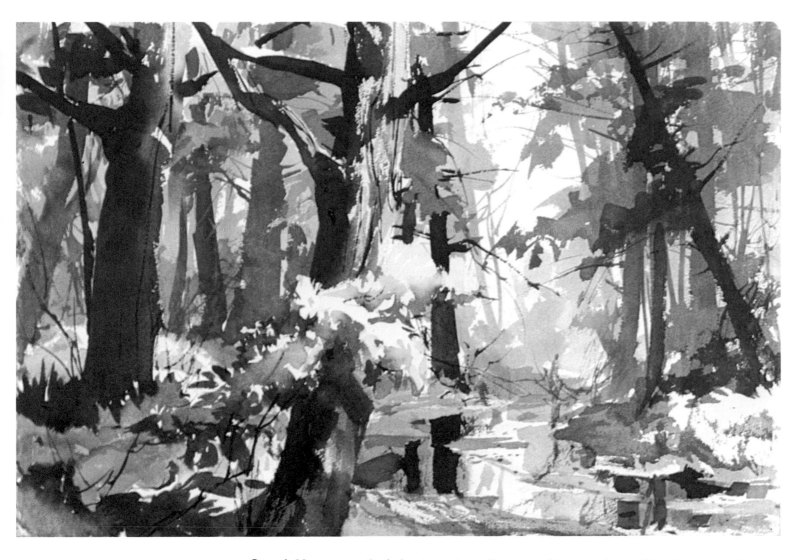

Step 4. Now comes the balancing act—pulling everything together and finishing up with all the little details of foreground textures to interest the eye. The upper part of the central treetrunk is finished with that same mixture of ultramarine blue and burnt sienna—with a bit of drybrush for texture, and some long, skinny, wandering strokes to suggest cracks in the bark. I do the same thing on the lower half of the main trunk, just below that clump of foliage. The shadows on that cluster of leaves are a mixture of phthalocyanine blue and new gamboge, toned down with a bit of burnt umber. I paint all the reflections in the water by bringing down the colors of the trees that you see in the distance and middleground. The bits of shore are mixtures of phthalocyanine blue and burnt sienna or phthalocyanine blue and new gamboge. Twigs and branches are saved for the end, and I do them with the thin, springy tip of a rigger. Adding these last details is so much fun that it's very easy to become intrigued with one little area and "noodle" or detail it to death—forgetting for a moment that it's the big, overall picture that counts. This is when it's important to stand back and see whether or not the painting holds together. While you work, always keep seeing the picture as a whole.

2 WOODS– LATE WINTER

22" × 30" (56 × 76 cm)
Collection of Anne Higgins

In this snowy landscape of the woods behind my house, I follow almost exactly the same procedure that you saw in *Summer Woodland*. But this time I bring my blue-gray wash down into the snow that covers the ground, leaving the paper white for the long streaks of sunlight. I've spent years trying to get away from painting snow shadows so blue—but dammit, they *are* blue! However, I *have* learned to neutralize that blue a bit, toning down my ultramarine with just a touch of burnt sienna or burnt umber.

Sketch. Here's another sketch consisting mainly of three tones: black for the darks, gray for the middletones, and bare paper for the whites. You can see that I don't fuss too much with details. The whole idea is to get down the big shapes. It's especially important to establish the big lighted planes on the tops of the snowbanks and the big shadow planes on the sides. Snowbanks aren't just a lot of mush—they're solid and three-dimensional and have strong lights and shadows just as treetrunks, rocks, and other solid objects do.

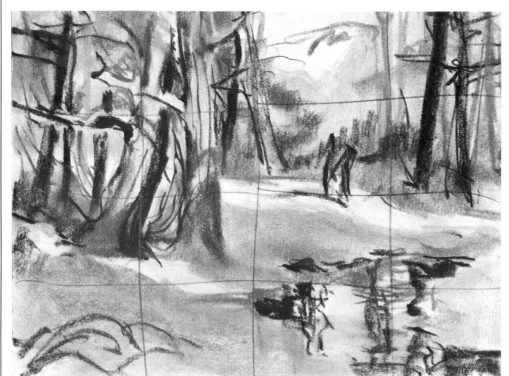

Chalk on bond paper, 9" × 12" (23 × 30 cm).

Step 1. I start by thinking of this picture in theatrical terms, painting the backdrop of the distant mountains as well as the closer trees and foliage. With clear water I wet the upper half of the sheet and drop in the slightest hint of yellow, which blurs away into the wetness. While the paper is still wet, I brush in a big, soft form with a mixture of ultramarine blue and burnt sienna. Then I skip down to the dry lower half of the sheet and brush in the snow shadows—here a flat tone to be contoured later on. I locate the two figures with just a few strokes, simply to establish where they go.

Step 2. When the backdrop is dry, I paint in the trees that fill the upper half of the picture—the distant and middleground trees— with the most distant trees painted first. When they're dry, the middleground trees go right over them. Once again, I work with a blue-brown mixture, with a little more brown in the bushes at the foot of the trees. I also wet that patch of bare paper in the foreground and add a blur of ultramarine blue and burnt sienna. Later on, this will look like a stream. The darkest darks will be in the foreground, and they'll come last.

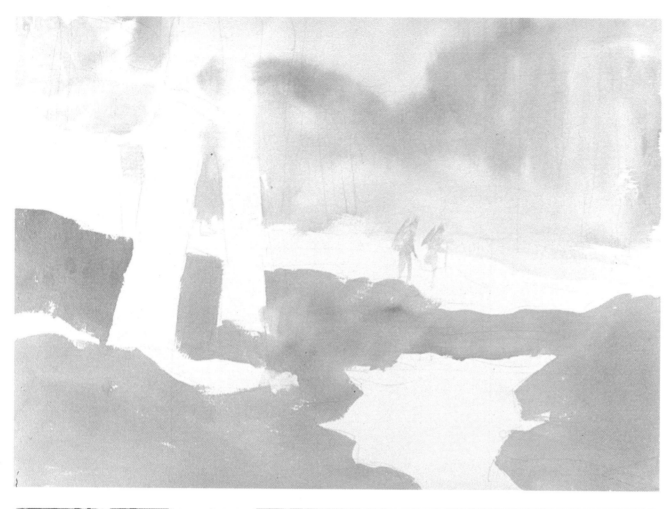

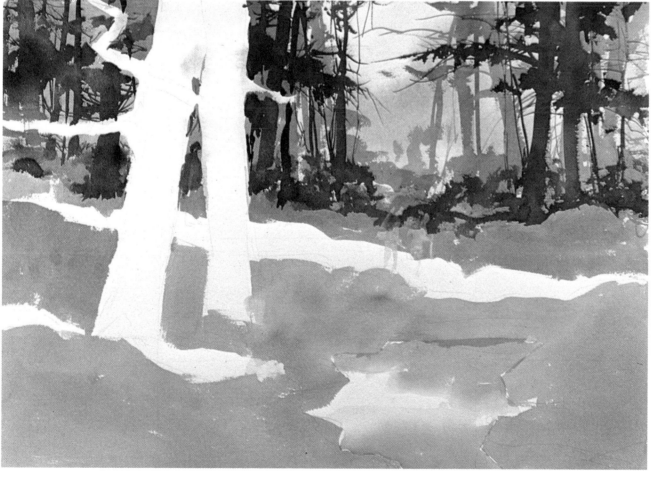

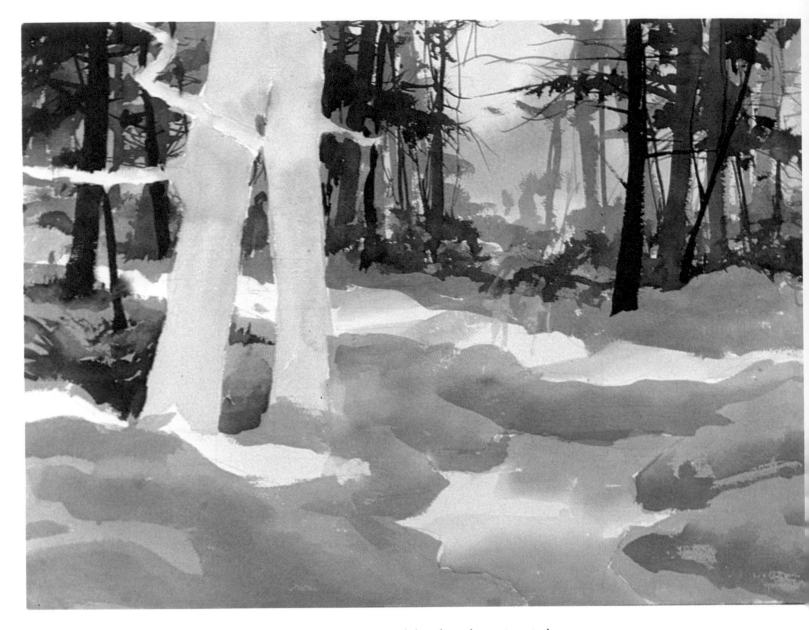

Step 3. Now I begin to model the contours of the snow with big, broad, curving strokes to follow the shapes of the snowbanks. I'm using the same mixture I started out with in Step 1, but darker, and I soften some of the edges of these strokes with clear water so that there's a sense of gradation. Some pale washes, warm and cool, go over the two big treetrunks: new gamboge, alizarin crimson, and phthalocyanine blue in different proportions for the warm and cool areas. In the final step, these tones will turn into sunlight on those two big trunks.

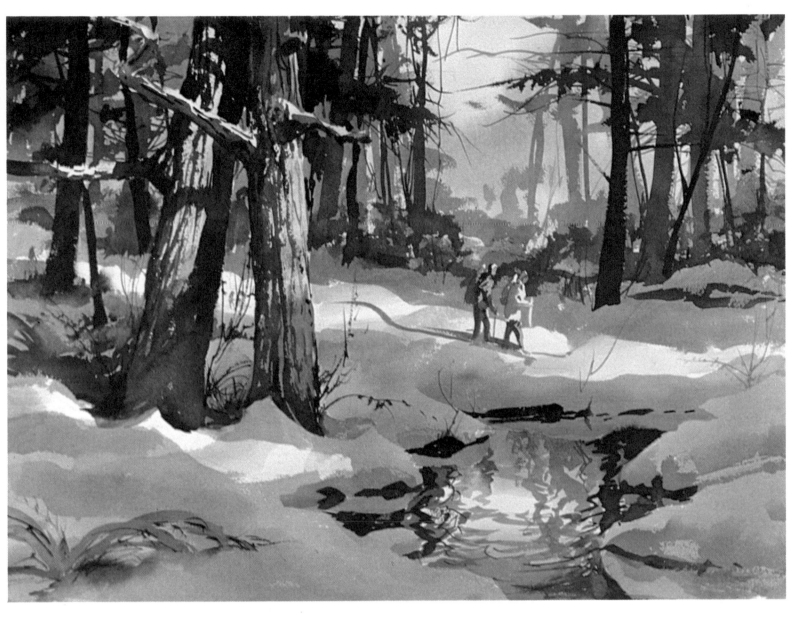

Step 4. At this final ''pull together'' stage, the darks and the foreground textures are brought together to force your eye into the painting. If you look back at the sketch, you can see that most of this is just barely indicated without too much detail, but the values are there. I add some more curving strokes to do the final modeling on the snowbanks—the same mixture, but even darker now. I carry some really dark shadows up the sides of the big trunks and finish off with some drybrush strokes and some slender lines for the texture of the bark. I add some juicy darks under the edges of the snowbanks alongside the stream and make some wiggly lines in the water with the colors of the distant trees, suggesting reflections and making the water look as if it's rippling. I finish the figures too, then add a warm note to the stream to suggest the reflections of the figures. And I bring in that rigger, as I do so often, for the last branches, twigs, and leaves. Look at the dark notes once again, and you'll see that they're not dead grays, but contain color. You can get lovely darks by starting out with a blue-brown mixture, then adding a hint of some other color—a bit of new gamboge or phthalocyanine green to make a greenish dark such as the luminous shadow on the big tree to the left. Notice how the figures cast a shadow that curves upward, traveling over the snow and suggesting the curve of the snowdrifts.

3 BURANO AT NIGHT

22" × 30" (56 × 76 cm)
Collection of Sara Hunter

In this painting, we have quite a change of pace in subject matter and in working procedures too. Most of the time I work from light to dark—remembering that I can always go darker if I need to, but I can't go lighter. But this time I toss the light-to-dark rule into the Venice harbor and start with a *middletone*. A night scene like this can be particularly tricky because there are several light sources—and the lights are multiplied when you have wet streets and wet rooftops. It's a lot easier in sunlight, when you have only one light which falls uniformly over the entire subject.

Sketch. This sketch is actually a composite of several buildings on the little island of Burano, just a few minutes from beautiful Venice. I was intrigued by the unusual roof construction on many buildings. The drawing is done in chalk on white paper. Particular care must be taken with the perspective and drawing of architectural subjects.

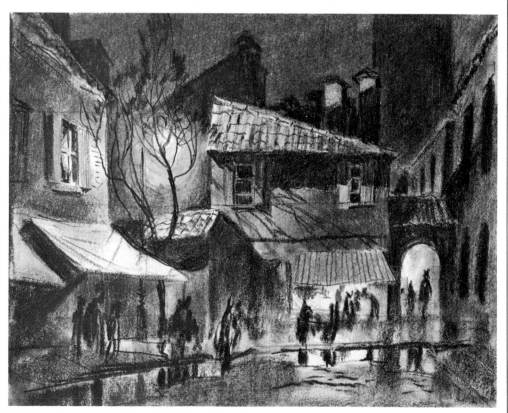

Chalk on bond paper, 9" × 12" (23 × 30 cm).

Step 1. When I'm finished with the pencil drawing, I put down some masking tape over the roofs and other areas that will be lighter than the background. Working carefully with a sharp razor blade, I cut around the strips of tape, peeling off the excess. Then I mix up a middle value—a sort of blue-gray-green "soup"—in a paper cup and wash this tone over the entire upper area, painting around the street light and that shiny spot on the wall of the building to the left. This "soup" is a mixture of phthalocyanine blue, burnt sienna, and a little new gamboge.

Step 2. When that blue-gray-green tone is dry, I pull off the masking tape—which won't harm the tough surface of a really good paper. I now begin to block in the shapes of the buildings, leaving gaps for the windows. I paint the warm patches with a mixture of new gamboge and alizarin crimson, carrying that tone down over the central building. I also strengthen the sky tone with the blue-gray-green mixture, which now defines the diagonal edges of the rooftops and the lines of the chimneys.

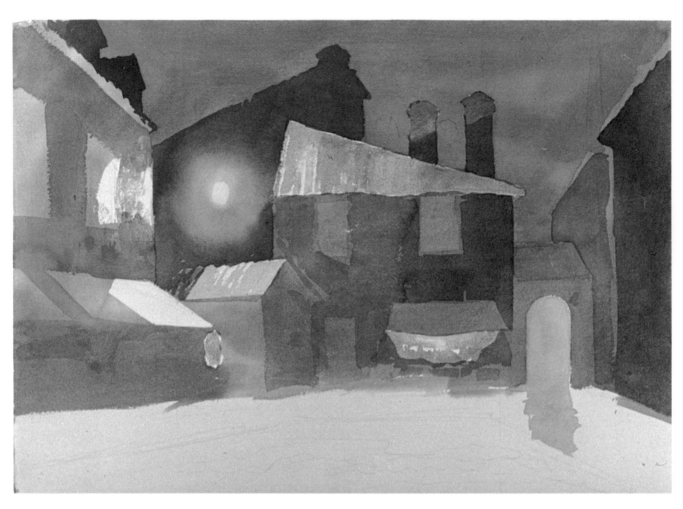

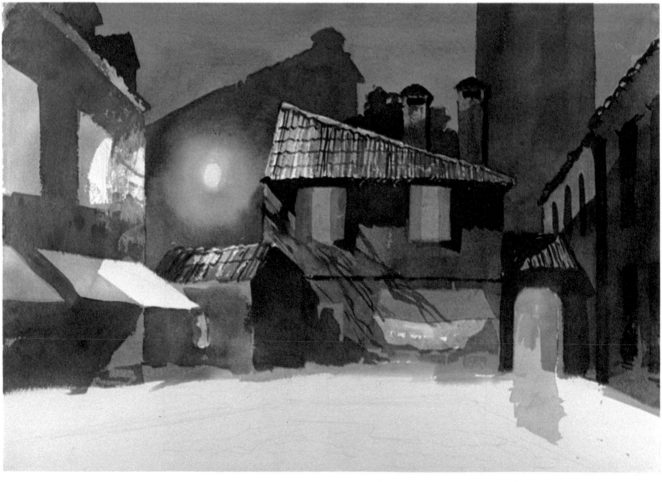

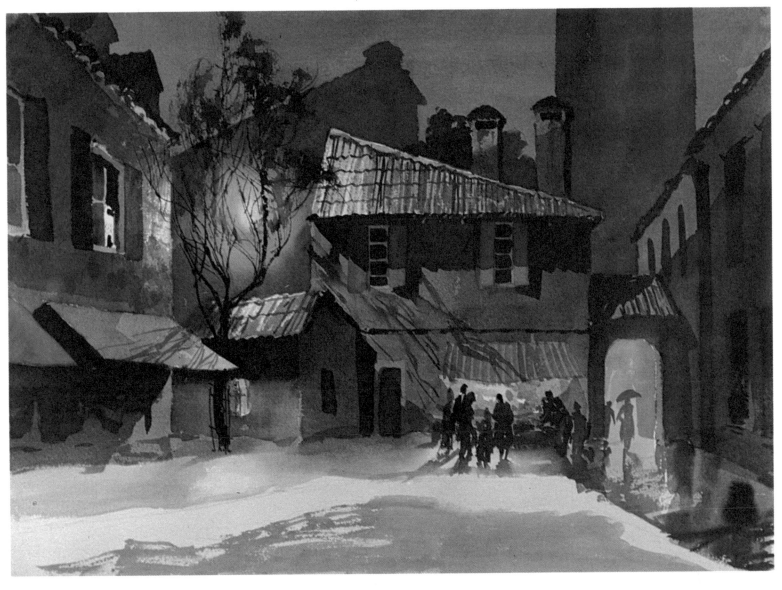

Step 3. (Top left) I block in the really strong darks of the diagonal building against the sky, plus the dark triangles on the rooftop to the left and the dark wall to the right. Now the sky really looks like a middle gray when it's contrasted with these darker notes. With the same mixture—but with more burnt sienna—I also darken the face of the central building. Now you can see the windows more clearly. And I tone the tops of the chimneys with approximately the same mixture I used on the rooftops.

Step 4. (Left) Still working with what is pretty close to my original "soup," I add more buildings to the background, and I put the shape of a tree behind the chimneys on the central building. With a really dark version of that mixture, I add a shadow under the rooftop of the main building, another shadow on the side of the smaller building to the left, plus some shadows and windows on the building on the right. And I start to add some details with a smaller brush: the roof tiles and the shadows of the branches.

Step 5. (Above) Here I'm in the home stretch, adding my darkest darks: more windows, shadows, and doorways. I kill a lot of that white paper in the foreground, adding a big shadow and leaving a strip of white for the long puddle you'll see in the next step. With one flat, dark tone I suggest the figures in front of the fruit stand and in the archway—no details, just simple strokes and flat shapes. I doodle around with the rigger, adding things like the tree at the left and some more shadows on the roof. The reflections in the pavement at the right are painted wet-in-wet.

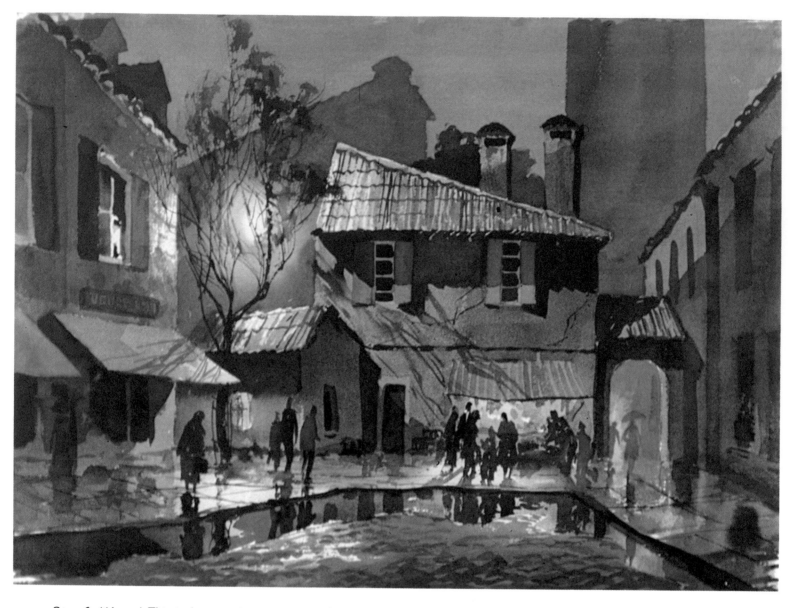

Step 6. (Above) This is the way the painting winds up—two-and-a-half hours later. All those small strokes are added to complete the reflections on the wet pavement and the cobblestones in the immediate foreground. The colors of the buildings, the lighted window, and the lighted fruit stand are all carried down into the curving puddle. When these colors are dry, I add the reflections of the figures. I use the rigger to draw skinny lines all over the sidewalk to suggest the edges of the paving stones; the lines aren't too straight, but they *are* in correct perspective. The most brilliant reflected lights are just bare paper, but not too many of them, or they'd be distracting. Frankly, I was nervous; what if I'd fallen on my face and goofed the whole thing at the last stage! About forty years ago, the owner of a Manhattan gallery on 57th Street where I was having a show, said: "Just remember, John, you're *only* the paint boy."

Detail. (Top right) In this close-up of the center of the picture, you can see how the figures and their reflections are painted with just a few strokes of flat color and how the rigger picks out details such as the branches in the upper left area, the reflections of those branches on the wall, the cracks in the pavement, and the cobblestones in the lower right section. That warm tone behind the figures really sings out in all that darkness.

Detail. (Right) Here's a close-up of the left side of the painting, showing how I get that glow of light on the buildings. Look back at Step 1 and see how that "bull's-eye" and that ragged patch of light now take their places in the picture. The rigger draws branches over the "bull's-eye," so now it melts back into space. Over the other patch of light, I've done some drybrush work to give it the texture of masonry. Those reflections on the wet pavement are just ragged scumbles of tone, but they work because the values are right.

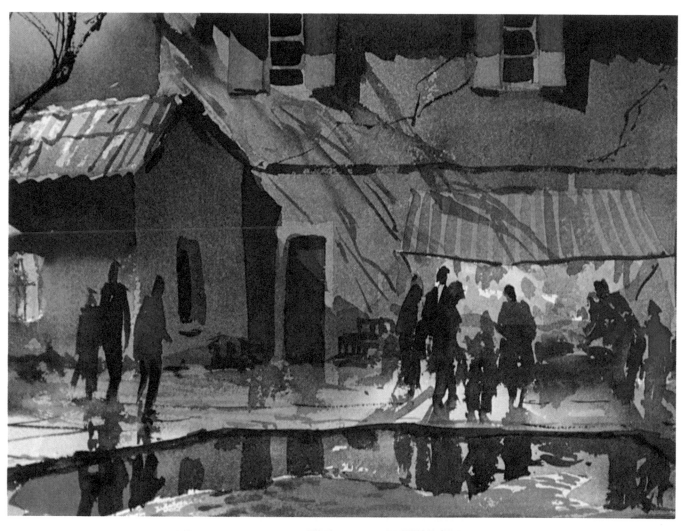

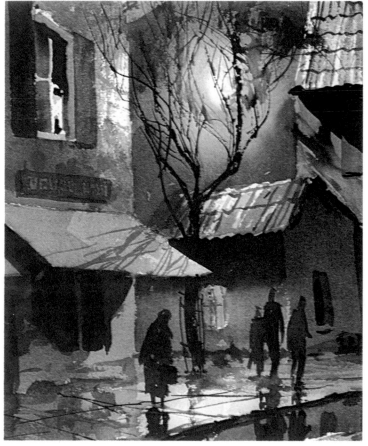

4
UNFINISHED PROJECT, SAVANNAH

22" × 30" (56 × 76 cm)
Collection of Robert York

This beautiful boat hull was at a shipyard and fishing wharf area at a place called Thunderbolt on the Savannah River. Apparently the boat was begun and built about three-quarters and then abandoned several years ago. Nearby, many large and spotlessly white shrimp boats would come in and load aboard tons of ice, then take off. Each had the name of some loved one lettered on the bow. Many of the skippers came from families who'd been in the trade for several generations. They were rugged, but most friendly gentlemen.

Sketch. This is done in graphite pencil, which can be bought at art supply stores in various degrees of hardness and softness, the softest being the blackest. A hard lead, which is pretty gray, would be 5H, while a very black, soft lead would be 6B, which is what this sketch is done with. An ordinary #2 writing pencil is equivalent to 2B. That's the kind your insurance salesman gives you with his name printed on it. Keep them. They're exactly right for drawing on your beautiful sheet of watercolor paper.

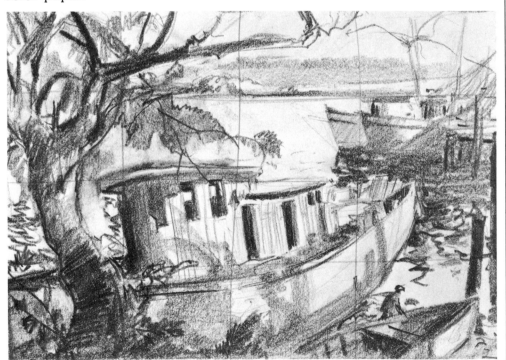

Graphite pencil on bond paper, 6" × 9" (15 × 23 cm).

Step 1. Here I want to create the feeling of late afternoon, just before the sun goes down. So I toss in a big, continuous wash, starting with a pale, pinkish warm sky made with alizarin crimson, a touch of burnt sienna, and merely a thought of ultramarine blue—plus some of that "palette gray" that accumulates on the mixing surface. Then I move that tone down and around the end of the boat and finally drop in a little cool blue near the shore. Before that wash dries, I draw in some dark ripples with ultramarine blue and burnt umber. The paper is still slightly wet, so these lines blur a bit, with just the right degree of softness but not too fuzzy.

Step 2. It's now necessary to establish a few solid middle values so that I know how much darker I can go and still keep my proper value balance. So I brush in the rough shape of the distant shore with some ultramarine blue and burnt sienna. With a little more burnt sienna and a little less water, I brush in the dark shadows on the boats in the middle distance and cover the big boat in the foreground with a blend of new gamboge, alizarin crimson, and burnt sienna. While this is still somewhat wet, I go back in with some quick strokes of ultramarine blue and burnt umber, some strokes warm and others cool. These blur nicely into the undertone, giving the feeling of tree shadows on the boat and a shadow under the hull.

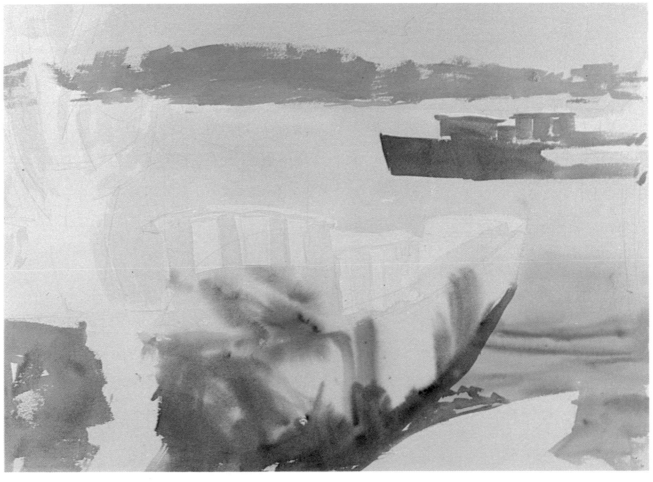

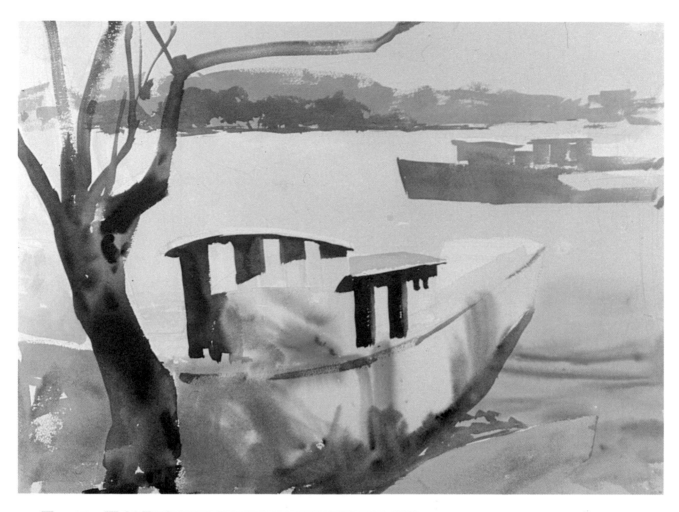

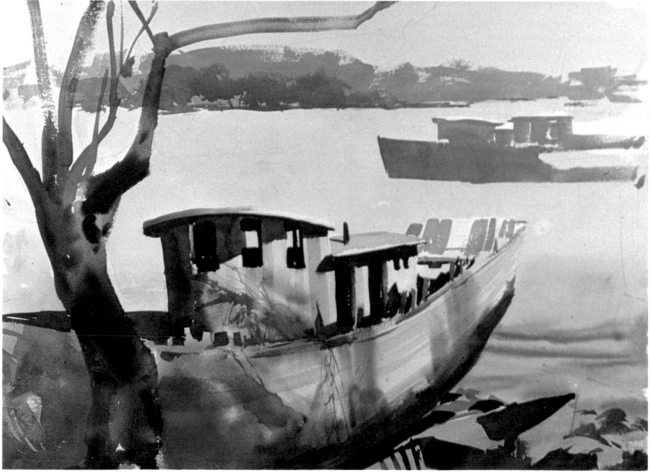

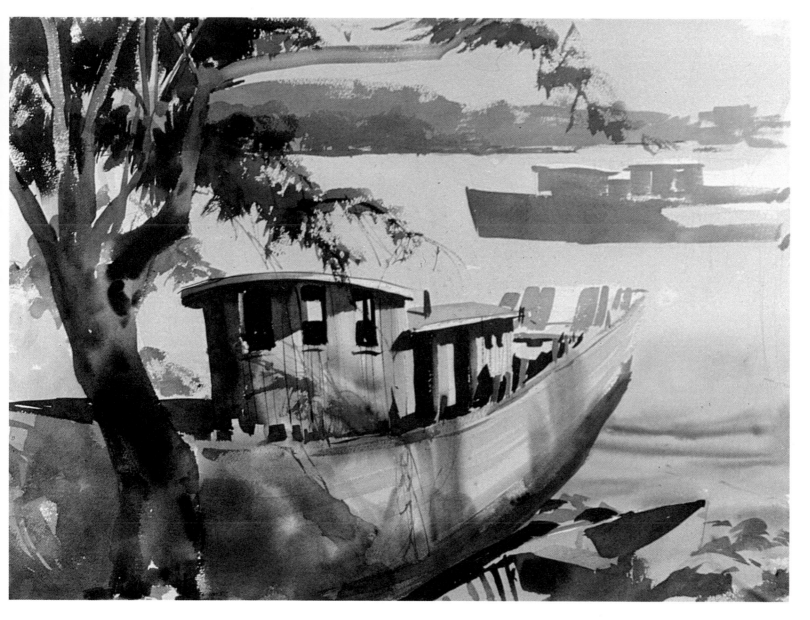

Step 3. (Top left) Here I start to go quite a bit darker in my lower middle values, staying just far enough up on the value scale so the difference will be discernible when I come to the darkest darks at the very end. With ultramarine blue and burnt sienna, I add the silhouettes of trees on the distant shoreline, then brush in a slightly warmer version of this mixture on the big tree to the left. While this is still wet, I stroke in some really strong darks—ultramarine blue, burnt umber, and not much water—which melt into the paler wash beneath. I finish this step with a flat wash of alizarin crimson, burnt sienna, and ultramarine blue on the shape of the rowboat in the lower right.

Step 4. (Left) Now I add many small, additional darks to help build the illusion of three dimensions. I work around and into the windows and doorways on the cabin and add shadows on the pink rowboat. Then I add water and a little more burnt umber to produce a paler tone for the vertical strokes that make the boards on the cabin and the curving strokes for the boards on the hull. I can't resist picking up that rigger and suggesting the shadows of a few branches on the boat.

Step 5. (Above) To bring the eye down to the picture's center of interest—the boat and the water—I add the basic color of the leaves on the tree. This is a mixture of phthalocyanine blue, new gamboge, and burnt umber, brushed in with quick jabs that have a kind of drybrush feeling. Some of the strokes contain a little less water, so they're darker.

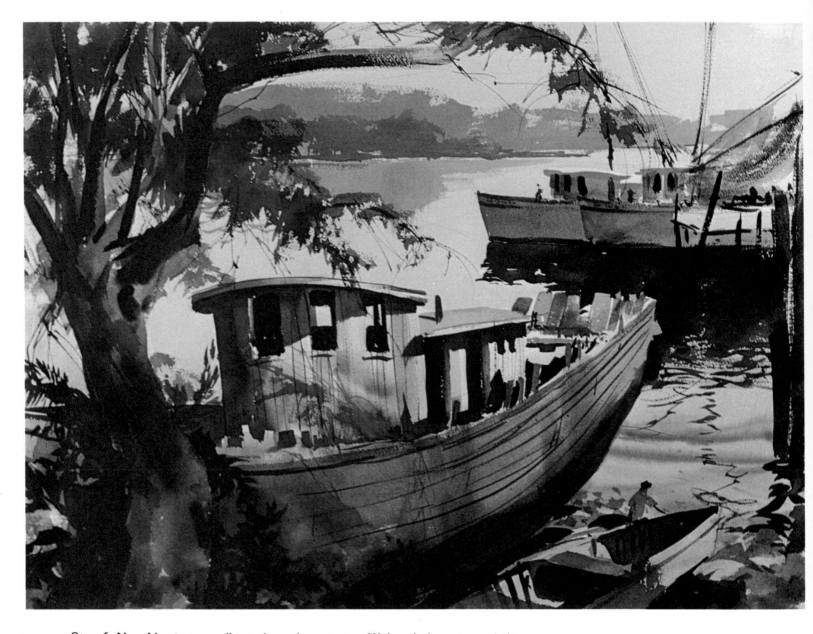

Step 6. Now I begin to pull together the painting. With a dark mixture of ultramarine blue, burnt sienna, and a touch of new gamboge, I add the pilings and their reflections to the right; the reflections of the boats in the middle distance, starting with a big brush and finishing with wiggly strokes made by a rigger; the dark foliage in the lower left; and some more shadows on the big tree to the left. Notice how the dark reflection in the water silhouettes the stern of the old, unfinished hull. The pilings at the right, along with the dark reflections, pull the eye around into the picture. And the dark foliage at the bow compels the eye to swing upward and around. The masts that hold the booms for the drying nets keep the eye from wandering out the upper right corner. Just before I call it a day, I add the lines of the hull timbers of the big boat, plus some more lines on the rowboat with the rigger and some dark strokes for windows, pilings, and masts on the boats in the middle distance. And of course I add the little man down by the red rowboat for scale. Your eye will lead you to him—an old compositional trick. At this point, think about the very limited number of colors I use to see how I stir around all these sauces. Each picture has just a few mixtures, made with just a few colors, which is all any watercolorist needs. There's no reason to buy out the art supply store!

Detail. In this close-up of the center of the picture, you can see different kinds of brushwork. Notice the drybrush effect in the leaves and the slender, spontaneous lines made by the rigger. In contrast, the reflection under the boat is wet and juicy, with crisp edges. A small, flat brush is used to paint the boards—each one is a single stroke. That original pink wash in Step 1—which looked almost too strong at the beginning—is put in its place by all the other colors and now hardly looks pink at all. It just gives the sky and water a very delicate, warm tone, only one step removed from pure white paper.

5
IRISH CLOUDS

15" × 22" (38 × 56 cm)
Collection of Dr. Robert Mackenzie

I don't start out with a preliminary sketch for this painting because I'm not really starting out to paint a "picture." I just want to demonstrate the mixing of warm and cool grays and show how burnt sienna and ultra-marine blue will sometimes separate a bit—no matter how well you mix them. I've spent a fair amount of time in Ireland—which is justly famous for its erratic weather and the kind of skies that go with that kind of weather—so I thought one of those dramatic Irish skies might be just the right subject to make my point. I finish the sky and I think I've made my point pretty well, when one of my charming students says, "Go on, I dare you to make a picture of it!" Well, I never could resist a dare, although I must admit that the alacrity with which I accept one has slowed down in recent years. Besides, there's considerable "ham" in my character, as all my friends know. So the beauty of the clouds in southwest Ireland springs forth—and we're off (with a pound on Killarny Kate's nose)!

About those warm and cool grays I mentioned a moment ago. So you've noticed, my favorite gray is a mixture of ultramarine blue and burnt sienna, which is why I don't need black on my palette. Obviously, the gray gets warmer or cooler depending upon the proportions of the mixture. More ultramarine blue gives you a cooler gray, while more burnt sienna makes it warmer. You can add more warmth by blending in a touch of burnt umber, and you can even try substituting burnt umber for the burnt sienna. You can also cool down the mixture with a tiny hint of phthalocyanine blue or green—but do this with great care, or you'll sud-denly find yourself with green, not gray. And never forget what I call "palette grays." All that colorful mess left over on your mixing surface can turn out to be more useful than you might think. Just throw in a little water and stir it around—it might turn out to be something beautiful. Of course, you can alter that "palette gray" to suit your desire—making it warmer or cooler by adding a bit of blue or brown.

Step 1. I start out by sponging the upper half of the sheet with clear water and then put on pigment at once with a very large, flat brush. How long you wait before going into a wet area is something you must learn by experimentation. If you go in right away, some of the water will still be sitting on top of the paper—it won't have soaked in all the way—and your colors will wander over the surface freely. If you wait a little longer until the water has soaked in a bit and there's no puddle sloshing around on the surface, your strokes will stay put a bit more, though they'll still blur. The longer you wait, the more the strokes will stay put. But if you want bold, splashy brushwork, it's best not to wait so long that the paper loses its shine and is just faintly damp. As you can see, I mix up my sauce very loosely on my palette, so the clouds are warmer in some spots and cooler in others, which is part of their charm. You can also see where the ultramarine blue and burnt sienna tend to separate a bit—one of the unpredictable beauties of this mixture. While the color is still nice and wet, I wipe out some of those whites with a big, damp brush. If you're working on a big area and you're not sure you want to mix the colors on your palette as you go, you can mix up your sauce ahead of time on the palette, then dig right in.

Step 2. Since the lower half of the picture is still pure white paper, it seems like a good spot to demonstrate a sparkling sun on the water with what I call a "drag brush" treatment. I pick up one of those cooler sky mixtures on a flat brush—not too much, so the brush isn't sopping wet—and drag the flat side of the brush across the sheet so that I just hit the tops of the bumps and skip over the low spots in between. In this way, I get flecks of color alternating with flecks of white paper, which will later turn out to look like light shining on the water. Now I've got to start putting together a decent composition, so I put in that distant arm of land, the island in the middle, and the rock formations in the right foreground. The darks at the horizon are a really dense mixture of ultramarine blue and burnt sienna. The reflection under the little island in the middle of the water is the same color I used for the "drag brush" treatment. The more subtle mixture of the rocks in the lower right is ultramarine blue and burnt sienna, with more burnt sienna toward the top, where the rocks look warmer.

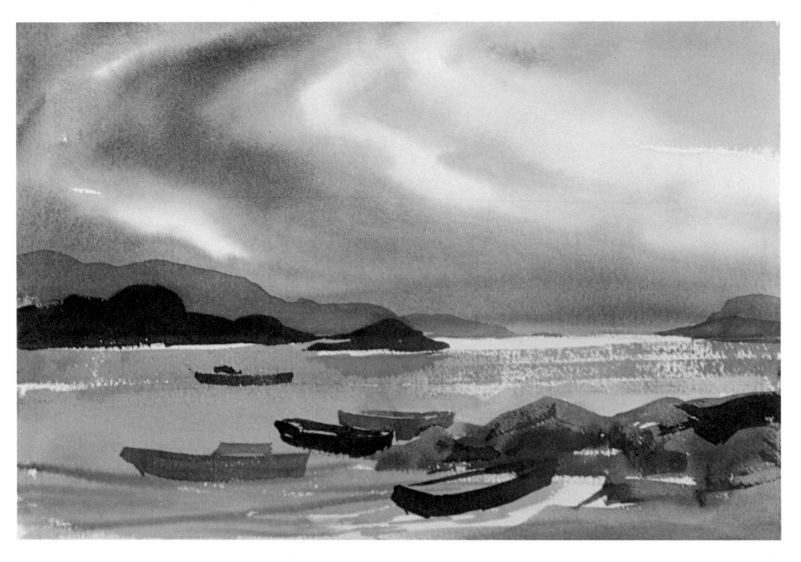

Step 3. That big, dark cloud overhead casts a shadow on the water—never forget about cloud shadows—so the water must, of necessity, be darker under that cover. Thus, I paint most of the water darker, using the same colors I used for the sky, but with more blue. I leave the sparkle to the right, where there's a break in the sky above. The water is a reflecting surface, after all, and normally picks up whatever color is overhead. While the water is still wet, I brush some curving strokes of ultramarine blue into the lower left; they blur a bit on the wet surface and suggest little waves coming into shore. Beyond the dark shapes on the horizon, I add some more coastline with a wash of phthalocyanine blue and burnt sienna, which comes out a little cooler than the mixture of ultramarine blue and burnt sienna. Then, to build a more interesting composition, I add many small boats typical of the area. These are also painted with mixtures of ultramarine blue and burnt sienna. If you study them closely, you can see that each boat is painted with just two or three quick strokes to get their silhouettes. Now that strip of white and those flecks of white paper really look like sunlight shining on the water.

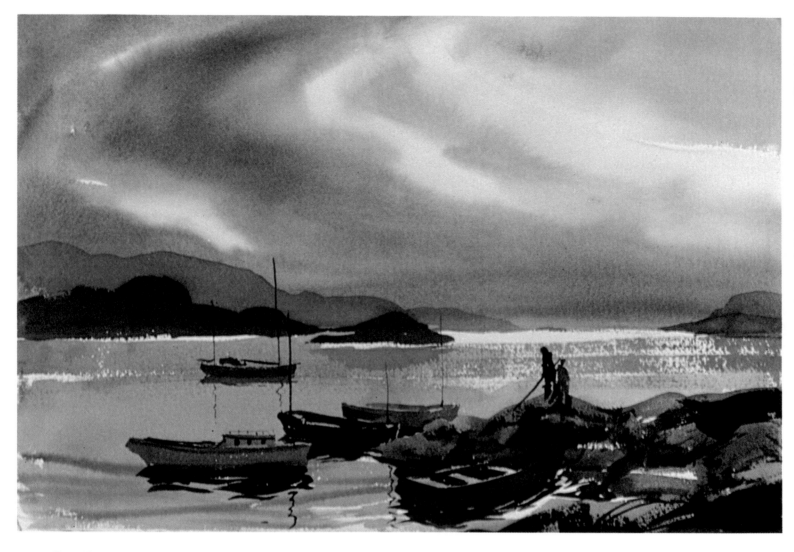

Step 5. In this final stage, I put in a bit of everything that I could "pull out of the hat." I guess this is an off-the-cuff watercolor—not something that's done with much planning—which is part of the fun. With my darkest mixtures of ultramarine blue and burnt sienna, I add the masts and the other details of the boats, along with their reflections in the water, the figures on the rock, and the ragged shadows on the rocks. Notice that I try to be consistent about where I put the shine on the water. The brightest spot in the sky is right of center. So that's where I put the shine on the distant water. And that's also where I put the shine in the immediate foreground, just below those two figures and the nearest rowboat. If you think about the color mixtures I've used in this picture, you'll realize that practically the whole thing is painted with ultramarine blue and burnt sienna, with just a little help from phthalocyanine blue and maybe some of that "palette gray." But the picture certainly *seems* to be full of color, mainly because there's so much variation from warm to cool.

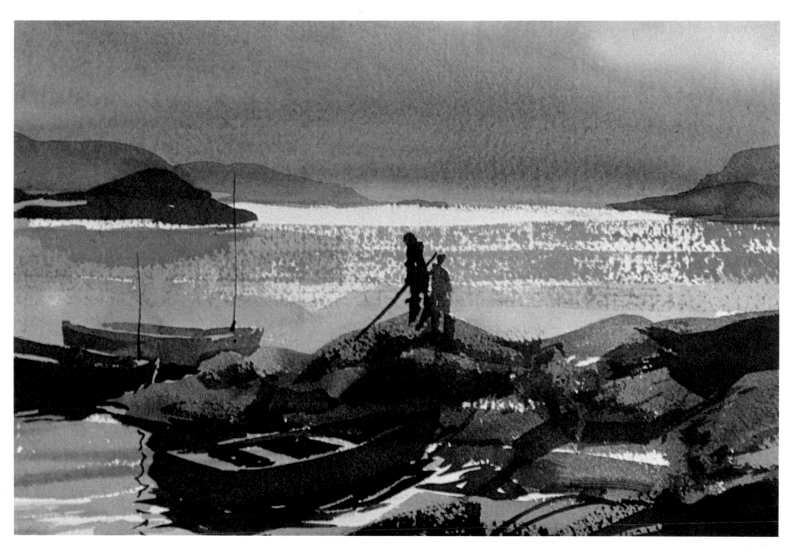

Detail. Here's a close-up of the center of the finished painting, which really shows what a brilliant photographer—my friend Don Selchow—can do to make that painting so much better. He knew exactly which hunk to take. I like this far better than the overall picture. You can really see the "drag brush" treatment on the distant water. You can also see how I've done something similar on the rocks. If you hold the brush at just the right angle—not straight up, but diagonally—you'll get a stroke which is solid and juicy on one side, but more like drybrush on the other side. What happens is that the tip of the brush deposits the solid color, while the side of the brush drags over the paper and leaves a kind of drybrush stroke. You can see this clearly on the rocks where the two figures are standing.

6
WEST INDIAN BEACH

15" × 22" (38 × 56 cm)
Collection of Tom Conner

I want to paint this quick half sheet as an exercise to demonstrate a combination of things. I want to show the soft clouds with the edges of the distant hills running into them; the sunlight on the water, with a long shadow running across it, created by some foliage away out of the picture to the right; plus the reflections on the wet sand and the objects that cause these reflections. Remember, when you paint any kind of reflection, there must be something that's creating it. Whether that "something" is in the picture or out of it, it's there, and it's got to influence what you paint.

Sketch. As I often do, I make this sketch very broadly in two tones of chalk: a middle gray and a black. The emphasis is on the placement of the lights and darks, rather than on details. You can see that I've paid careful attention to the reflections of the trees, the boat, the figure, and even the sky, despite the fact that this is just a very simple, very rough sketch. And even here it's obvious that the darkest darks are the trees, their reflections, a strip along the horizon, and the figure with its boat.

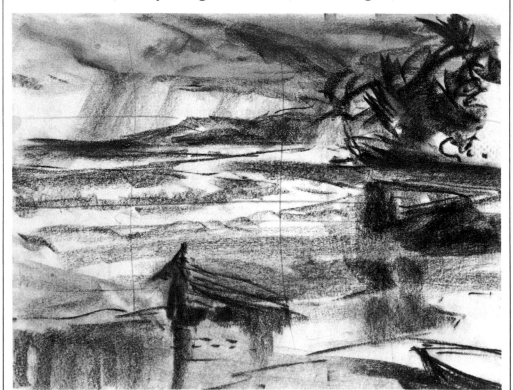

Chalk on bond paper, 9" × 12" (23 × 30 cm).

Step 1. After quickly penciling in various areas, I wet just the cloud section with a sponge, cutting a sharp edge at the horizon, where the wetness stops to form a crisp line. Then I go into this wet area at once with my grays and the patches of blue sky beneath the clouds. The grays are blue-brown mixtures once again, giving me that lovely variation from warm to cool. The clear bits of sky are phthalocyanine blue with some "palette gray" to tone it down—otherwise, phthalocyanine blue would be too "electric." The sky area is quite wet, so the pigment takes a little action of its own, making the sky more interesting.

Step 2. That first pass is now thoroughly dry, so I put a little clear water over the dry sky where I want my hard-edged mountains to disappear behind the clouds. Then I rapidly paint in that mountain and pick up the excess water from the top, where it's supposed to melt into the clouds. When it's dry, I paint the windblown trees with a bright mixture of ultramarine blue and new gamboge for the lighter part, adding more blue and a little burnt sienna for the darker strokes that blend, wet-in-wet, with the brighter green. The dark strokes curve to create the feeling that the wind is really blowing. I then paint the shadows of the trees on the water and the long, diagonal blue-gray shadow across the whole foreground.

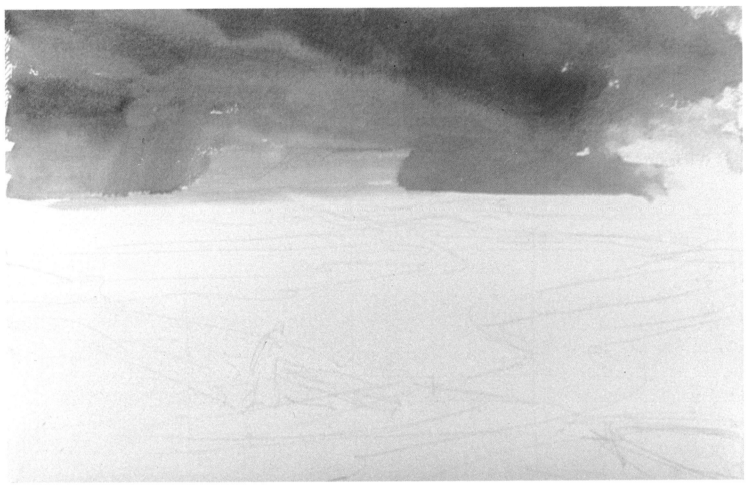

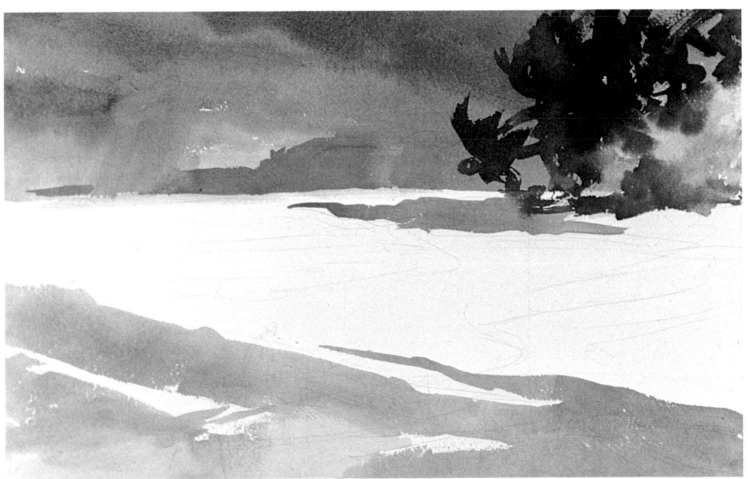

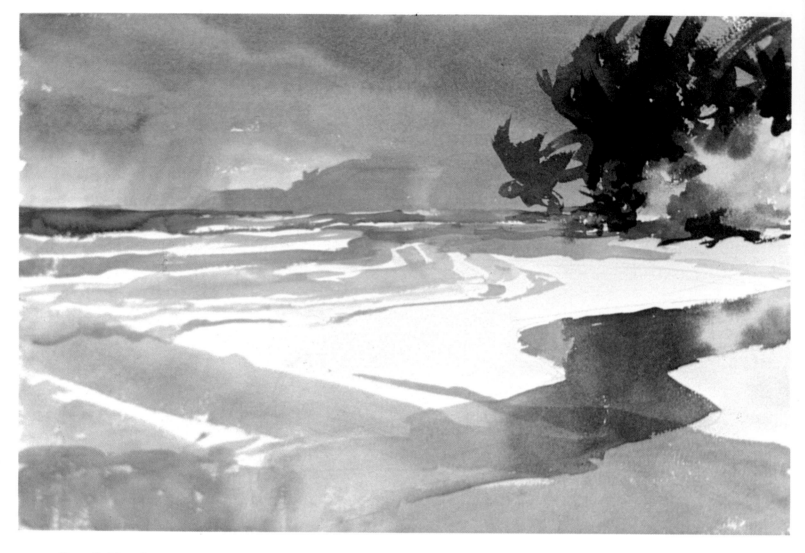

Step 3. Now I paint the pale, broad expanse of water that flows over the coral reefs and sand flats, using various combinations of my two blues—ultramarine and phthalocyanine—plus some phthalocyanine green. You can see that some strokes are bluer and others are greener. The strokes follow the curve of the shore, and I leave strips of white paper between them to suggest foam on the incoming waves. For the S-shaped backwash on the sand directly beneath the trees, I start out with a pale wash of burnt sienna. While this is still wet, I immediately drop in the soft, dark reflections of the blowing trees with the same mixtures I used to paint those trees. Of course, these mixtures are just a little paler in the reflection, as they should be. I then carry this curving, watery pool across the foreground and down to the lefthand corner, where it's mostly the same ultramarine blue-burnt sienna mixture I used to paint the sky. After all, the water is supposed to *reflect* the sky.

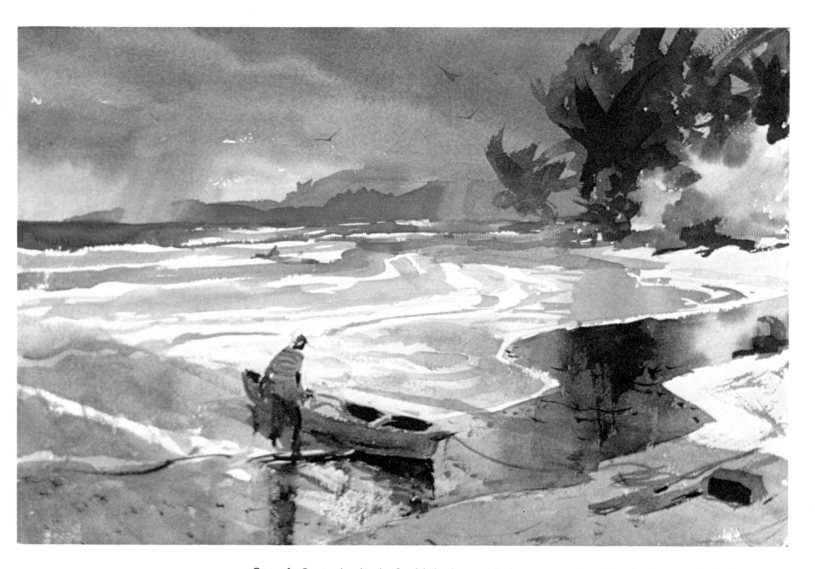

Step 4. On to the finale. I add the lower, darker mountains at the horizon, doing it the same way I painted the other mountains in Step 2. There are two misty spots—one next to the trees and the other toward the left—where I lift out some of the dark color with a damp brush. I carry the color of the water forward over the beach here and there—more phthalocyanine green and a little burnt sienna, as in the distant water—to make the sand look wet. But I stop just short of the dark strip of backwash, leaving a pale line of bare paper along the edge of the dark shape. I warm the sand in the immediate foreground with a little burnt sienna and mix this with some "palette gray" to paint the boat and the figure plus their reflections. I use this same color to suggest another figure in the boat out there in the water. I give the figure some stripes on his shirt with alizarin crimson and a little cadmium red; they'd be too bright if I brushed them over bare paper, but they're subdued because there's a grayish tone underneath. I finish up by adding a little drybrush texture, some dark flecks, and some wandering lines to the foreground, suggesting such things as the rope that leads from the boat to the oars on the beach, some pebbles, and other debris on the sand. I also go back into the dark reflection of the trees to give the reflections a bit more emphasis.

7
HIGH WINDS, WEST INDIES

22″ × 30″ (56 × 76 cm)
Collection of Susan Bloomfield

If you've ever lived in the real tropics for any length of time, you'll know the feeling. The air becomes very still. The sun is shining, but the horizon is black. There's a strange silence. But when the hurricane or typhoon signals go up, there are sudden sounds up and down the street: a few shouts, running feet, the clanging of the large steel doors rolling down over the storefronts. Strangely, it's never a feeling of real fear—more a sensation deep inside of great awe and excitement. I try to create some of this violent atmosphere in this painting.

Sketch. This sketch wasn't made for this particular watercolor, but I'm using it as a point of reference. The trick is often to combine some sort of sketch with a good pictorial memory. I want to demonstrate that you can create a mood and then build on it if you've really developed a retentive memory for what you've seen. You see, I do occasionally break my own rules. Fortunately, this painting works out all right, but I must admit that it's still far safer to do a very comprehensive sketch for the actual painting.

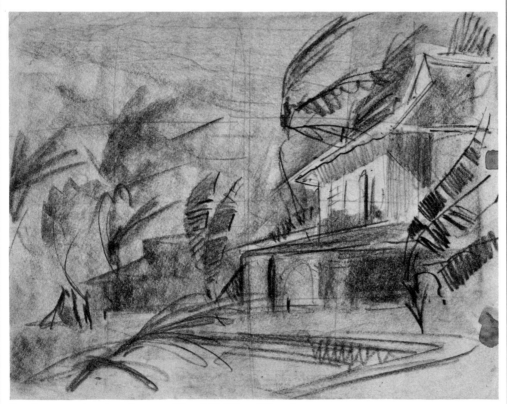

Graphite pencil on bond paper, 9″ × 12″ (23 × 30 cm).

78

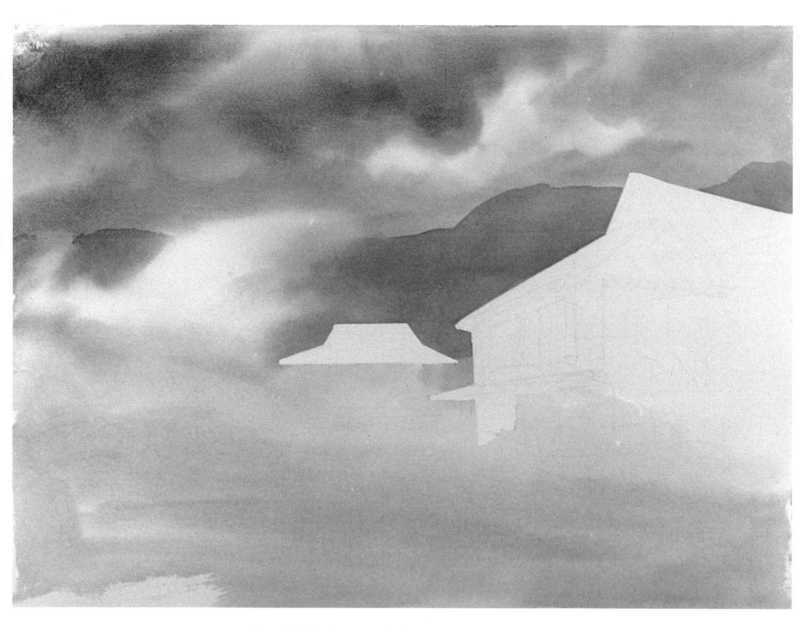

Step 1. This first step looks pretty simple at first glance, but it's actually the result of three major moves. First, I put masking tape over the roofs and the fronts of the buildings where they catch that last bit of sunlight. I want to make sure that those areas are protected from the color that I'm going to brush over most of the sheet. Then I sponge the entire paper with clear water and go in at once with the modeling of the heavy clouds. Once again, this is my favorite stormy sky mixture of ultramarine blue and burnt sienna, leaving some gaps of clear paper for the lighted areas of the clouds. I paint around the top of the dashing foam where the sun hits it; that's the big, light blur to the left of center. Then I go down and across the entire bottom with a blue-gray wash that puts the whole foreground in shadow. I dry the whole sheet. Then I put in a dark, sharp-edged mountain at the horizon, blurring the wash with some strokes of clear water where the mountain is hidden by the big splash of foam. When the whole sheet dries again, I peel off the tape to reveal the pure white paper of the buildings.

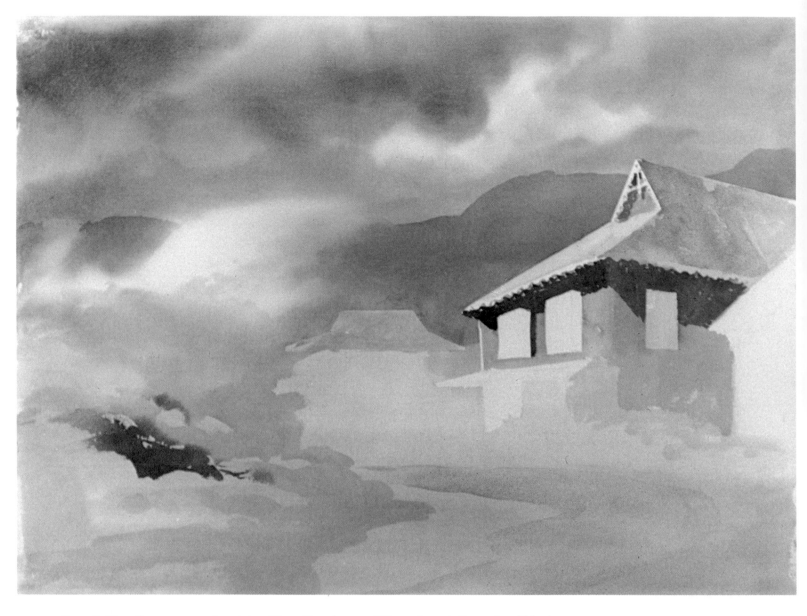

Step 2. Now I'm concerned mainly with getting down a little underpainting color. I block in the green of the building: phthalocyanine green and a little burnt sienna to make the green less harsh. I run a warm tint of burnt sienna (muted with a little blue) over the tin roof and then down on the crescent of the beach. With a grayish mixture of ultramarine blue and a little burnt umber, I cover the distant tin roof and then carry this tone down over the surf, where I begin to model the shapes of the flying, splashing water with broad, curving strokes. Into this wet tone I stroke the shape of a dark rock—burnt umber and a little ultramarine blue—whose top melts away into the wet tone of the water. Now you can see why I protected that green house with masking tape: those walls are the brightest, clearest note in an otherwise subdued picture.

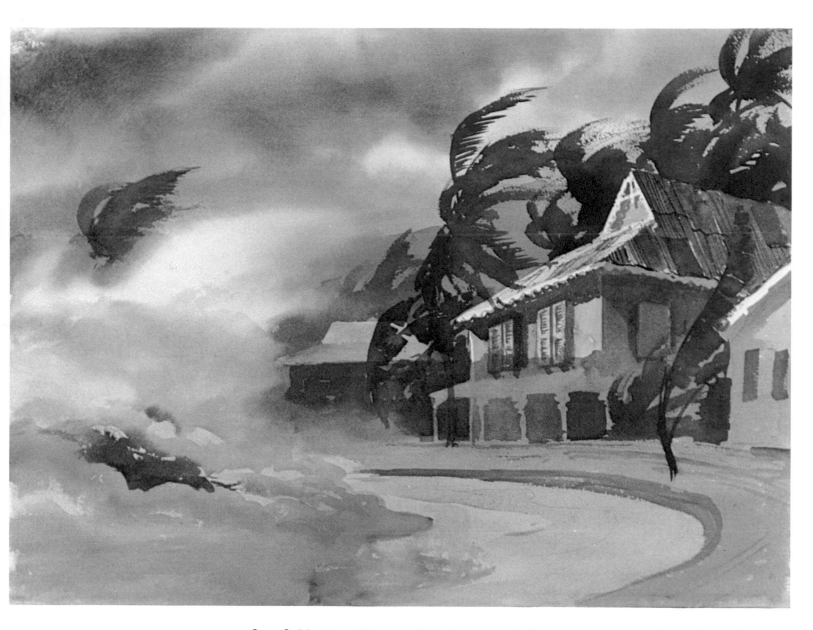

Step 3. I begin to hit some of the large, very dark areas—the accents that make each value stay in its proper place. Most important are the big, dark palms, a rich mixture of phthalocyanine green and burnt umber, painted with rapid, curving strokes of a round brush. I plan the design of those very dark, windblown coconut palms very carefully, as they're stark naked against what now seems a much lighter sky. Values, values! It's those dark palms that make the lighter sky go back in space. For composition, I need the soft palm that's seen through the spray at the left. I add the detail of the roofs with some "palette grays" and the tip of a slender, round brush. I darken the near side of the building and put some darks under the arcade. I also darken the face of the more distant building and add some details to the little pink building at the right. I put a curving shadow along the sea wall and dash some reflections of sky color into the pool of water that's spilling up the beach.

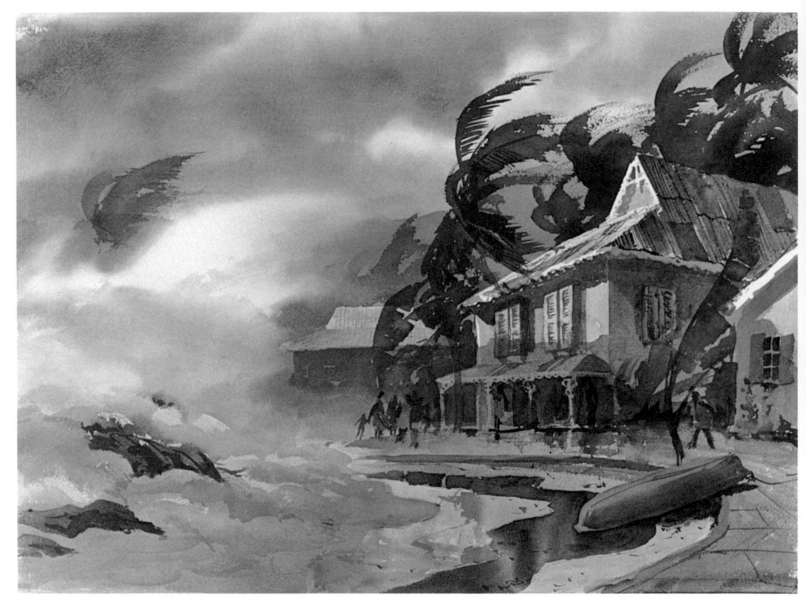

Step 4. (Above) Here's a complete view of the finished watercolor. I add more dark rocks to the boiling surf—for compositional reasons once again. As I said a moment ago, I also add some shadows to the forms of the foam. I add a dark strip of water to the beach, first painting a pale wash of burnt sienna and then dropping in the dark tones reflected by the buildings and trees above. I add the bottoms-up dugout in two flat washes, one covering the whole shape of the boat and the other just covering the shadow side. The rigger adds details such as the lines on the most distant tin roof, and on the pavement to the right, plus the little, dark flecks on the beach. The reflections on the wet pavement are drybrushed with the side of a round brush, which makes a ragged, unpredictable stroke. I've said many times that I always paint standing, which is true. But, after finishing this one, I sat down. Most of the painting has been pulled from the mental filing system at the rear of my skull, and that makes my back very tired.

Detail. (Top right) This close-up of the center of the finished painting shows some tricky stuff. Remember how I left open some grayish strips above and between the shadows within the arcade? Now I go back in to add all those dots and strokes of darkness that define the architectural detailing. You might think that all those curves and skinny columns were done with opaque color, but I'd consider that cheating. The whole idea is to plan the painting so carefully that you leave your light areas open, then go back into them with the right touches of darkness.

Detail. (Right) Here's another close-up showing all that modeling in the water. Foam, like clouds, isn't just a lot of smoke or mush. It has distinct lights and shadows. Study these foamy shapes carefully and you can see that I've clearly defined the lights, middletones, and shadows. I've also added just a few dark strokes to suggest that the rocks, emerging from the water, have shadow sides too.

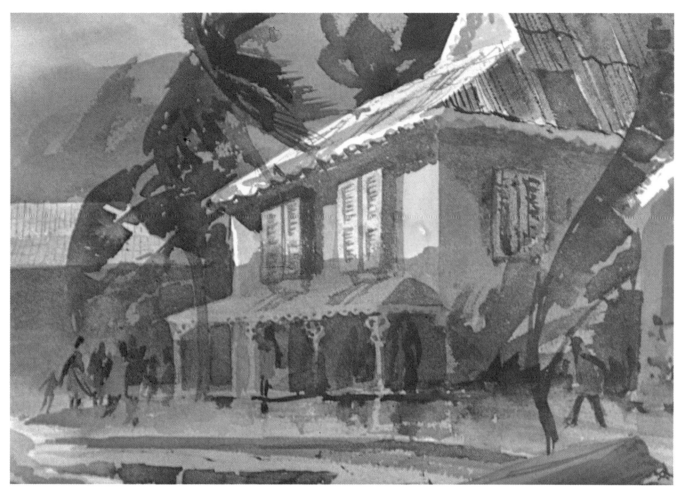

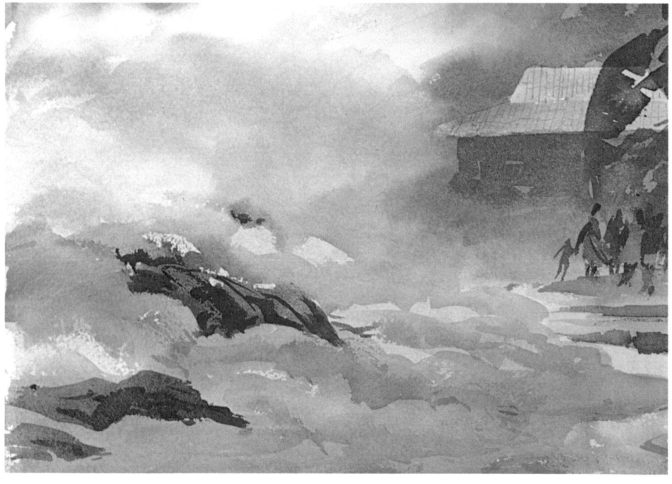

8
THE LAKES OF KILLARNEY

22" × 30" (56 × 76 cm)
Collection of Albert Ondush

Some of the most beautiful cloud formations I've ever seen are in the southwest sections of Ireland. Whatever causes them, they're spectacular! However, watercolor painting in Ireland can sometimes be a little frustrating to someone who hasn't had much experience painting in the field. Occasionally, a lovely small cloud will float overhead through a sunny sky and make his comments in the form of a little "Dublin dew." When I paint in Ireland, or in any rainy territory, I take along some common lightweight trash bags—the plastic kind that keep out the water. These have saved many of my efforts just in time. This painting shows one of those wet Irish days when you can really use those plastic lifesavers.

Sketch. A broad landscape must be composed carefully so that the eye doesn't start to slide out of the frame at some point. Yet you still have to give the feeling of a great expanse beyond what you see—to the right and to the left, as well as above, high in the sky, and beyond. You must create the feeling that it's all there, even though you're putting down just the part you see before you. You can't paint everything in sight, of course. So swing around full circle, look over the entire landscape, and then pick your spot. That's what I'm trying to do here. I've picked the best spot I can find to suggest the vast landscape on all sides—beyond the picture.

Chalk on bond paper, 9" × 12" (23 × 30 cm).

84

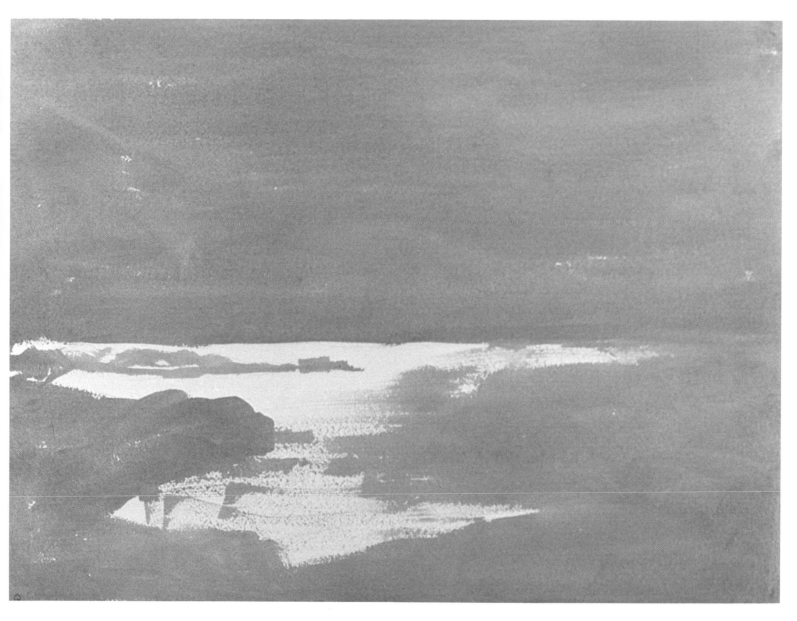

Step 1. How to gain the high, sparkling values of the lake? Put a *neutral* gray wash over everything else in the painting. It takes experimentation to determine how light or dark that tone ought to be. But the idea is to make it *dark* enough so that patch of light really sings; yet the tone should be *light* enough so that the really dark darks will stand out later on. This trick—and it's a valuable one—may be used in any painting where you want to emphasize the brilliance of one or more areas. When you mix grays, don't worry about how much of this color or how much of that color is in the mixture. Don't have any predetermined ideas about what colors are right. Just stir and slop around on the palette until you've got what you want. Those old "palette grays" have a way of happening by themselves.

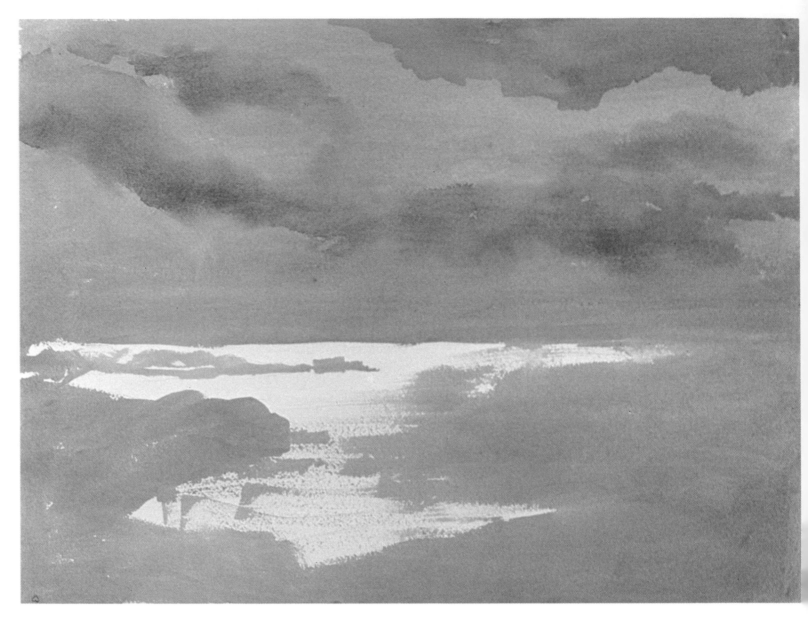

Step 2. When the first big, neutral gray wash is dry, I rewet some of the upper area and model the clouds with darker tones. Some of the edges are hard and others are soft, depending upon whether the brush hits a dry area or a wet one. The topmost cloud shape in the upper right has a hard edge, so it's obviously painted on a dry part of the paper. I'm still not touching that precious hunk of white on the water.

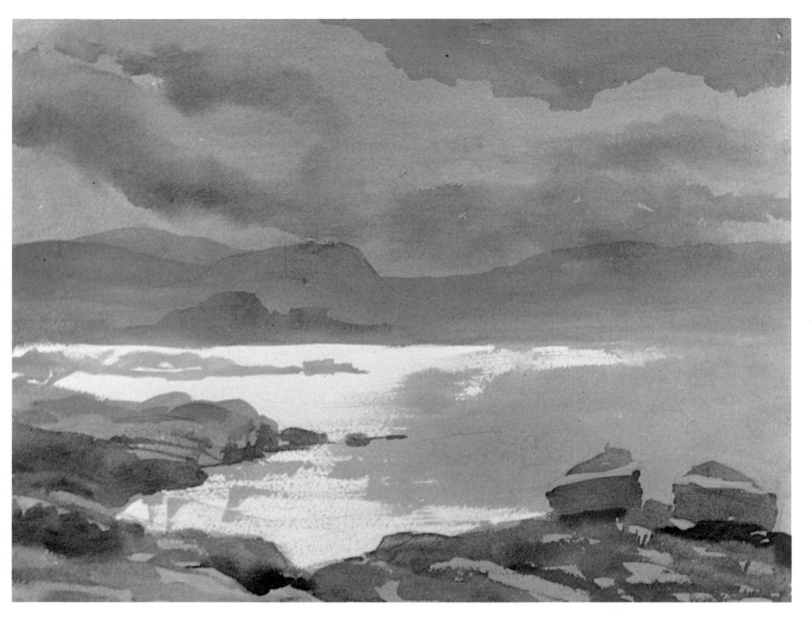

Step 3. When Step 2 is dry, I paint in the farthest of the distant hills, let that dry, and then paint the nearer hills right on top. Now I start to identify some of the darker forms in the middleground and foreground. I put some flat gray tones over these shapes first. Then, when this is dry, I go back with some darker tones to suggest shadows. I add two beached boats in the lower right to give me scale. I do some more modeling on the rocks and put shadows under the boats.

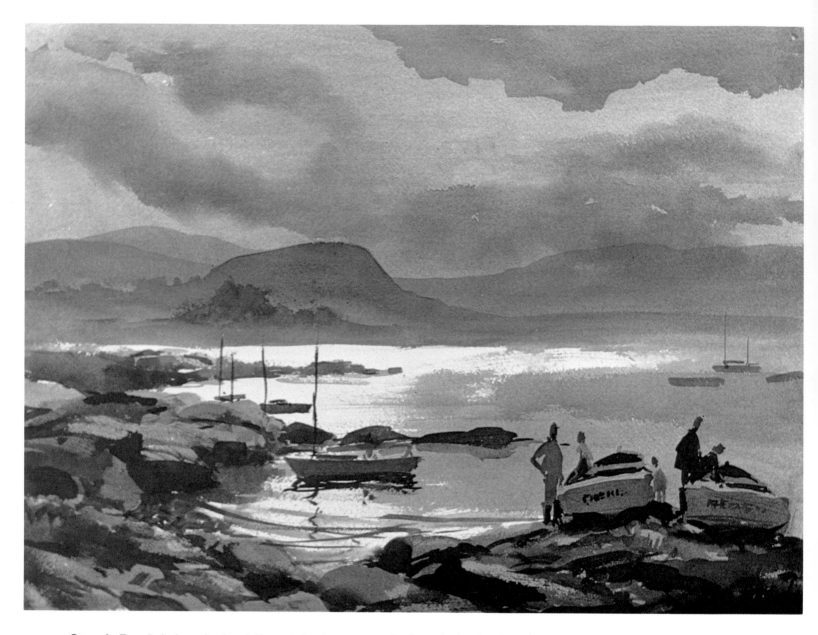

Step 4. First I darken the big hill just left of center, and when that's dry, I put some rough strokes at the foot of that hill to convert the dark shape—painted in Step 3—to a more irregular, tree-covered shape. Then I do the small craft moored in the water, plus the reflections and the ripples in the cove. To suit the weather, I'm working mainly in grays: blue-grays, brown-grays, whatever. I add more detail to the boats in the right foreground, along with the figures—I like a world that's peopled—all done very rapidly. I add strong shadows to the rocks and some curving lines for ripples at the edge of the water. I've resisted the temptation to do any more work on that brilliant patch of light, which remains just as you saw it in Step 1. But I do have a confession. I spoke earlier of the eye starting to slide out of the frame. Well, after the watercolor is finished, I sneak back and put in those three distant boats above the figures—just so that *wouldn't* happen. These days, who's secure?

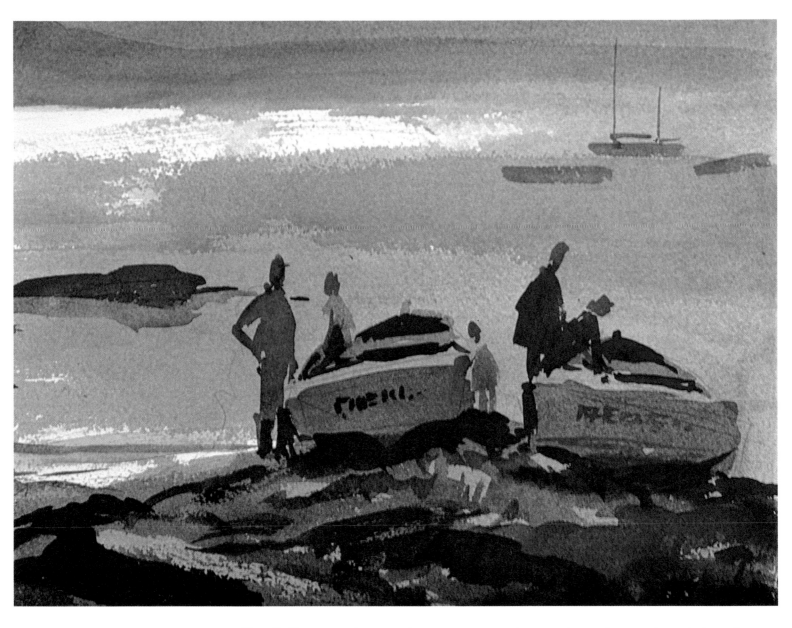

Detail. This shows how simple it is to create a figure with just three or four strokes of the brush. Don't become entrapped by all the little details. Don't show that bottle of John Jameson stashed under the stern seat or the case of Guinness under the tarpaulin. I make those dark notes—the figures and the foreground—*very* dark because I know they've got to stand out against the middletone that covers the whole picture. They'd look harsh against a lighter background, but they hold their place here.

9
DUBROVNIK, OLD CITY

22″ × 30″ (56 × 76 cm)
Collection of Corbin Ross

Dubrovnik is a coastal city in Yugoslavia, with a rugged history as part of the old Austro-Hungarian Empire; so the architectural influences are endless: Austrian to the North, Turkish and Islamic to the Southeast, Venetian to the West. It's an incredibly beautiful country, all the way from Bled in the Julian Alps down to the South, with warm, friendly people all the way. Purely architectural drawing—with all its various angles and vanishing points—can be most frustrating to the person who doesn't draw easily. Working so hard to get those elusive angles can make you forget the picture you want to paint. Right? Well, old friends, here comes the "sales pitch." For information on "John Pike's Wonderful Perspective Machine," write me in Woodstock, New York 12498. Honest, it can help.

Sketch. All my life, one of my deep side interests has been architecture—both its structure and its design. So, over the years, I've had the fun of doing many creative projects for architectural and engineering firms. This watercolor expresses my affection for buildings. The sketch, like the painting, is direct and straightforward. The light source is the sun. The subject is the buildings and their cast shadows. Painting buildings requires precision, so this sketch is carefully rendered. The solid planes of shadow—which contrast dramatically with the sunlit planes—are blocked in with the side of the pencil lead.

Step 1. After a very careful drawing to get the shapes of the architecture exactly right, I start with a standard light-to-dark procedure. I begin with the light tones of the clouds: ultramarine blue for the patches of sky; ultramarine plus a little burnt umber for the shadows under the clouds. I touch the cloud strokes here and there with a little clear water to soften some edges. Then I put the warm and cool tones on a few of the buildings: pale alizarin crimson to the left, then phthalocyanine green plus burnt sienna and a little new gamboge on the walls at the center of the picture. So far, I'm working with very pale tones, and I'll work gradually toward the darks.

Step 2. Now I start to go a little darker, putting in the half-light on the near walls and on the sea wall in the middleground. I get these multicolored areas by putting wet strokes side by side and letting them flow into one another. On the walls to the left, you can see where some strokes of burnt sienna flow together with strokes of ultramarine blue, warmed with a touch of alizarin crimson. The same thing happens on the sea wall, where the colors are phthalocyanine green and burnt sienna. The rooftops are painted in flat washes of burnt sienna, new gamboge, and alizarin crimson. I try to vary my color here for more interest.

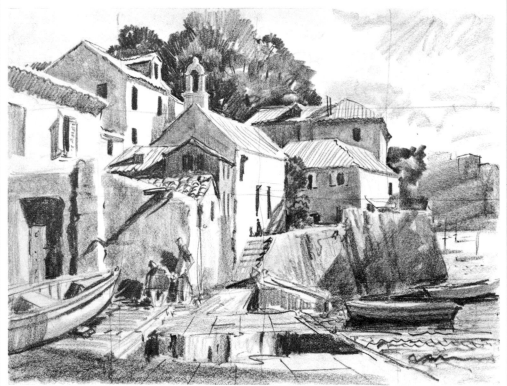

Graphite pencil on bond paper, 9″ × 12″ (23 × 30 cm).

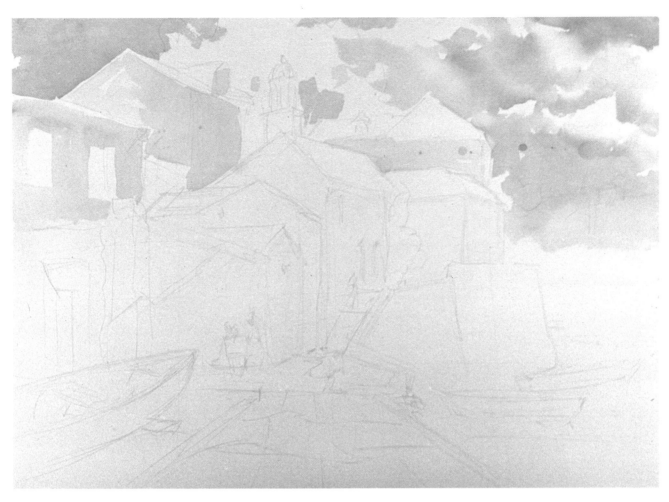

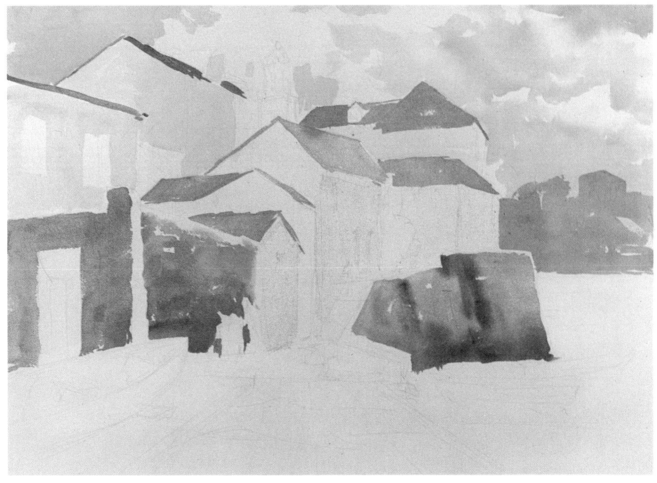

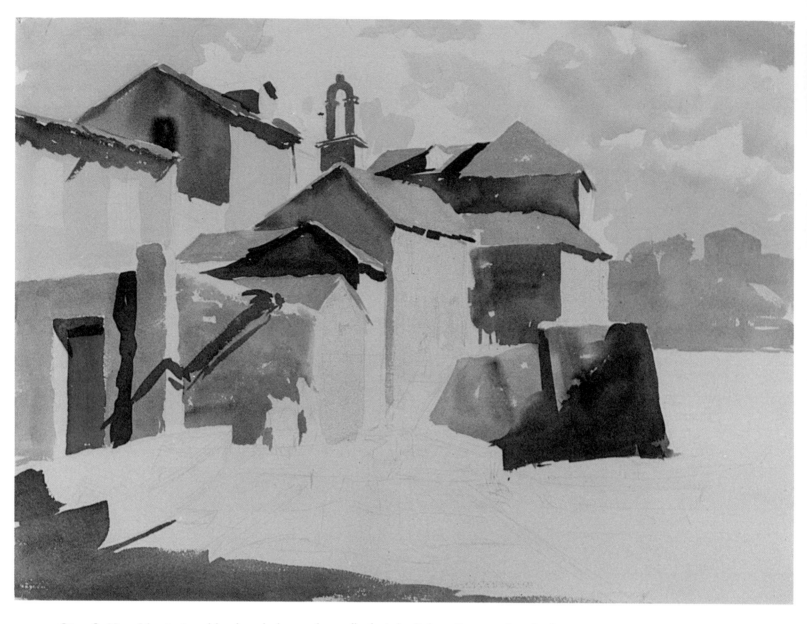

Step 3. Now I begin to add a few darks on the walls that don't face the sun directly. I brush in shadows across the half-lit wall and under the roof overhangs, plus the long shadow over the boat to the left and across the bottom. Notice how warm color merges with cool, wet-in-wet. This is particularly interesting in the scalloped shadow under the edge of the tiled roof in the upper left: the warm color seems to suggest reflected light within the shadow. In fact, all these shadows seem to contain some warm, reflected light, which makes the shadows look more transparent and luminous.

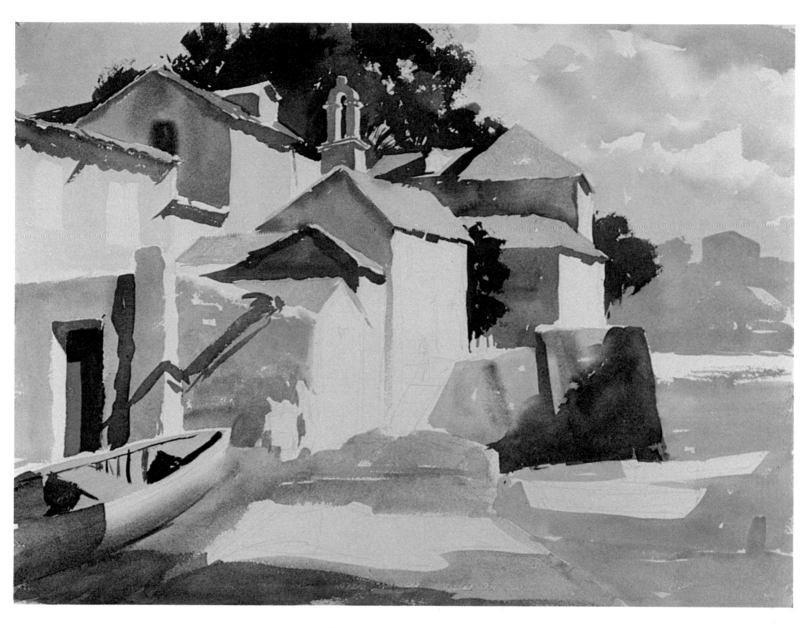

Step 4. Now I add the very dark green of the great trees that silhouette the tops of the buildings and the little church belfry. These dark tones give me one more "step" in establishing a sense of depth in the picture. They also accent the angular structures by intensifying the brightness of the sunlit sides. The dark green is a mixture of phthalocyanine green and burnt umber. I put a warm underpainting wash over the stone dock—alizarin crimson, ultramarine blue, and a little burnt umber—leaving the white paper in the middle of the docks, where there's going to be a puddle. I paint the inside of the boat at the left with phthalocyanine green, add some dark lines for shadows, and put a shadow on the curving side of the boat. And I put a cool tone over the water with a mixture of my two blues.

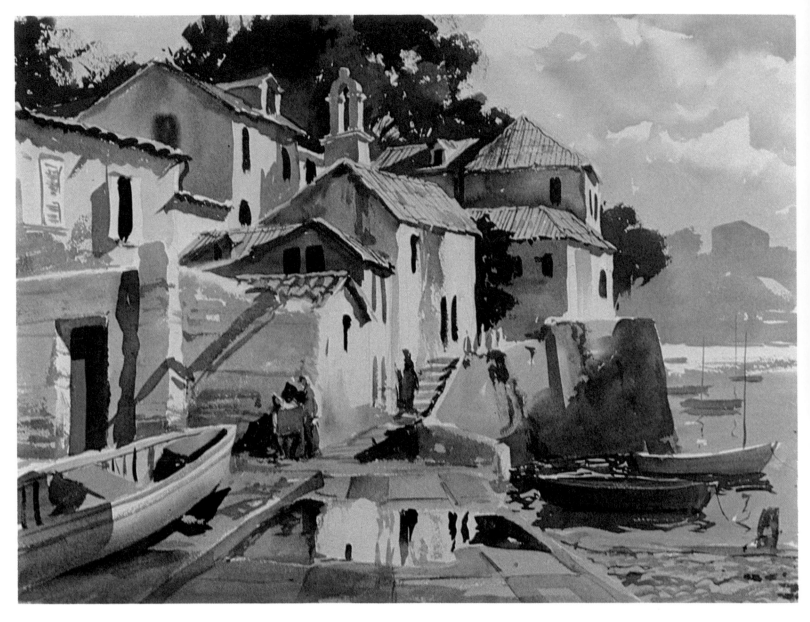

Step 5. Windows, walls, and roof tile textures go in toward the end. You saw how these are done in the detail on the facing page. That bare paper on the top becomes a reflection, mostly vertical strokes that pick up the colors of the buildings and trees directly above. In Step 4, you probably noticed that I left white spaces for the boats in the lower right. Now I put shadows on the sides of these boats and add a few dark details—leaving a strip of white paper along the upper edge of one of the boats to suggest the glint of sunshine. I put some wiggly reflections under the boats and some more wiggly strokes on the sand in the lower right. Some figures are added, along with their dark shadows cast on the walls to the left. The rigger adds masts and lines to the bows of the boats. It's worthwhile to compare the first step with the final one. By starting out very pale and working from light to dark in distinct steps, I've been able to hold onto the strong contrasts of light and dark that are typical of the sunny coastline of Yugoslavia.

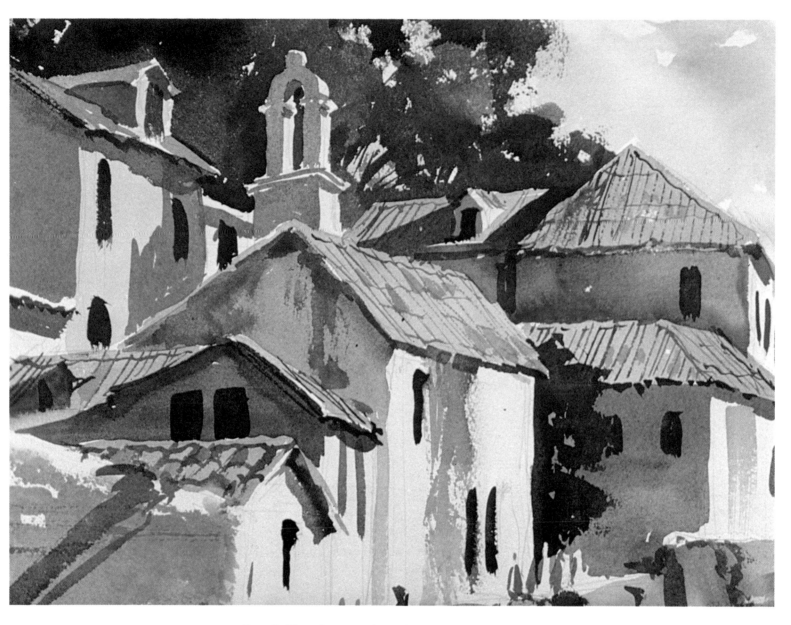

Detail. This close-up shows how simply I've handled the fine details: just dark patches for the windows, not even neat rectangles; thin lines, some straight and some wavy, for the roof tiles. I scumble some "palette grays" down the sides of the buildings to make them look older and more weathered. And speaking of "old and weathered" buildings, it's about time I got a sermon off my chest. In the United States, we have an unfortunate habit. Every time some politician gets an "esthetic" inspiration—and usually has a close buddy in the construction business—large areas are bulldozed flat, trees and all. New, imposing concrete block structures rise, and new four-foot saplings are planted where that 200-year-old oak once stood. Practical, I suppose, but in Europe they don't seem to tear things down—maybe for lack of bulldozers. They simply build on top of or against the existing structure. Maybe not as practical, but certainly far more pleasing to the artist's eye. However, there's hope. In recent years, I was commissioned to oversee the restoration of some seventy buildings in the old city of Kingston, New York State's first capital.

10
VENICE, MOTHER AND CHICKS

22″ × 30″ (56 × 76 cm)
Collection of Marie Nugent

No one architect, stage designer, or mad dreamer could ever have created this incredible fairyland called Venice, which belongs not just to Italy, but to all the world. Over the centuries, hundreds of thousands of craftsmen have contributed to its charm; the results make it perhaps my favorite of all the cities of the world.

Very early one morning, Zellah and I were having our cappuccino at an outdoor café in St. Mark's Square at the far end from the cathedral. The sun had just come up, and we were sitting directly in the long shadow of the belltower. It was also high tide, and the water had seeped up here and there through the stone paving of the enormous piazza. I expressed the wish to paint it, but the subject had been done from every possible angle over the last 400 years. Zellah's answer was simple: "Why not just paint the reflections in the puddles?" I did, and it hung, by invitation, in the Metropolitan Museum's exhibition of *200 Years of American Watercolor*. Ah, Zellah mia!

Sketch. This sketch is done mainly for composition, values, and overall tonal arrangement. The small details and textures are only indicated. They'll be put in later on as I proceed with the painting. The main thing is to capture the strong darks in the doorway and windows, plus the shapes of the lights and shadows on the walls.

Step 1. Blocking in the shapes of the shadows with a blue-gray wash, as I've done here, helps to establish the main shadow areas very quickly. It also sets up the various planes. Rather than starting with the usual lightest value, I'm beginning this one with a middletone. Later, I'll work in both directions from this middletone, going both lighter and darker.

Step 2. I start with the warm, light colors on the wall: burnt sienna, new gamboge, alizarin crimson, and a little ultramarine blue. I paint right over the first gray wash. You can see some drybrush strokes for that old, weathered texture. Here and there, I add a bunch of bricks, but not too many. I don't want to get lost in too much detail. I'm treading lightly because my later texturing will darken these areas quite a bit. I don't want to overdo it.

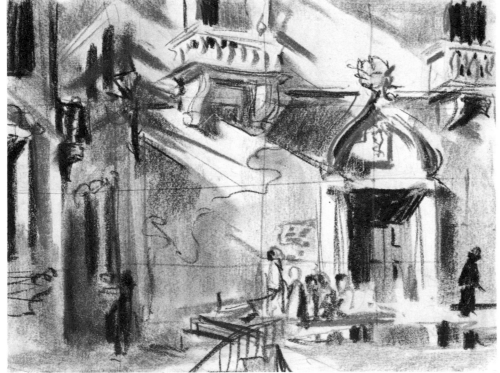

Chalk on bond paper, 9″ × 12″ (23 × 30 cm).

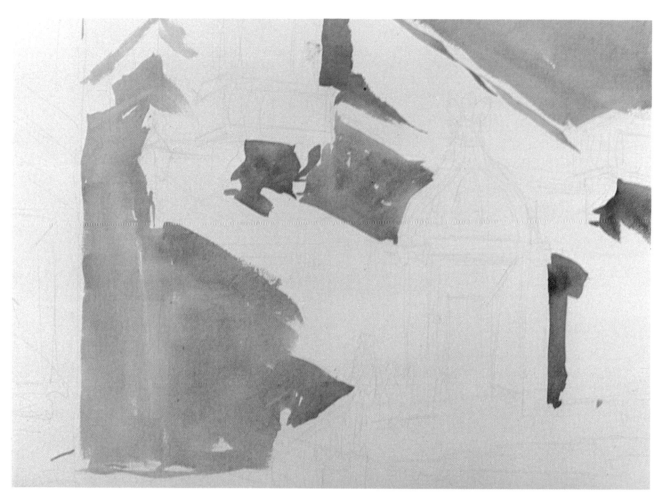

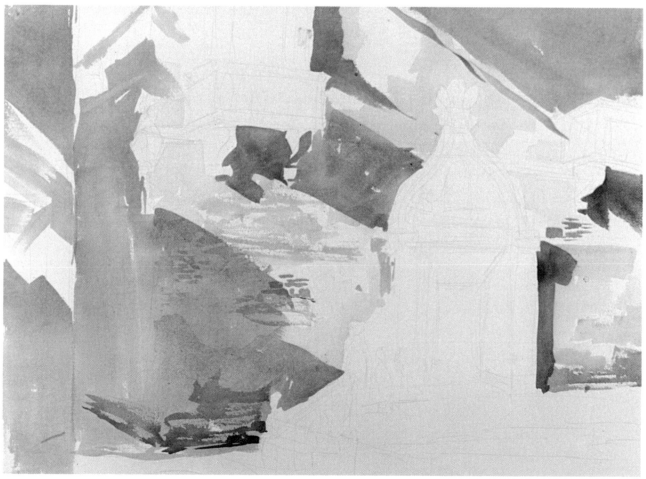

97

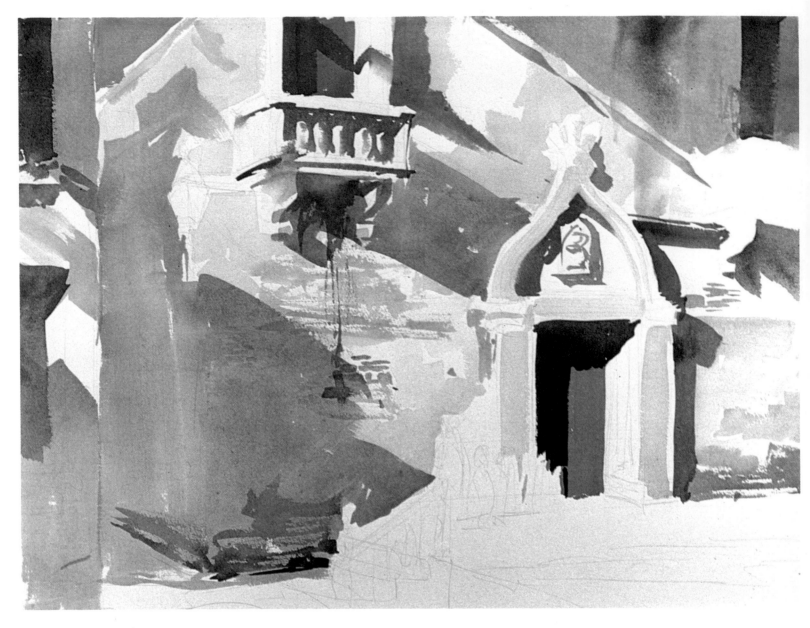

Step 3. Now I start to add the first real darks. The bright color of the window is ultramarine blue with a little alizarin crimson. The door is phthalocyanine green and a little burnt sienna. Right over these strong colors, I brush some big, dark shadows. I also add some shadow details to the Moorish arch and the balcony. To get that drippy discoloration on the stonework in the upper right, I wet the paper and then brush in some burnt umber, pulling the stroke downward onto the dry area of the paper. These strong shadows begin to establish the precise architectural shapes.

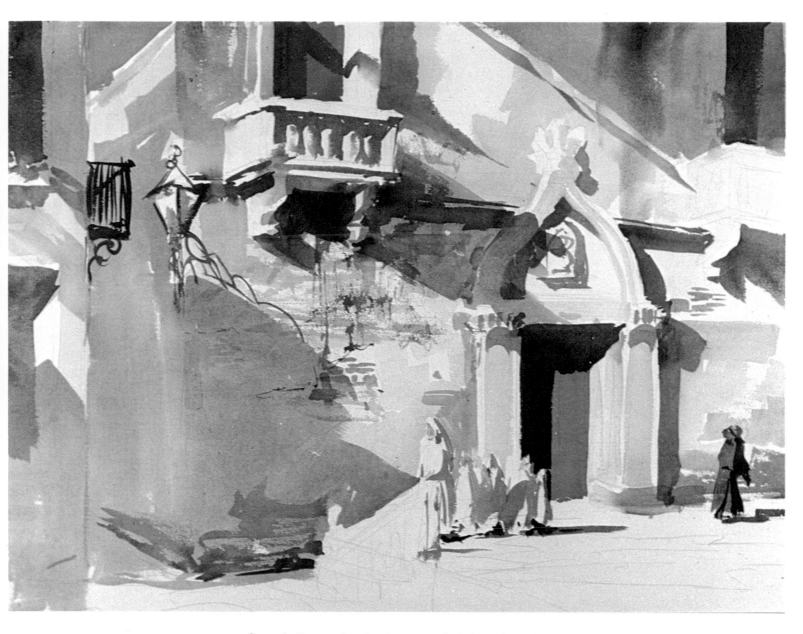

Step 4. Except for the foreground dark and all those small details and textures, the painting is almost finished. I put in the "mother and her chicks" just by painting shadows on their clothing and the shadows that the figures cast on the ground. I draw the corner lamp and the iron railing of the balcony at the left with the point of the rigger. I pull an additional shadow over the arch above the big door. The figure of the good Franciscan Father is done in two washes: a brown for his cassock, followed by a darker color for the shadow side of the figure and the shadow he casts on the ground. Now you've got a really strong sense of where the light is coming from—out there to the left—and this explains why all those shadows are leaping off to the right.

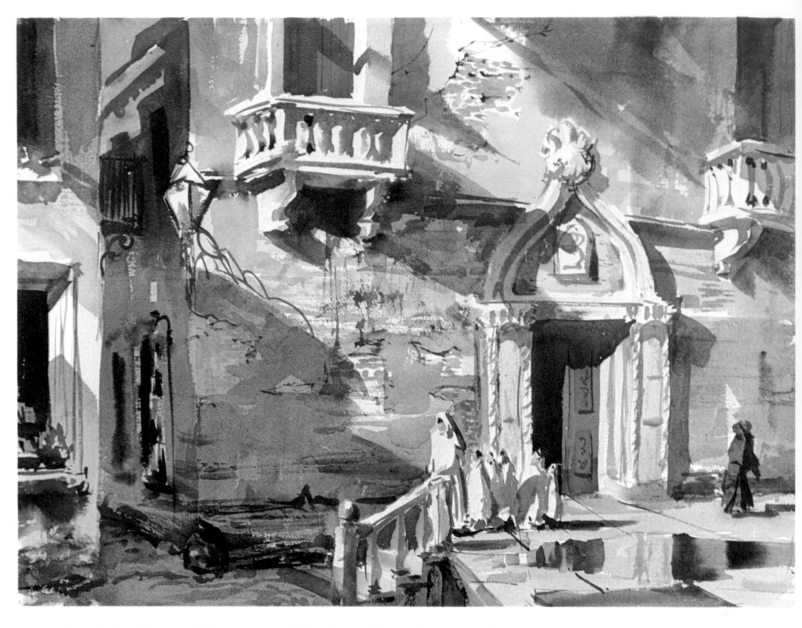

Step 5. In addition to all the drawing and doodling I told you about on the facing page, I've added some other important features. I always love to paint puddles such as the one under the doorway. This one is filled with the colors of the "chicks" at the left, the tones of the architecture in the middle, and even the color of the Franciscan friar at the right. To make the building turn the corner down the little side street at the left, I find it necessary to darken the wall. I've put in that important foreground shadow. I complete that vertical strip of the building to the left, even suggesting a pot of flowers on the window sill. Let your eye travel over the picture and see where I've added other details such as the exposed bricks to the right of the window at the top of the picture. In working with an almost single-plane painting like this one, you have to create the entire interest for the viewer by texture, feel, patterning, understanding of the subject, and your skill in handling the medium. No one teacher can do more than point the way. All the rest, and the most important part is *you.* As I pointed out in the introduction to this book, you can *read* forever about how to ride a bicycle.

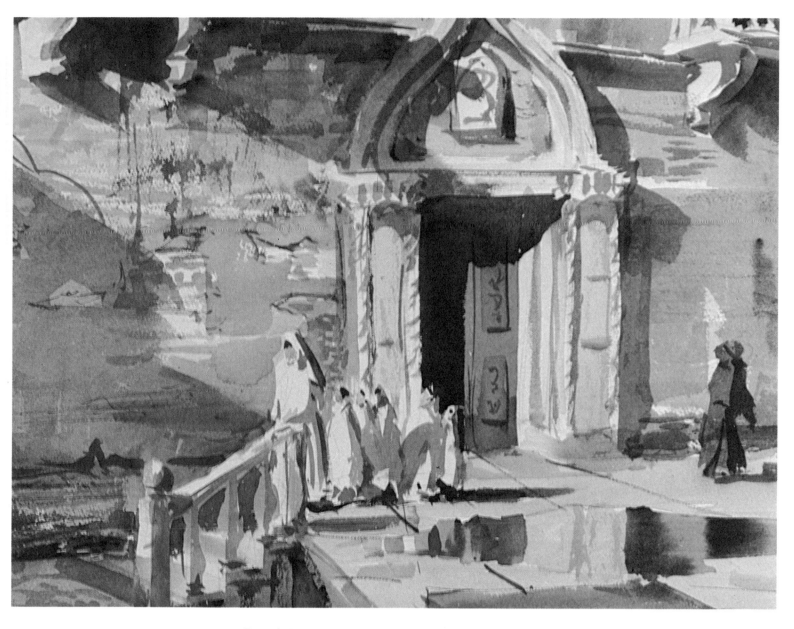

Detail. Here are some of those little details and textures which finish up the painting. I'm doing a lot of drawing and doodling with the point of a small round brush. I draw the architectural decoration around the doorway—all those nice curves on the columns—and add some lines up above. There's drybrush work on that moldering wall to make it look really crumbly. More darks are added to the figures, and I handle the stairway in exactly the same way, painting the shadows and leaving bare paper for the lighted edges. This doodling isn't supposed to be very precise. It gives you the *feeling* of lots of detail without being too specific and cluttering up the picture. An ancient and slightly peeling wall like this one may be read almost like an open book. What materials were available to patch that seventeenth century cannonball hole? What were the color tastes of the various owners down through the years? Why was a certain window bricked up? Use your own imagination. It's all there for your interpretation—build your own history.

11 MYKONOS CHURCH

22" × 30" (56 × 76 cm)
Collection of George Bakes

The beautiful little Greek island of Mykonos is truly a land of churches and whitewash. It's claimed that there's a church or a chapel for every day of the year—365! I confess that I've never counted them all, but I've done watercolors of several. They take many forms and sizes, all the way from tiny little chapels—about twelve feet square—up to large cathedrals. They're all snow white, with different colored domes or roofs: pink, red, pale blues, and greens. It seems that *everything* is painted white, including the very cobblestones of the winding side lanes. Little old ladies sit outside their doors knitting, while the ball of yarn rests, clean and happy, in the street. Fishing is the main industry, and the fishermen have their own chapel on a neck of land on the north side of the island.

Sketch. This broad, simple sketch, like the one for *Venice, Mother and Chicks,* is done for the large patterns and values, rather than for detail. My first question to myself as always, is "Will it hold together?" I want to make sure I get the exact values of those big shapes: the shadow planes on the walls and the street, the deep tone of the sky, the darks of the trees. And I want to identify the beautiful, sunlit shapes that stand side by side with the shadows.

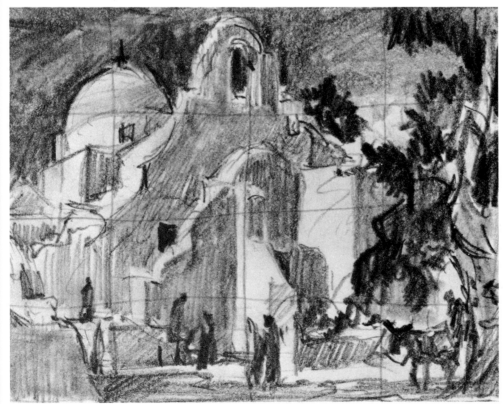

Graphite pencil on bond paper, 4" × 5" (10 × 13 cm).

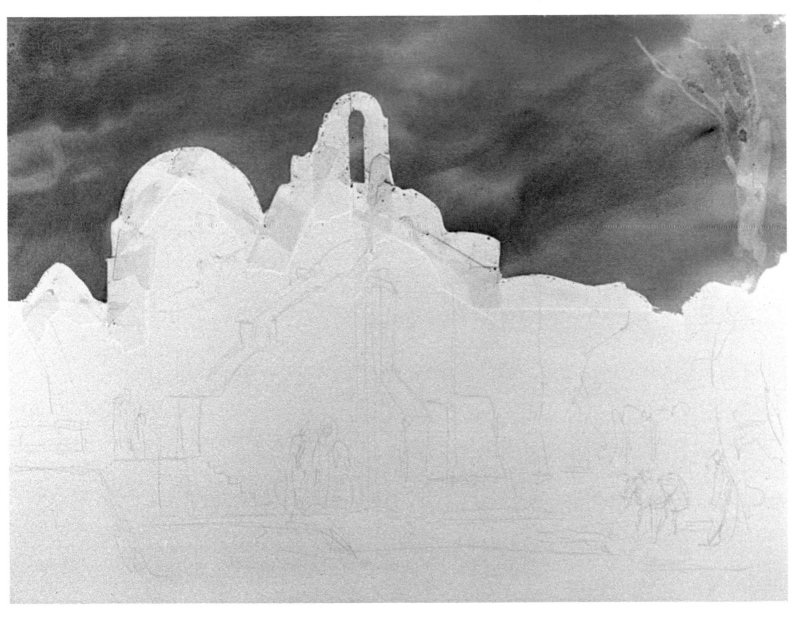

Step 1. To make sure that I hold onto the intense whiteness of the church, I decide to put in a dark, ominous sky. That's not out of place, believe me. Few seas of the world can kick up a better storm than the old Aegean. Greek mythology makes many references to the severity of these storms. Let me say, the last one I went through sure wasn't any myth! To keep the whites of the buildings intact, I put masking tape over the tops of the buildings and carefully cut around the shapes. I also brush a little liquid frisket on the upper treetrunk to the right, so that trunk stays white at this early stage. To produce a really dark, stormy tone, I wet the sky and brush in one of those irregular, blue-brown mixtures I like so much. The yellowish color you see here is the tape, which I'll peel away before I go on to the next step. In the upper right, you can also see the ghostly shape of the tree, with the color going right over the frisket, which I'll peel off when the wash is dry.

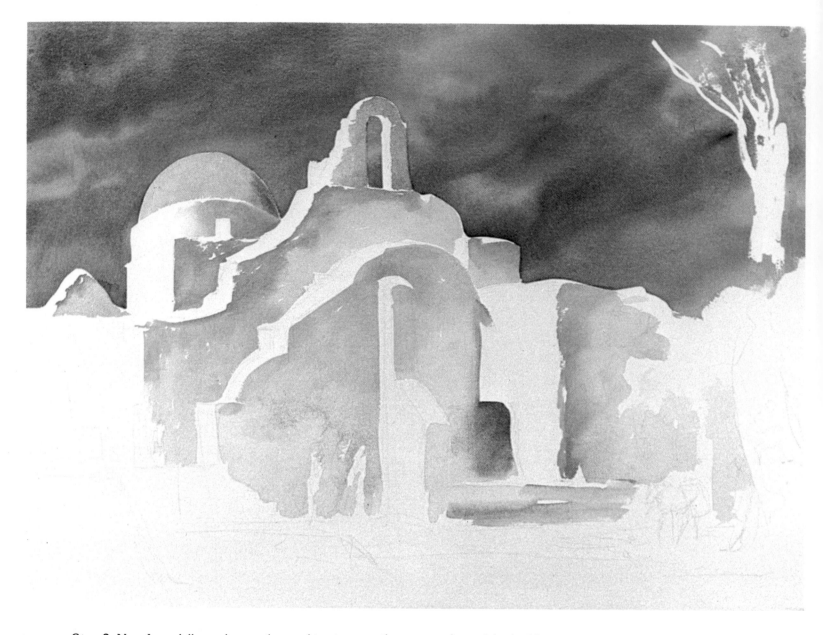

Step 2. Now I carefully peel away the masking tape on the upper edges of the buildings. I peel away the frisket too, leaving a nice, white shape for the tree. Even though most of the building is in shadow, I want to retain the feeling of its intense whiteness. So it's necessary to accomplish two things when I paint those shadows. First, I place cool tones at the edges of the shadows where they come up against the sunlit planes. Then, while these cool tones are still wet, I brush in some warmer tones that suggest reflected light in the shadows, caused by sunlight bouncing off the ground and off the other surfaces that receive the direct sun. Now I've got a strong contrast between the lights and the shadows on the buildings—and an even stronger contrast with the darkness of the sky. Damn! I wish I could set out a mess of rules to follow, but there just aren't any. In my old open cockpit flying days, you had throttle control, plus a couple of panel instruments that told you (more or less) what direction you were going in and whether you were right side up. You did all the rest by the seat of your pants, with a considerable assist from "you know who" up there. And that's also watercolor!

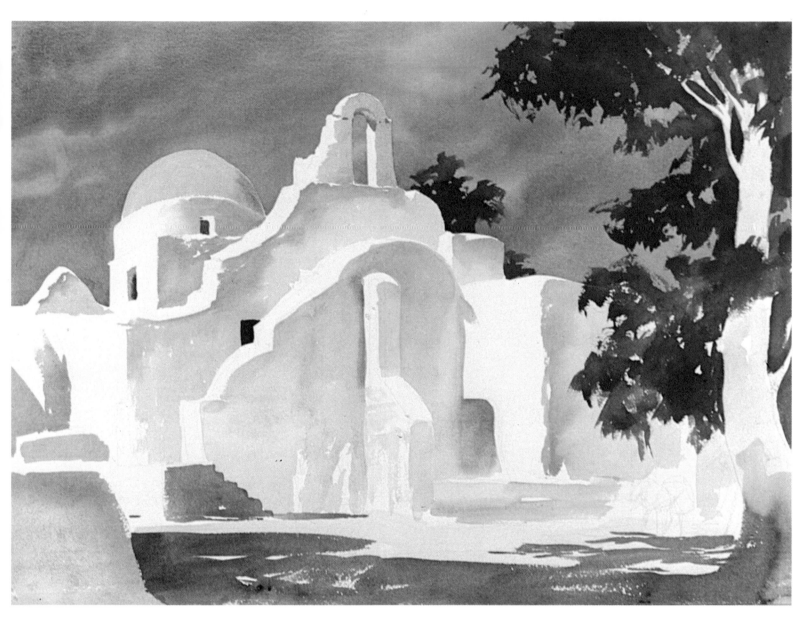

Step 3. The big darks of the tree on the right come in and begin to give the feeling of a one-two-three movement into the third dimension—the illusion of *depth* that you get when you've got a clear-cut progression of values. That deep, dark, juicy green is phthalocyanine green, phthalocyanine blue, and burnt umber. The darks of the trees are echoed in the little, dark windows that I now add to the building. The dark shadow across the foreground also helps to create that sense of space. I know I have a tendency to overdo that ploy, but you'll have to admit that it does help to push things back. The shadow tone is repeated on the side of the little stairway, which helps to push the building back too.

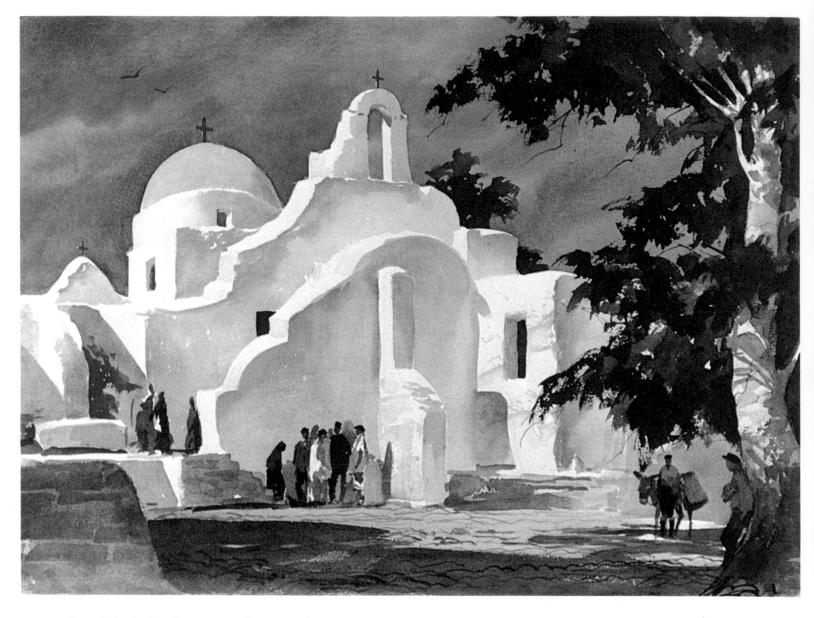

Step 4. In the first three stages, I've painted everything very broadly. I've saved all those intriguing little details for the very end, though I don't want to overdo them and possibly spoil the very sparse, dramatic design of the architecture, the street, and the trees. I texture the treetrunk with some quick strokes and add a few more twigs with the rigger. I hold all the other detailed work down toward the very bottom of the picture and leave the upper part pretty much as is. I add more shadows to the street and a few strokes to suggest masonry, as I mention when I talk about the detail on the facing page. I draw some wandering lines across the foreground to suggest paving stones. I add a few drybrush strokes, to the sunlit sides of the walls to suggest a little texture. And I put in a few more figures, such as the town drunk who didn't quite make the service, plus the stalwart and his donkey just coming in from the country to be ready for Monday morning's market. (Yes, I can't help but romance and dream. There's so much enjoyment in imagining that I'm living a little with the places and people I paint.) Of course, any finish-up of a painting comes down to the simple point—how do *you* feel about it? Do you feel an excitement? Do you say: "By gosh, I've done it!" Or do you say: "How I wish I'd made that area lighter"—or "Why did I leave it so light?" Plan, plan. Think, think. Know exactly what you want to say before you start slopping around. Oh, believe old John, who knows from thousands of mistakes. *Know* where you're going—and remember that only *you* can know the road.

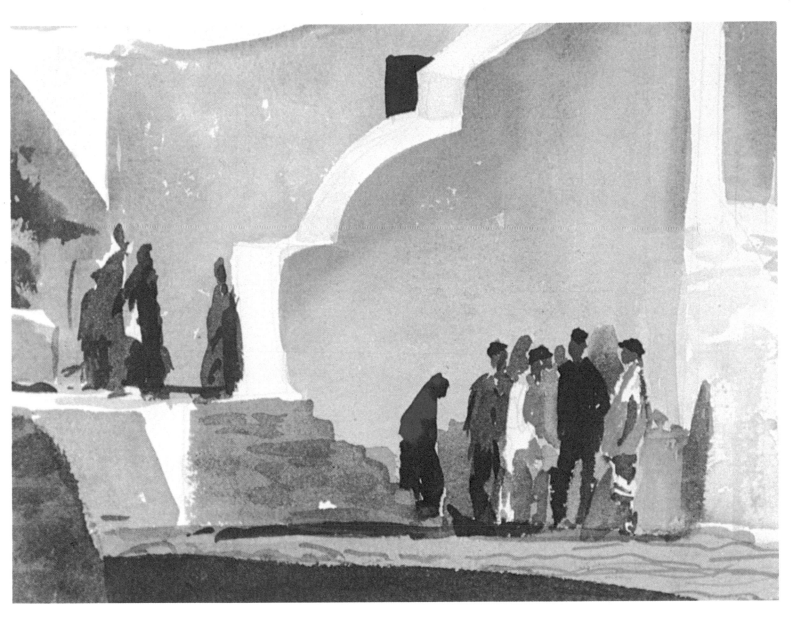

Detail. Perhaps the merit of this detail lies in the simplicity of the way I've painted the figure group that's probably discussing the morning's sermon or the fishing fleet's haul. Although these figures are terribly tiny, I'm still thinking about values and giving them distinct lights and shadows. I don't worry about the details of the figures. Coming in this close to a section of the painting, you can really see the warm-cool effect of the shadows on the sides of the walls. You can also see those flat, horizontal strokes that I use here and there to suggest masonry within some of the shadows.

12 COLOMBIA, FISHERMAN'S COVE

22" × 30" (56 × 76 cm)
Collection of James Calivan

I've been in Colombia before, but only high up in the Andes in Bogotá and the surrounding areas at around the 10,000-foot level. This trip, however, was down at the coastal level, which reminded me so much of my old second home, Jamaica. The climate, with its steady sea and mountain breezes, is ideal the year round. The architecture is predominantly Spanish colonial, along with bamboo and thatch in the country areas. The poverty in those small hamlets is real, but those poor seacoast Colombians have got bananas, mangoes, coconuts, fish, and rum—and a climate which is not too hot and not too cold.

Sketch. This layout is planned carefully so the eye will swing from the right, dark side, over to the fishing canoes at the left, creating a feeling of space toward the sea and the land beyond. The large tree, which divides the composition, is either a type of banyan or a silk-cottonwood (kapok) tree. I should know, but in this case I don't. This is drawn a little more precisely than my usual preliminary sketches. I've taken care to get the shape and the textural detail of the tree exactly right, since so much depends upon this one big pictorial element.

Step 1. The drawing on the watercolor paper looks very free, but I've actually worked hard to get the curves of the tree and the boats right. I've redesigned the upper part of the tree so that the S-shaped branch doesn't overlap the vertical trunk and creates a more interesting "negative space" between the trunk and the curving branch. Now I run a warm wash of burnt sienna over the tree area, plus a little yellow where there will be leaves with sun shining through. Most of these bits of underpainting won't show up in the final painting, but they lend a lot to the warmth of the completed watercolor.

Step 2. I'm not sure whether to paint the tree or the background first—but obviously the background has to come first. If I paint the darks of the tree first and then do the background, the darks will bleed into the blue-gray. So I begin with ultramarine blue, a little alizarin crimson, and a little burnt sienna, working around the leaves and trunk, leaving a sunlit halo for the leaves. When the background is dry, I paint in the large, dark trunks with burnt sienna, ultramarine blue, and a little new gamboge. I leave some unpainted parts on the tree where the sunlight hits and take a couple of swipes at the boats at the left. That dark patch to the right of the tree will also turn out to be a boat later on.

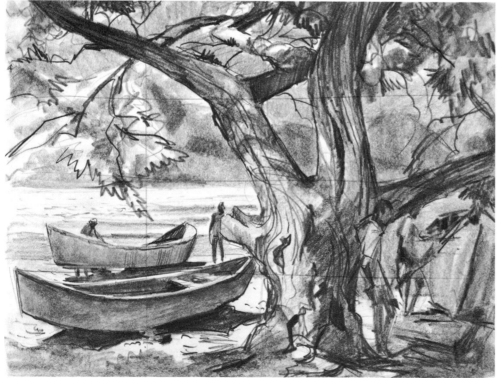

Graphite pencil on bond paper, 8" × 10" (20 × 25 cm).

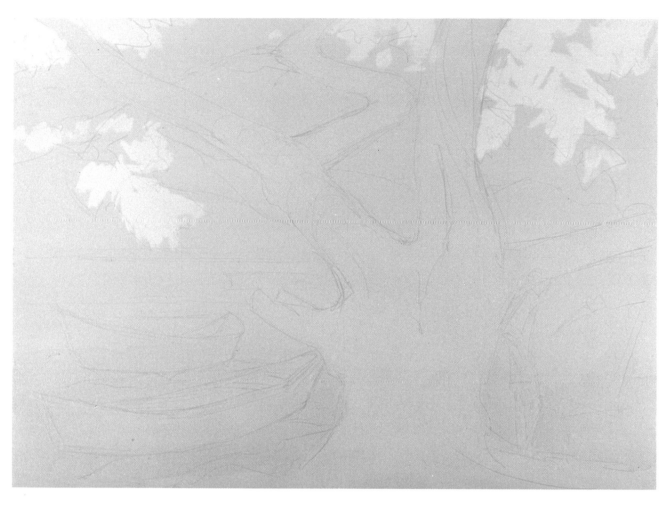

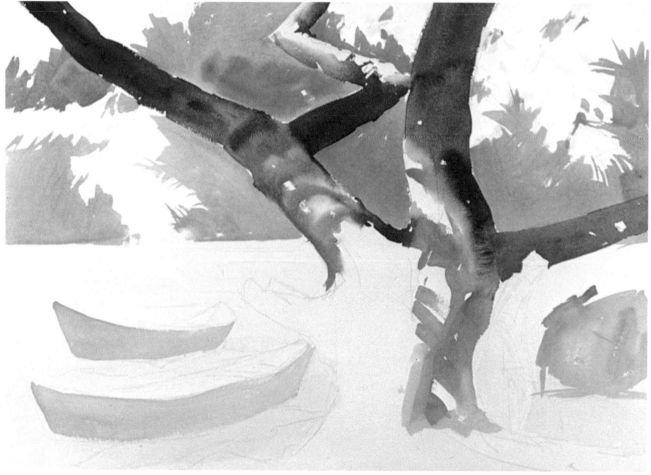

Step 3. I've said it before: the one thing the great John Whorf taught me was to paint all my foliage *yellow* at the start of a painting. It's a very good bit of advice. Working right over the yellow that I put down in Step 2, I paint in some of the darker tones of the leaves in varying shades of green—ultramarine blue and new gamboge, darker in some places and lighter in others. That yellow underpainting gives me sunlit edges around the clusters of leaves. Going back with a darker mixture of the original background colors, I put in some darker shapes on the distant hills. And I use my rigger to dash in some twigs and branches among the leaves.

Step 4. Across the water just below the horizon, I drag a stroke of ultramarine blue, which doesn't completely cover the paper and allows some flecks of white to show through so that the water seems to shine in the sunlight. Then I add some more strokes of ultramarine blue and phthalocyanine green, with strips of white between. That brings me up to the edge of the beach, and I start to work on those canoes. I paint just the shadows and leave the lighted parts of the canoe bare paper. I put a slender, dark stroke along the lower edge of the hull to emphasize the roundness and make the canoes look like usable craft. And I put strong shadows right under the canoes on the beach to emphasize the feeling of strong sunshine. I start to add darks and textural strokes to the big tree, following the direction of the trunk with my brush. With a few flat tones, I paint the young man who's leaning against the tree—doing nothing. And I put another big shadow to the right of the tree—dark, but just a little more transparent and luminous than the shadows under the boats. I paint the shadow sides of the boat to the right, so now it looks a little more three-dimensional. Now the big tree has gained texture and personality.

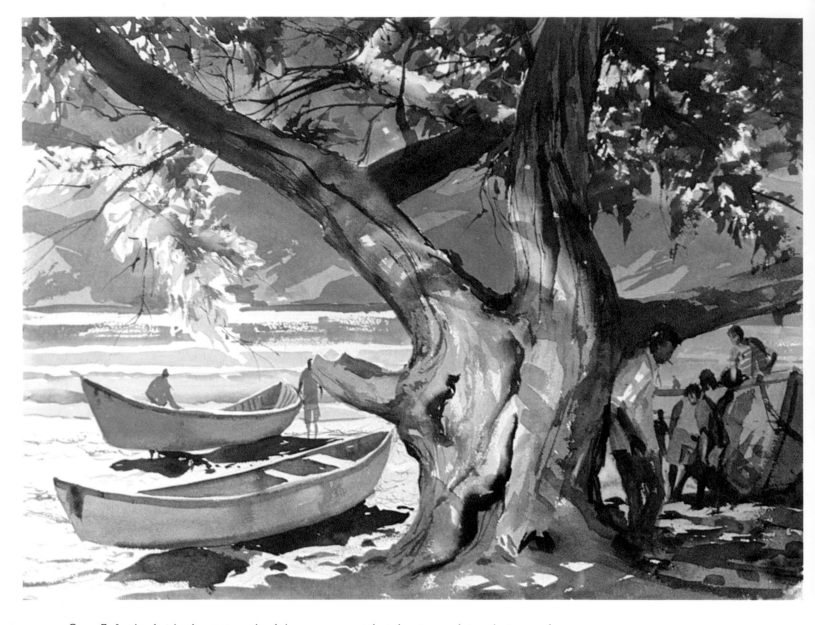

Step 5. In the finished painting, the fishermen are at their boats, readying their gear for the next day's adventure for food. The group under the shadow of the great tree are caulking—hoping to be ready to go out with the fleet. The shadow under the big tree and to the right isn't just one big tone, but contains lots of smaller strokes to suggest the dappled effect of light breaking through the shadows cast by the branches and foliage. I add more strokes of green to the foliage so that the leaves are darker and hold their place in the same plane with the upper branches. And I draw in more lines with the rigger to suggest more twigs hanging down. There isn't much color on the sand, just the pale tone I put down in Step 1. But I make wandering strokes across the sand with the rigger to suggest shadows and other irregularities on the surface. The figures caulking the boat to the right are all in shadow. There's only a little sunlight on the sleeve of the man who leans against the tree—and that's bare paper. The figures standing out there with the boat in the sun are painted with washes that look like the colors I used on the boats; that makes them the same value and puts them in the same spatial plane. Let your eye wander over the picture and see how many bits of bare paper I've left to suggest little patches of sunlight among the shadows.

Detail. Here's a close-up of the finished tree, showing all that ragged brushwork that communicates the texture. Warm and cool strokes are pulled down over the entire lower half of the trunk and continue down onto the ground where the roots go under. When these first strokes are dry, I go back with drybrush, which makes the tree look rougher. And I add thin lines with the rigger to suggest cracks and irregularities in the bark. To make the shadows underneath the tree look more transparent, I add some dark notes within the shadows, suggesting pebbles and other nondescript stuff that you find on a beach. Notice that I haven't put too much dark color on the sunlit portions of the tree, and I've left some bare paper where direct sunshine comes through the leaves and the branches and hits the trunk.

13
TROUBADOR'S REST STOP

22″ × 30″ (56 × 76 cm)
Collection of Julian Nuss

This is a fun still life for lots of reasons. Some time ago I did a large one in oil, quite similar, and it hung in a show at the Cowboy Hall of Fame in Oklahoma City. Everything in it has something to do with our family. The hat was my father's; he wore it all through his year or more of service in Cuba in the Spanish-American War. He was a gymnast member of the Sixth Ohio Volunteers in 1898. I had the old leather bag made from a similar camel bag down in the old section of Cairo known as the Mooski. It was my "home upon a strap" for many years. Inside the flap, I kept a record of my travels in World War II, as well as later years. The old guitar has been a friend since I can remember. The bottle? I probably drank the contents. The brass candlestick was my great-great-grand-father's in the eighteenth century.

Sketch. This is done very broadly, without detail, and again, mainly for the value relationships. I make sure to capture the dark shadows beneath the still life objects and in places such as the hole in the guitar or under the flap of the bag. And I try equally hard to define the middle-tones that alternate with the patches of light. The strongest contrast of light and dark is on the hanging bag; you can see that clearly in the sketch. I have all the props here in my studio, plus a photo of the oil painting, so I can move along quite easily. In fact, I'm wearing my father's hat while I paint.

Step 1. You've seen me do this before. I paint everything with a gray shadow wash, leaving just the highlight areas: the bottle, the lighted areas on the bag and the guitar, the candlestick, and the window. This time, I don't use any masking agent. It's fun to paint around the lights when you can. In mixing this gray wash, I'm starting with a high middletone so that I can work up and down from there. The tone is a mixture of ultramarine blue, burnt sienna, and some of that priceless "palette gray."

Step 2. For my own peace of mind, I *have* to get in a few dark colors to convince myself that I haven't made that first big wash too dark. So I put in those darks, and I find that the first wash is okay after all. I add the strongest darks on the hanging bag and on the hat. I work a little bit of burnt sienna into the bag and the candlestick, starting to warm up the subject. I'm especially careful not to lose that ragged patch of light on the right side of the bag and those strips of light around the edges of the candlestick. The little blob of phthalocyanine green on the bottle adds a cool note.

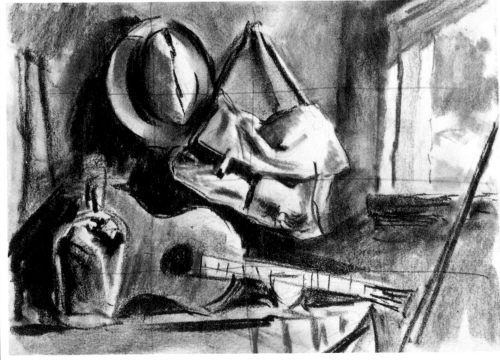

Chalk on bond paper, 9″ × 12″ (23 × 30 cm).

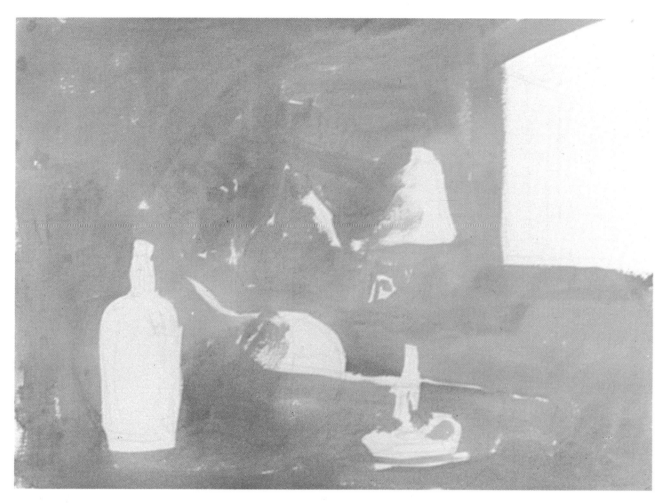

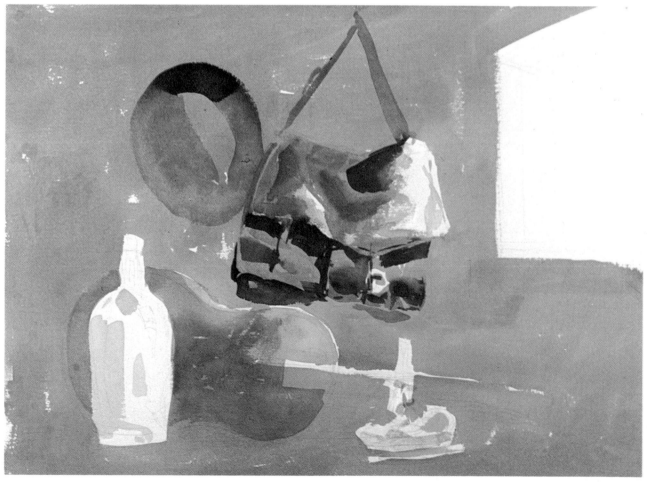

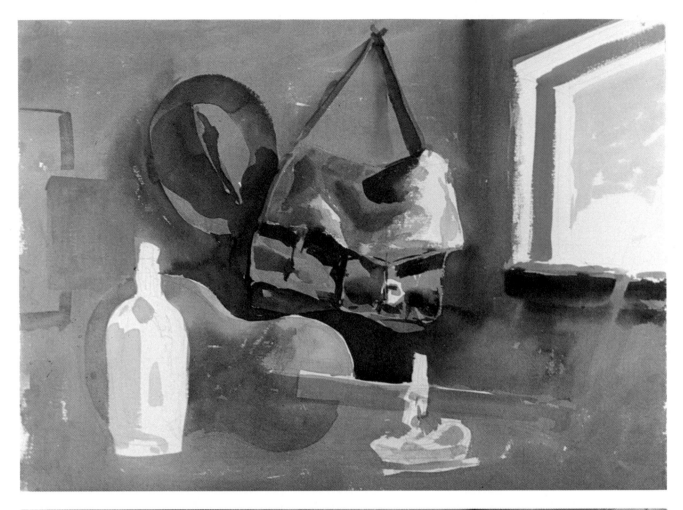

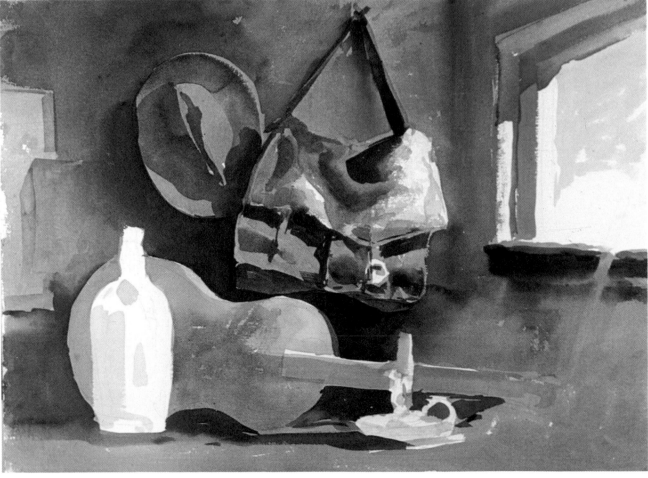

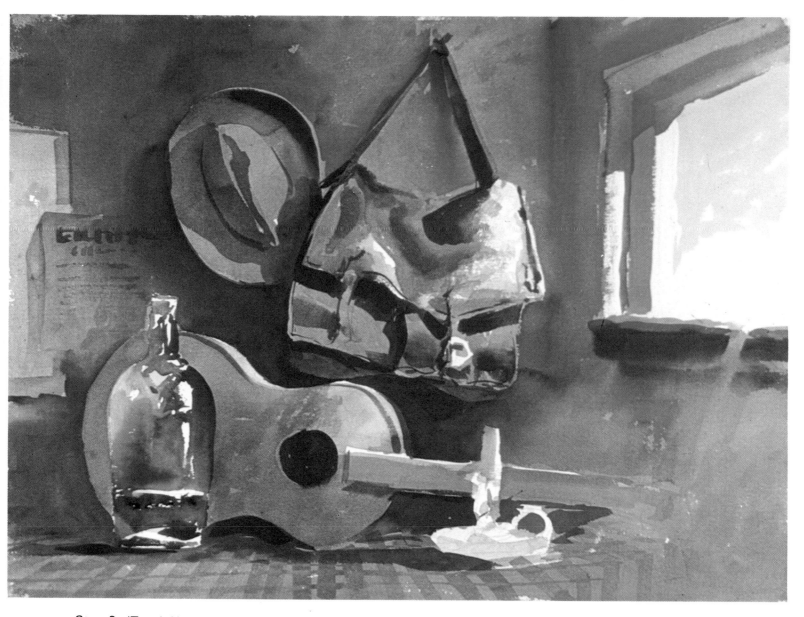

Step 3. (Top left) I put in a few of the darker darks underneath the bag, which gives shape and form to the guitar, and I add more darks to the hat and put the shadow on the wall. Then I start to render the window shape, adding a strip of color around the edge, putting a shadow under the sill, and suggesting a little sky outside with a pale tone within the window. By now, the lighted area on top of the guitar has a pale tone over it so that there won't be any competition with the lighted patch on the bag. I also put some tone in the corner where the walls meet; now the room has a three-dimensional feeling. That window is the only light source, so I've got to consider it carefully and not do too much to it until I'm absolutely sure about how to handle it.

Step 4. (Left) Very quickly I punch in a few darks to push the various objects out from the wall. You can see these darker tones above the hat in the upper left corner, beneath and to the left of the guitar, and around the candlestick. Now the shapes have more character and are more identifiable. I also put a shadow under the window frame; that dark tone contains a note of warmth to suggest reflected light from outside.

Step 5. (Above) Now I move into those areas that say a little something just beyond being a few objects hanging on a wall. I paint the bright, luminous color of the bottle with phthalocyanine green and a little burnt umber, letting the dark strokes blur into the light ones while the color is still wet—leaving some gaps of white paper to represent the highlights. I add a black hole to the center of the guitar and run a line of shadow around the edge. Notice the phthalocyanine blue sky reflection close to the burnt sienna of the highlight on the leather bag; this cool tone obviously comes in through the window. Naturally, I've got to have a checkered tablecloth, so I paint stripes of alizarin crimson with the square end of a flat brush, keeping the stripes in more-or-less accurate perspective. I still haven't done much work on the candlestick or on the window. These come last. I might point out that I didn't drink all of that old-time gallon jug.

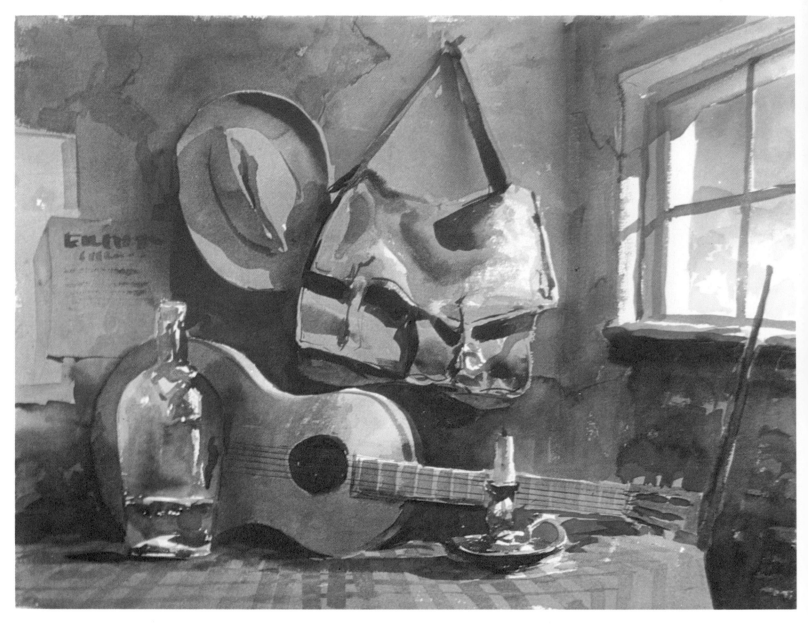

Step 6. In the final stage, I concentrate on the window and the wall around it. I put a hint of landscape in the lower part of the window. When this is dry, I stroke in the mullions that hold the panes of glass in place. Not forgetting that the light is coming through the window, I add the shadows of the mullions on the window frame. Of course, the wall beneath the window doesn't get much light, so I darken this with drybrush strokes that also create the feeling of the age and character of the old plaster. I finish up by adding the strings to the guitar—using the rigger—and I draw more dark lines for the detailing on the bag. That's as far as I think I ought to go—though it's always tempting to go on—so I stop here.

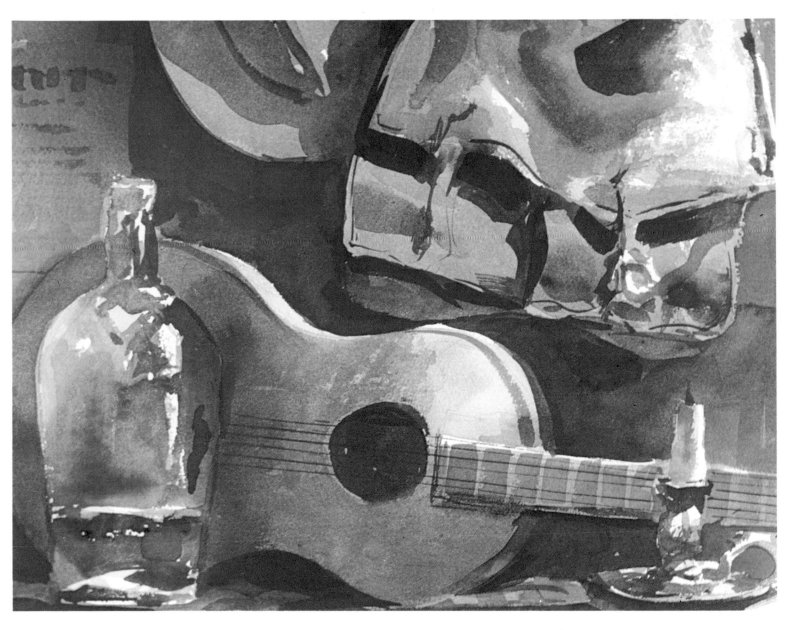

Detail. This section of the finished picture shows how free the brushwork really is. The bottle, for example, is just a lot of dabs and pats, all in the right places. Glass isn't really any harder to paint than anything else; you've just got to see where the different spots of color go—and then put them there. Notice how I've added a tiny hint of shadow between the bottle and the guitar so that the bottle stands forward a bit. The metal candlestick isn't any harder to paint than the glass; once again, it's a matter of putting the right spots of color in the right places and leaving some bare paper for the shiny, sunlit edges. Those dark strokes under the flap of the bag really make the flap stand out. Notice that the lettering on that piece of paper—the one tacked to the wall on the left—doesn't really say anything!

GALLERY

The painter, according to many authorities, doesn't necessarily know what's good or bad about his own work. Every painting presents certain problems to the artist. In the struggle to overcome these problems, he often begins to feel something very personal about the picture. He may develop an attachment to it—or maybe an aversion—which may have nothing to do with the fact that the painting is good or bad.

Anyhow, here's a selection of my watercolors with some comments about why and how I painted them. I'm rather pleased with a number of these paintings. About others, I just feel so-so. And I must admit that there are others that I can't stand—but other people seem to like them. You'll have to make up your own mind. In the meantime, I hope you'll learn something by looking at these pictures and reading what I have to say about them.

Frankly, once I've done a fair watercolor, I don't usually care if I ever see it again—except for wishing to get it back so I could do a better job next time.

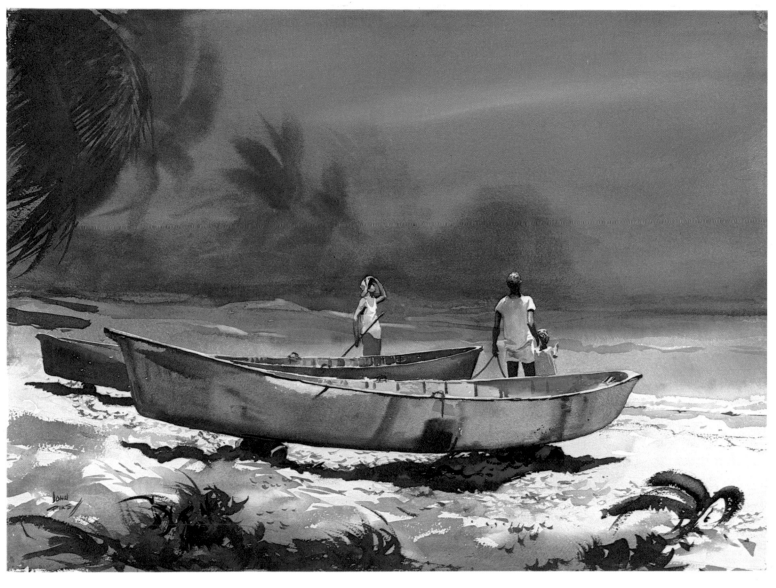

H'ya She Come!

22" × 30" (56 × 76 cm), collection of Dr. Bruce Sorrin.

Way back in the demonstration section, I spoke of the feeling of awe that's produced by tropical storms. This painting says "fright" by the simplicity of the two main values: the blackness of the sky and the sunlight that still appears on the beach. The figures are tense. I like to think that this feeling of tension comes through. You know that they'll run for shelter in less than a minute—and they'll find it.

The brushwork of the sky reflects the movement of the oncoming storm. The overall tone of the sky was painted in a series of long strokes, roughly parallel to the horizon, but tilting slightly. These strokes overlapped and fused into a somber, wet-in-wet effect. The darker shapes of the distant shore and the wind-blown palms were painted right into the wet surface, where they look blurry and mysterious. The curves of the tree strokes tell you where the wind is coming from. These curves are echoed in the windblown foliage on the beach.

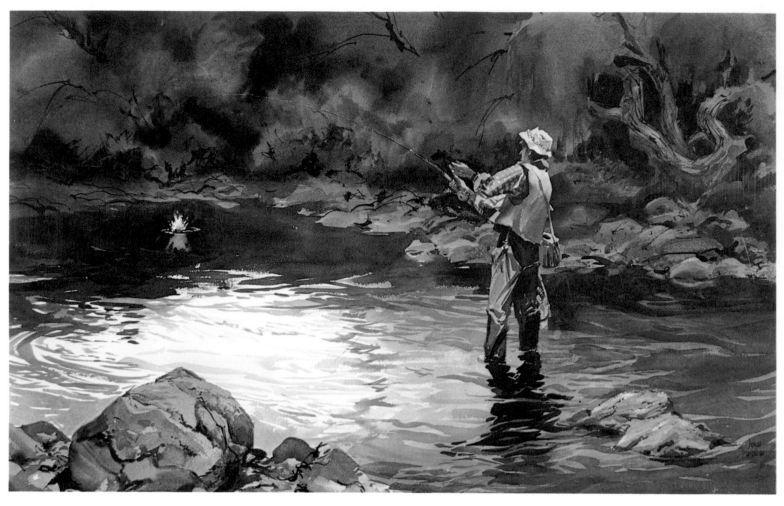

Early Riser
24" × 40" (61 × 102 cm), collection of Dr. Jack Davis

The real dry-fly fisherman is in his own world. He doesn't mind company— just as long as that company is way upstream or downstream. Knowing both the fisherman and the fish, I kept my distance. But in the painting, I got the subject just as he made a strike in that pool.

The painting is essentially a two-value job. The dark background silhouettes both the figure and the fish that's breaking the water. The lighter value of the sparkling water in the foreground pulls everything together to create a simple, but powerful, watercolor. Notice how the shadowy background is not only dark, but slightly out-of-focus, with a lot of wet-in-wet painting. The strokes of the water change gradually from dark to light as the brush approaches the shining center of the pool. And these strokes curve to keep your eye in the picture.

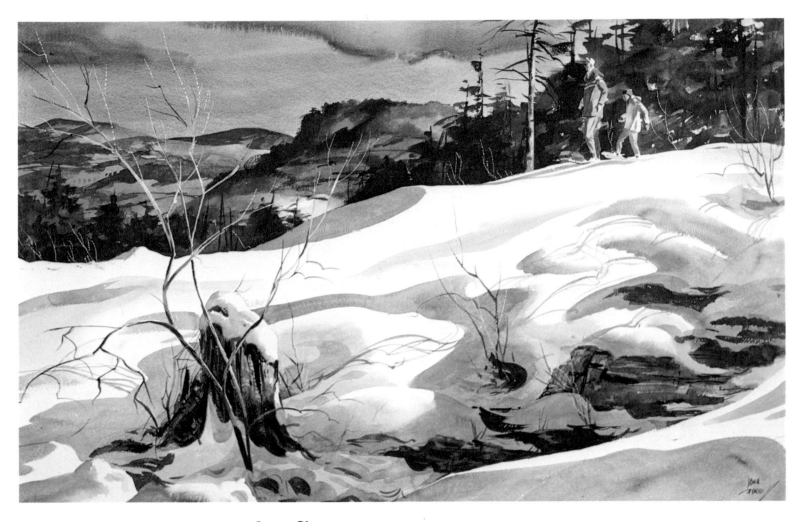

Snow Shoes
24" × 40" (61 × 102 cm), private collection

This is the kind of chancy watercolor that can either make it or fall flat. I say this because I was playing with two extremes—very dark and very light—and trying to relate them to one another. The problem was to decide how light to make the lights and how dark to make the darks. This is when those little black-and-white sketches are so important because you can solve things in the sketch before you start to paint. In the finished painting, you can see that the shadows on the snow are just light enough so that they remain part of the snow and don't just look like dark holes in the paper. The snow, in turn, carried just enough tone to integrate it with the shadows—it's not just bare paper. The snowy foreground looks even brighter because the distant landscape is so much darker. Notice how the curving shadows lead the eye from the foreground to the center of the picture.

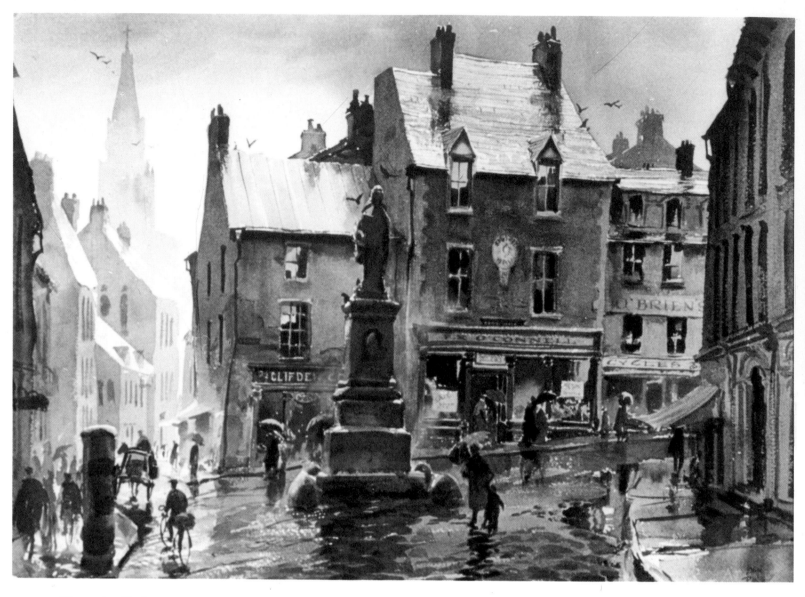

Town in Cork
22" × 30" (56 × 76 cm), private collection

For some strange reason, people always want to know the exact location and the name of the place that the artist has painted. But my watercolors are never literal records of what I've seen. If complete literalism was what I was after, I would have thrown away my brushes long ago and bought a good camera. I've purposely avoided learning *anything* about photography beyond how to take a black-and-white Polaroid for quick sketching purposes—used only when there isn't time or space to do a sketch. The painter is a creator, an interpreter of a mood, a searcher after the feel of the place—he's not a camera. So I honestly don't know if Sarah O'Toole still lives over O'Brien's Cycle Shop!

In this rainy-day painting, I wanted to catch the high, misty down-light from the entire dome of the sky. This meant masking out the various roofs which would catch the shine from above. I used masking tape to protect these roofs while I put the darker wash of sky around them. When I peeled off the tape, I kept the tones of the rooftops paler than the sky, which is why they look so wet and shiny. As I worked down the vertical surfaces of the buildings, adding tones and details, I went from dark to light as I approached the street. This gives the feeling of mist and distance. I like the way the dark figures and their reflections are silhouetted against the light that shines off the wet surfaces of the walls and street.

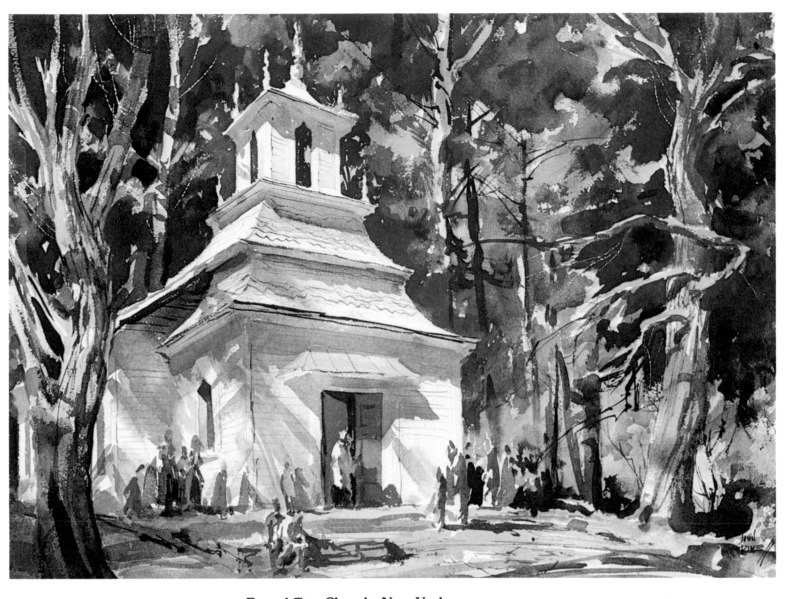

Round Top Church, New York
22" × 30" (56 × 76 cm), collection of Anderson-Morris

This little nineteenth century country church was a most unusual and beautiful example of what's known as "carpenter scroll saw" architecture. The name "Round Top" had nothing to do with the shape of the structure, which was still in a little hamlet of that name, a few miles north of Woodstock, New York. Yes, I speak of that lovely church in the past tense. After standing there on the edge of the pine grove for 150 years, it fell victim to some kids who thought it would be fun to have a bonfire.

My old friend Eliot O'Hara often used that great combination of burnt sienna and ultramarine blue for reflected light and cast shadow. As you can see at the top of the steeple, the idea is to let the burnt sienna run into the ultramarine blue so that the warm color becomes the reflected light, and the cool color becomes the shadow. The effect can be a little flashy, and you mustn't overdo it. For the background trees, I could have used frisket as a shortcut, blocking out the lights so that I could paint over them. Instead, I carefully painted around the lighted shapes of the trunks and branches. Some of the sunstruck twigs are just scratches made with the corner of a razor blade.

Bottle Hunters
22" × 30" (56 × 76 cm), collection of Dr. Albert Frontera

We live in old bluestone quarry country. New York City was practically built of Ulster County stone. This old, very small, long-abandoned quarry is on my property—maybe 200 yards from my studio. We discovered that it had been the dump of a famous old family who'd lived here for many generations before us. Zellah immediately became a bottle expert and sent for every known book on the subject. Many students abandoned painting for digging. This went for Zellah, too, until one day she was all alone deep in the quarry and saw a large snake looking at her—with interest. She lost interest in bottle hunting "same time," as the Jamaicans say.

Painting spotty shadows can be fascinating if you really look at them. You'll discover that the farther away the object that casts the shadow, the fuzzier the shadow will be around the edges. The closer the object is to the surface that receives the shadow, the sharper the shadow edges will be. Seems obvious, once you think about it. This principle explains the fact that some of the shadows on this rocky wall are soft while others are crisp. The shadows have a lot to do with the drama of this watercolor. There were large trees at the far end of the quarry, so I painted their shadows while the wall wash was still wet and the strokes would go soft. When the wall was dry, I painted the shadows that were cast by the closer trees and branches—the shadows with the sharper details.

Below the Falls, Kaaterskill
24" × 40" (61 × 102 cm), collection of George Bokes

In this wonderful, undiscovered spot, you can swim in a crystal pool that overflows onto the shallower, water-rounded stones and on toward the mighty Hudson. We used to dig a hole in the sand between the large rocks, bury our corn (still in its green husks), then add the fat potatoes, cover them with sand, and build a small fire with dry driftwood on top. While the coals died down, the icy beer, tied by a string, was pulled in from the stream. Then came the time to grill those juicy hamburgers—with slabs of butter for everything—and get the French bread, the corn, and the potatoes, which we pulled out from beneath the coals. When night closed in, we had to make the climb back up that wall. So we'd bury our coals deep in the sand, pour stream water over them, and pick up every scrap and cigarette butt and put them into our garbage bag. A little later, touring "city slickers" found the place and enjoyed the sound of smashing pop bottles on those beautiful rocks.

This painting is based on two simple contrasts: dark against light and cool against warm. But when you make the decision to paint something as stark as this composition, you have to plan your middletones carefully so that they tie the lights and darks together. Otherwise you run the risk of having the picture break in two. Where the dark, cool shape of the near cliff comes up against the paler, warmer shape of the distant rocks, they're linked by the cool middletones that appear just above the water, so that the contrast isn't jarring and doesn't split the picture.

Rainy Tryst
22" × 30" (56 × 76 cm), private collection

Although I did this painting at home in Woodstock, the original sketch was made from our hotel balcony on a very wet night in Bled, Yugoslavia. The painting was chosen for a Gold Medal and $5,000 award by the Franklin Mint of Philadelphia.

Wet night scenes take a lot of planning because you have several light sources as well as their reflections. The center of interest must be emphasized, either by the composition or by planning the intensity of the light. Be careful that some side light isn't going to pull your eye away from the center of interest. The high background light at the crosswalk was probably some kind of mercury vapor type which gave me the chance to play its bluish-green color against the warm light that was hitting the foreground trees. I kept those forward trees quite simple to make an interesting textural contrast with the brick walk. The center of interest is framed by the trees and spotlit by the bright reflections on the path.

When I made the original sketch, it was bedtime and all my gear was locked up in the small dining room that we used for a studio. So I made the sketch on the back of a menu, using a felt tip pen and a cotton swab dipped in local wine. It worked!

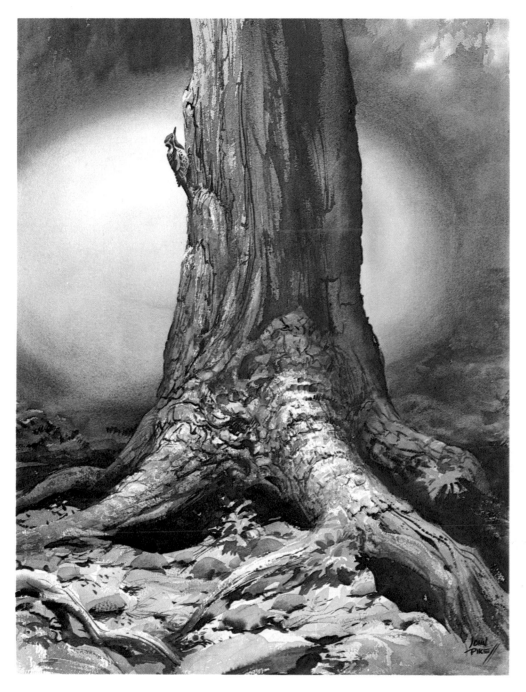

Sinbad's Roc Foot
22" × 30" (56 × 76 cm), private collection

As youngsters, we had no television and not much radio, so we all read a lot. The *Arabian Nights*—especially the adventures of Sinbad the Sailor—made a strong impression on all of us. Years later, on a rainy night in late summer, I stepped out of my shop, and right there was the great, clutching foot of Sinbad's giant, mythical bird, the Roc. My parking lot light is high on the same tree, and the long, dark shadows give it a look of mystery. I made the sketch on-the-spot in the rain. The illusion of the enormous egg in the background is pure whimsy, of course. I put in the yellow-bellied sapsucker to bring us back to a little reality and to add scale.

Look carefully at the brushwork that renders the form and texture of the tree. On the vertical trunk, the strokes travel upward; the brush was moved swiftly so that the texture of the paper would break up the strokes and produce a drybrush feeling. On the lighted roots, a lot of the strokes curve around the cylindrical form. This is a good example of selective detail. I did a lot of work on the base of the tree, but the rest of the picture is painted very simply.

Wash-Up Time
22" × 30" (56 × 76 cm), private collection

Raccoons, those charming, mischievous, masked clowns, are either loved or hated. There seems to be no middleground. In the country, when you build any kind of container, the first question you ask is: "Is it raccoon proof?" Believe me, *nothing* is, unless it's made of steel with a rotary tumbler lock. And even then, I think they're smart enough to figure out the combination. Here, at our summer school in Woodstock, our students buy their groceries in town so that they can cook lunch and dinner at the school and work well into the night. When a group of four or five raccoons come marching out of the woods some time after 10:00 P.M., students from urban areas find it hard to believe that these are actually wild animals. If you sit very still, they're liable to walk right over your feet on their way to the trash barrels. I love them!

In designing this array of snowbanks, broken by a dark stream, I was careful to vary the shapes so all those curves wouldn't become monotonous. No two mounds of snow are exactly alike in size or shape. The dark form of the stream carries your eye diagonally between the snowbanks and out toward the top of the picture, where the raccoons are crouching. Even in this shadowy landscape, you can see the light and shadow sides of the snowbanks, which are subtly modeled to make them look round and three-dimensional. Practically the entire painting is covered with a gray wash that makes the sparkle on the water—in the left foreground—the one bright spot in the picture.

Black Water

24" × 40" (61 × 102 cm), collection of Dr. Bruce Sorrin

Dark water—which reflects the shadowy tones of the surrounding woods—isn't a terribly difficult subject to paint, but it must be well planned. It's too easy to make one area too light and another too dark, and the whole thing falls apart. As always, the secret is values. Here, I think I've managed to get a pretty fair "triangulation" of the lights. (1) The upper left is slightly subdued. (2) The light on the figures and on the snow behind them is also held down in value. (3) On the sparkles in the water, I've gone as light as I can manage—just the white of the paper with a small amount of color. The broken ice, as it dips into the water, doesn't usually have edges as sharp as I've shown. But they *could* be that sharp. I emphasized the sharpness of the shapes because this helps the composition and makes a more interesting form where the black reflections come in from the forest at the upper end of the painting.

This was a cold morning. I sure hope they had a little touch of Catskill "applejack" to lace that container of hot coffee.

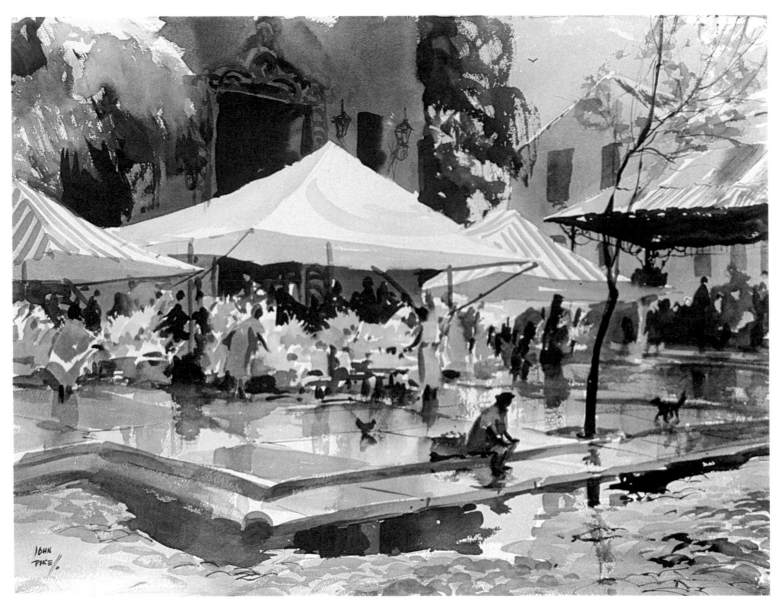

April Showers, Ecuador
22" × 30" (56 × 76 cm), collection of Richard Frisbee

At an altitude of 10,000 feet among the beautiful mountains of Ecuador, there are lots of clouds that can give you beautiful sunlight, drop down a light mist, or drench you in a deluge. In this painting, I wanted to give the feeling of the light just breaking through following a quick, heavy rainfall. The people were just putting their flowers back into the open, and they'd soon be starting to sweep the water off the stone plaza with twig brooms.

Squint at this picture, and you can see that the whole thing is light silhouetted against dark. The bright, pale shapes of the canopies are defined by the dark buildings behind them. The reflected light on the pavement is defined by the surrounding darks. When you work in transparent watercolor, of course, you can never paint a light—you just create a light by surrounding it with darker tones. In the same way, the bright flowers under the canopies *look* bright because they're surrounded by more subdued colors: dark tones behind them and shadowy reflections underneath.

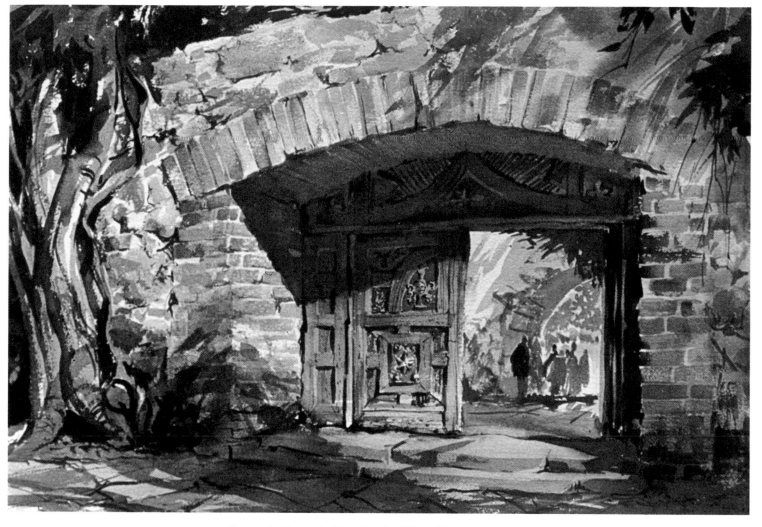

Cortez' Chapel, Hacienda Vista Hermosa
22" × 30" (56 × 76 cm), private collection

Cortez originally built this beautiful complex as both a sugar mill and a fortress. No doubt he needed the sugar to sweeten the souls of his soldiers after killing off so many Indians during the day. The fortress was obviously needed to protect them from their Indian attackers. I'm part Mohawk, so my stomach churns a bit when I think of the Conquistadors. But I must admit that those Indians did beautiful brickwork and magnificent woodcarving—under the whip. Here I tried to record a bit of the beautiful texture of both the brick and the wood.

The door is accurately painted, but those brushstrokes are purposely made without the benefit of a ruler so that they don't have the mechanical precision of an architectural rendering. Look closely at the bricks and you'll see drybrush strokes made with a flat brush that picks up the rough texture of the paper and turns it into brick. The doorway is placed slightly off center, and the bright color of the opening is accentuated by the dark shadow above. The entire doorway is framed with shadows on all sides. The dark figures in the doorway are silhouetted against the light.

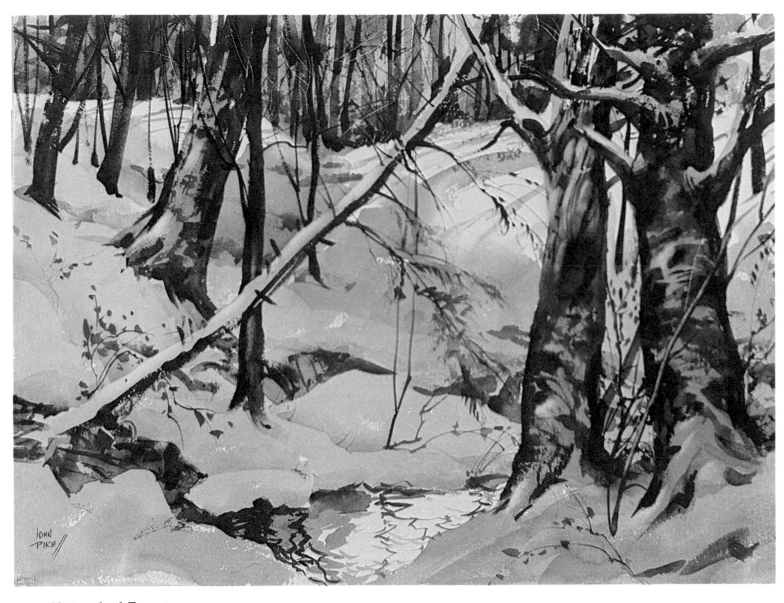

Untouched Forest
22" × 30" (56 × 76 cm), collection of the American Cancer Fund

I must admit that the title is really a misnomer. The forest has remained "untouched" in the thirty-odd years that we've owned these beautiful woods. But it's mostly second and third growth, with the trees ranging from thirty to seventy years old—so someone obviously did some cutting before we got there. "Untouched" means only that if an old tree falls and doesn't endanger people, then we let it be. The branches and twigs will form a natural ground cover for birds and animals.

Once again, you can see the old trick I emphasize so often: the lighter areas show up so strongly because most of the painting is in shadow. I've also kept my light and dark contrasts fairly subdued throughout the picture, saving the strongest contrasts—the opposition of the lightest lights and the darkest darks—for the center of interest.

Castle Invaded
23″ × 40″ (58 × 102 cm), collection of Wallace Wilson

The great pines reach high into the clean, crisp air. The red-tailed hawk makes a startled exit from his home at the approach of the young skiers. With man's relentless encroachment on all of nature, I can't help wondering who are the hawks and who are the doves. In this painting, I wanted to create the illusion of clean, clear air and space—both are a little hard to come by these days.

This is a straight one-two-three value job. The sky and the light on the trees and snow are the highest values. The shadows on the snow make the middle one—leaving the trees for the darkest. I put just a little liquid mask on the thinner tree branches, and then I braced myself for that huge, graded blue sky wash. When your work is large, don't try to put in the entire sky at one time. Use the trees as a stopping place—then continue. To put in the snow, I first washed clean water over the area and then laid down the blue-gray shadows, letting them flow into the water to give the soft edges. A pale yellow and burnt sienna wash went over the sunlit parts of the trees. When this was dry, I textured the rough trunks and branches. I wound up with the figures and my friend, the hawk.

Study the composition and you'll see that I took great care with the design of this watercolor to make it hold together. Just an inch or so in one direction or another could make the painting fall flat on its derriere. For example, just block out the hawk with your hand, and you'll see what I mean.

Coral Hunters, Jamaica
22" × 30" (56 × 76 cm), collection of Betty Nicholls

When I first went to Jamaica in my early twenties, we did a lot of underwater
exploring and spearfishing right in this very spot. This was long before there was
such a sport as scuba diving, with air tanks and masks and air-propelled spears.
We made our own spears: a thin steel rod, usually from a Model T, sharpened
to a point, then painted red or yellow so we could find it again. The propellant
was a kind of slingshot, made from bamboo and a long strip cut from an old
inner tube. Face masks were unknown; we could buy goggles for a few shillings.
Air tanks? Our lungs. We took two or three deep breaths, went straight down,
and stayed until we were ready to bust!

 The water sparkles because I put a tone over everything else. Think carefully
about this lesson. If you wish to make some spot the brightest area in your
painting, then *everything else* must come down in value. That spot will look
bright only if everything else is darker. The brushstrokes swirl around the focal
point of this picture, which becomes a kind of vortex. The first strokes of the
water were painted into a wet wash, which is why they look soft and blurred.
Then, when this passage dried, more strokes, now sharper and better defined,
were carried over them. Even though the sun isn't in the picture, you can tell
exactly where the light is coming from.

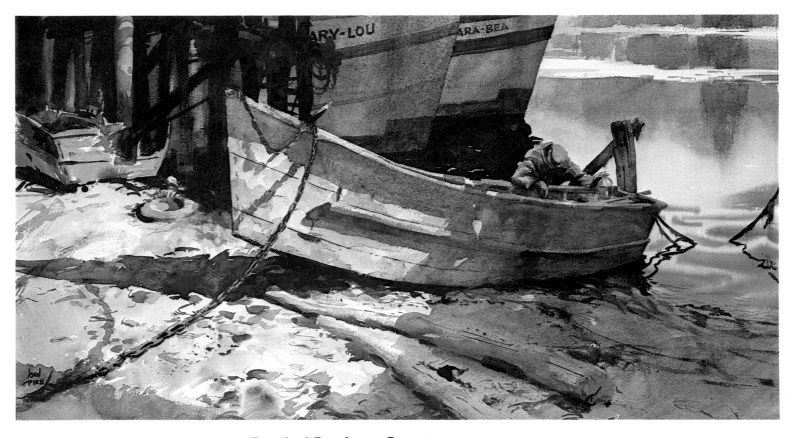

Beached Derelicts, Georgia

22" × 40" (56 × 102 cm), collection of Dr. Jack Davis

I did the sketches for this watercolor at the same place and time as I did the study for the demonstration painting called *Unfinished Project, Savannah.* The old, green rowboat was chained down, but the tides had washed over it for many years, and the old "wino" had a few barnacles growing on him too. There were several odd pieces of boats and hunks of rusted iron lying about.

There was a kind of diagonal interplay of lights and darks. You can see that the lights are in the upper right and in the lower left, playing off against the darks that are in the upper left and lower right. It's almost a crisscross pattern. The big shadow across the rubble-strewn beach and rowboat makes the design even more dramatic. Notice that the line of the dark boat at the top of the picture continues down across the rowboat and into the foreground, where the light and shadow meet. You get this kind of interesting lighting in the early morning and late afternoon, when the shadows are longest and most dramatic.

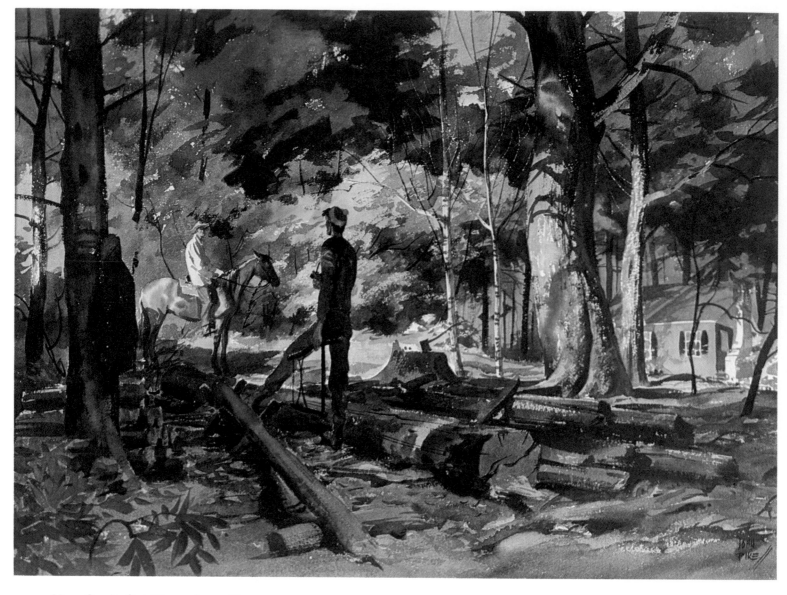

You Can't Get There from Here
22″ × 30″ (56 × 76 cm), Zellah's collection

Thirty years after I painted this picture, you still can't get there from here. In my woods, this spot is the end of the line. The watercolor was painted when we'd just finished the little red house in the background to the right. Originally, it was a guest house for Zellah's mother and father, who liked the painting and hung it in their beautiful home in western North Carolina. Now the house is my cozy winter studio.

Like so many of my paintings, this one is based on what I'd call the "spotlight and dark silhouette" concept. The dark, central figure is placed against the sunniest spot in the painting. The rest of the painting is a lot darker and revolves around that focal point. The shapes are mostly horizontals and verticals, but the fallen logs move diagonally and lead your eye into the center of interest. At first glance, I feel that this watercolor looks a little too busy. But when I half close my eyes, I think it holds together pretty well after all.

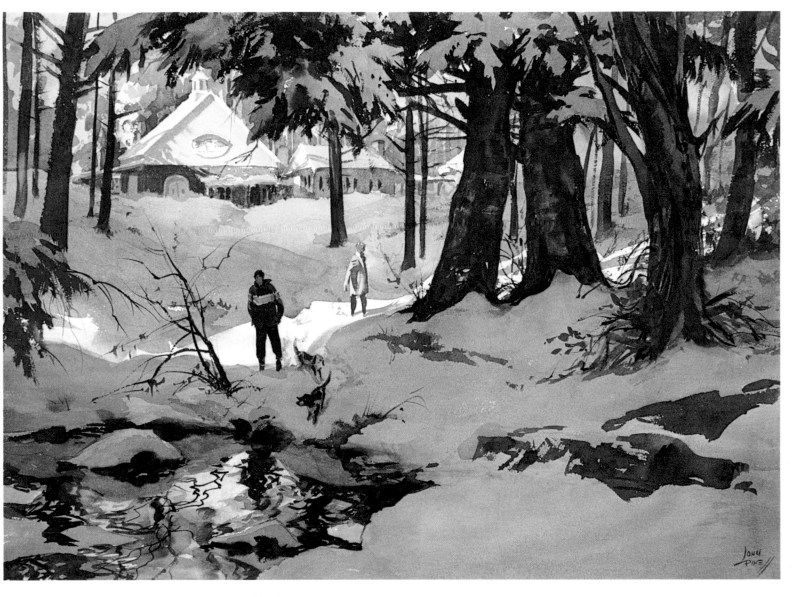

My Studio
22″ × 30″ (56 × 76 cm), collection of Dr. Israel Ranel

Here's where I've spent about ten hours a day for the past thirty years. I'm really talking about the little house just to the right of the big one. Aside from the usual painting gear, it's complete with kitchen, shower, and my big, fat, beloved Lowrey organ.

A way to control a snowy landscape is to place most of the snow in shadow, reserving the lights for the parts of the picture that you really want to emphasize. That's what I've done here, covering most of the snow with a gray shadow wash and letting the light break through to create a bright path that leads you to the figures. A few more patches of light bring your eye up to my favorite buildings at the top of the picture. Although I love to paint the texture and detail of treetrunks, I keep these trunks simple. They're just dark shapes with very little detail, so they don't distract your attention from the center of interest. Most of the fancy brushwork is in the area of the figures, where you see those branches popping out of the snow and all those lively reflections in the water. By now, you know that I like to use shadows, treetrunks, and other darks to frame the "action," where I concentrate my strongest lights. But I make sure that the "frame" is always a little cockeyed—such as these tilted trunks and diagonal shadows—so this compositional trick doesn't look too neat and contrived. It should look like it just happened.

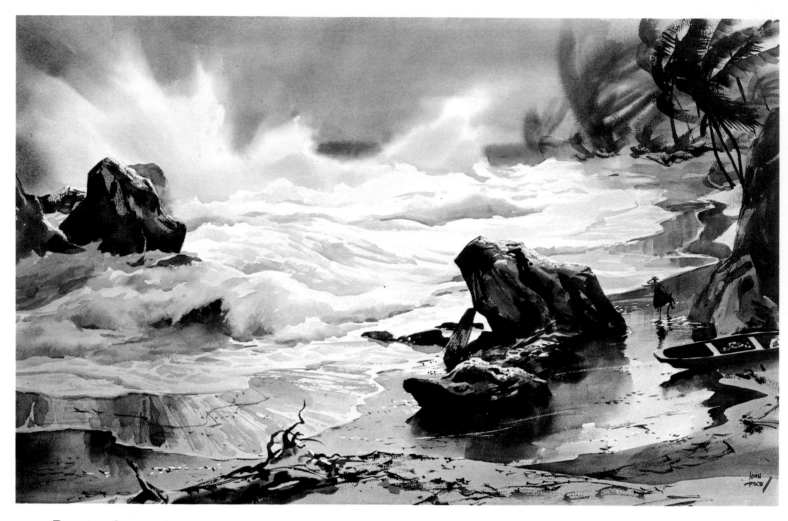

Brewing Storm, Jamaica
24" × 40" (61 × 102 cm), collection of R. P. Risenburg

I'm afraid that many painters who don't really know the sea have a tendency to paint foam and surf as a sort of light, airy, cotton candy blown gently by the wind. Hoo boy! I grew up on the coast, where we could all swim as early as we could walk, and we learned to respect the incredible power of the smallest wave, with its accompanying undertow. I feel that this watercolor gives a sense of the power of the sea as well as any painting I've done on the subject.

It's the brushwork that communicates the action of the sea. In the upper left, the brush leaps upward from the rocks to express the movement of the exploding foam. On the sea below, the brush follows the curves of the surging waves. And as the water spills toward you across the beach, the brush moves toward you.

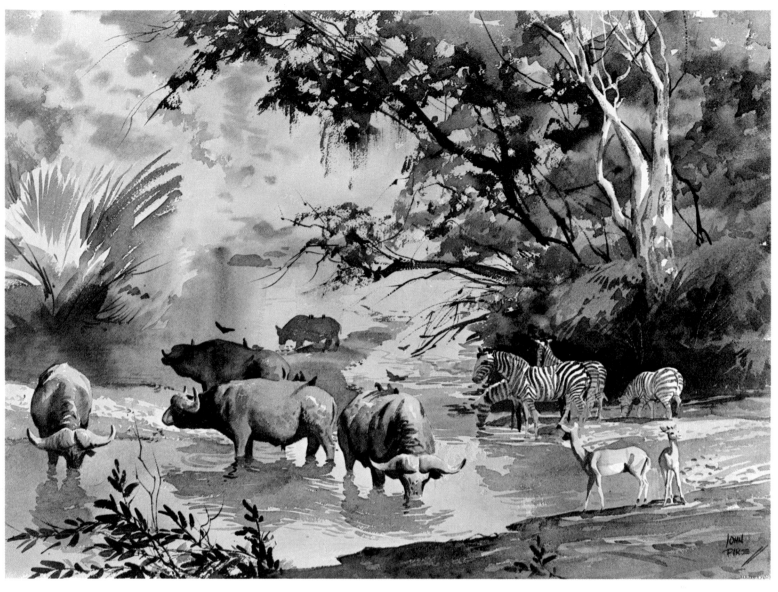

Jungle Beasts Gather for a Refreshing Pause, Africa
22" × 30" (56 × 76 cm), collection of General Tire International

I've always enjoyed drawing and painting animals of every kind. The most important thing is to be sure that the anatomy is correct and that you've got the right "facts" in the background. You've either got to paint on the spot—which is difficult for most people—or you've got to make sure that your research is reliable. You can't fake it: there are too many experts ready to jump on you if you goof. You've also got to think about vegetation. What kind? Is it correct for that altitude? Will the trees really grow that close to the water? Will the water be clear or muddy? A lot depends on whether it's a running stream or a sink waterhole—with a gravel or mud bottom. Can you be sure that these three different species of animals—water buffalo, springbok, and zebra—would really drink together?

Notice how the wet-in-wet effect in the upper left creates a sense of distance. In the foliage that hangs down over the stream, the drybrush work is done with the side of the brush, which makes a more ragged stroke than the tip.

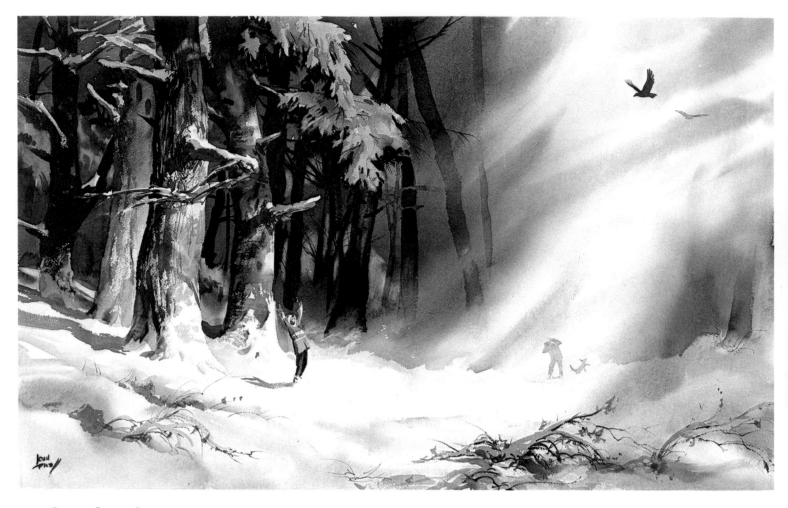

Snow Cascades
24″ × 40″ (61 × 102 cm), private collection

A whole flock of crows, plus a few of their relatives, are resting on the intertwined branches and twigs of the forest while a light powder snow is falling. Complete silence. Then the lookout pushes the panic button. The first few lads come out—as you see here—and then the rest follow. The pulsating air from their powerful wings blows the snow down in cascades, which I've tried to paint.

Here's another large watercolor in which it was important to plan ahead so that I had a stopping place for a big, juicy wash. No matter how much experience you've got, there are times when it's almost impossible to carry a single wash all the way through a really big watercolor and still retain the freshness you want. Here, I had several possible stopping places among the trees. The cascades at the right were painted all at once. Working very wet so that the strokes blurred and fused, I added darker and darker color as I moved toward the big, sunlit tree, leaving streaks of sunlight slanting through the darkness and painting around the little figure in red. When the surface was dry, I put in the dark silhouettes of the background trees as well as the dark in the lower right, adding strokes of clear water to create soft edges in the falling powder snow.

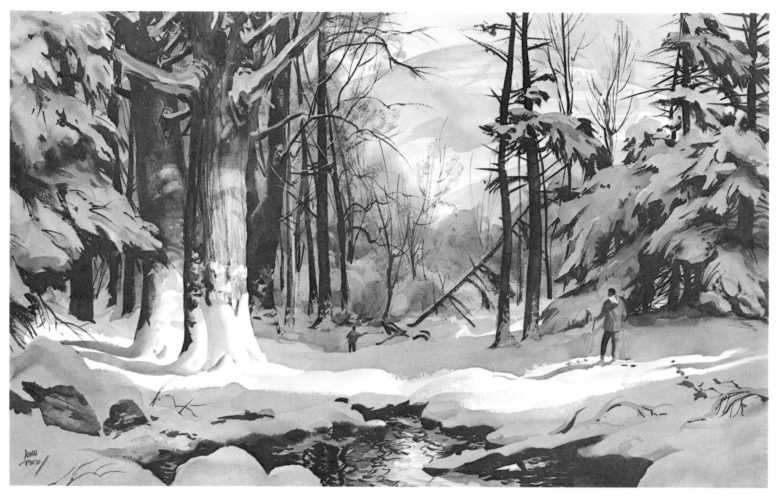

Overlook Mountain
24″ × 40″ (61 × 102 cm), collection of Heritage Bank, Kingston, New York

When people live in a huge, gaseous, high-decibel cementville, I sometimes wonder how they feel deep down when I say that this is the view from my studio window. (Actually, I'm lying—this is the view from about 200 feet to the northwest.) For more than a half of my life, this beautiful country has been our home base. We're gone no more than one month a year, so this really is *home*.

When you're working in transparent watercolor, it's always essential to think about the effect of one wash over another. How do they affect each other? To paint the warm lights and cool shadows of this mountain, I began by putting a pinkish wash of burnt sienna (plus a little crimson) over the entire area. Through experience, I knew that pure ultramarine would be changed by this undertone—and that's what happened when I added the cool shadows. You can see that the warm tones are all concentrated in the center of the picture, which is surrounded by cooler washes. Here and there, a bit of the warm appears within the cool, like the reflection in the water. This helps to tie the picture together.

Early Morning Mist, Cincinnati
22" × 30" (56 × 76 cm), collection of Maxon Construction Company

This is Cincinnati from the Kentucky shore in the early morning. Contrary to general opinion, painters *are* early risers. That's when the light is often best for landscape painting.

I used a bit of liquid frisket to mask the top of the old bridge and its reflection in the water. But I painted right around the tree, which I borrowed from another spot about a hundred yards upstream. The sky was very pale, so I brought it right down to the green bushes in the foreground, giving me a consistent tone for sky and water. (Remember that the water usually reflects the sky.) When the sky and water were dry, I painted the silhouette of the tall buildings and faded them out with clear water to create the misty feeling. This was the tough part. When these dangerous steps were over, I added the bridge, the boat, the barges with all their reflections, plus the darks of the tree and the foreground greenery. The reflections are simpler and more irregular than the shapes they reflect. The strokes in the reflections suggest the action of the water. It's also a good idea to break up the reflections with some strips of reflected light, as you see here.

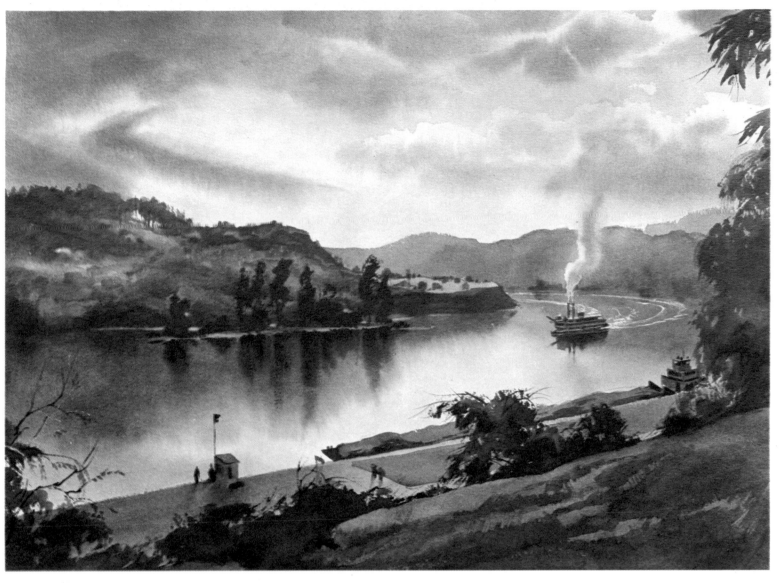

Evening Sky, Lock 44 on the Ohio River
22" × 30" (56 × 76 cm), collection of Maxon Construction Company

I painted this watercoler and *Early Morning Mist, Cincinnati,* for the Maxon Construction Company of Dayton. The assignment was particularly delightful because it came from Glen Maxon, a gentleman of the old school, and a fine watercolorist and friend. The steamer is the "Belle of Louisville," formerly the steamer "Avalon," rounding the bend near Lock 44. I believe she's about the last of the old stern paddle-wheelers on the Ohio.

This looks like a tricky sky to paint, but it's not difficult if you *plan* well ahead. It was done in just two moves. First, I wetted the sky area with clear water, right down to the distant edge of the river—washing on the light, warm undertone at the same time. While this was still very wet, I dropped in my grays for the clouds, having pre-planned exactly where I *wanted* to drop them. When the entire area was dry, I brushed clean water gently over the *undersides* of the clouds. Working down from the top of the picture, I painted in the pale blue-greens, shaping the sharp upper edges of the cloud formations. Where the tone hit the wet areas, it took its own action and faded away. The reflections on the river were painted into a wet undertone. Then the darks of the hillside, the "Belle," and Lock 44 in the foreground were all completed when the surface was dry.

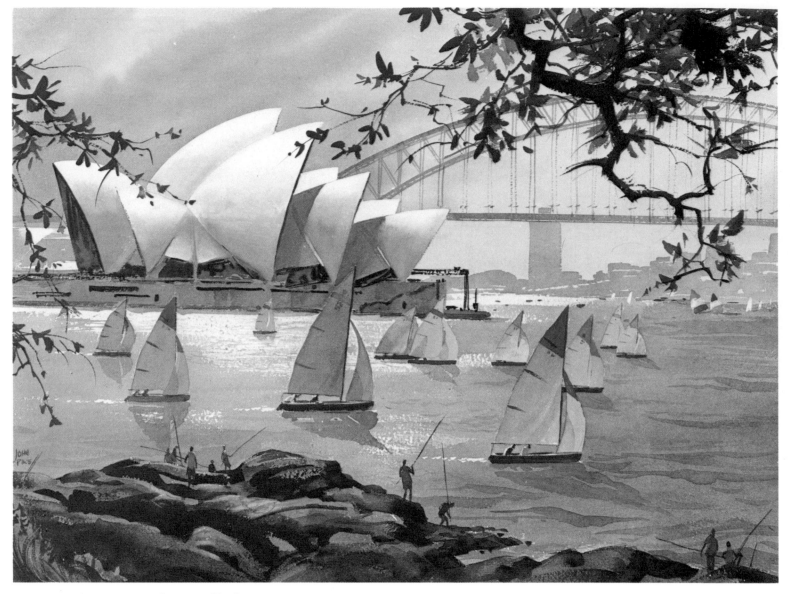

Opera House at Sydney Harbor, Australia

22″ × 30″ (56 × 76 cm), collection of General Tire International

A confession—my head is held low. I worked hard on this composition, trying to bring into play the sail motif of the small craft against the similar shapes of the huge building. So I decided to mask out (with tape) a few of the sails, but mainly the great, demanding curves of the Opera House. All went very well. I peeled off sail after sail and painted as I went. Then I painted the rocks in the foreground, with the city and the famous bridge in the background. In fact, I painted the whole damn picture except the Opera House, which was still under the tape. And then I peeled those big, white shapes, and I could have gone out in the backyard and been eaten by owls, I felt so low!

Obviously, I needed a clean, sharp line. But that miserable gray of the sky had seeped under and around all the edges of the tape, leaving nauseating lace patterns. I took that jug of opaque white and dashed on, hating myself all the way, and finished the painting. As a purist about transparent watercolor, I'm horrified at what I did—but somehow it came off. So please forgive a transparent watercolor man for just one lapse.

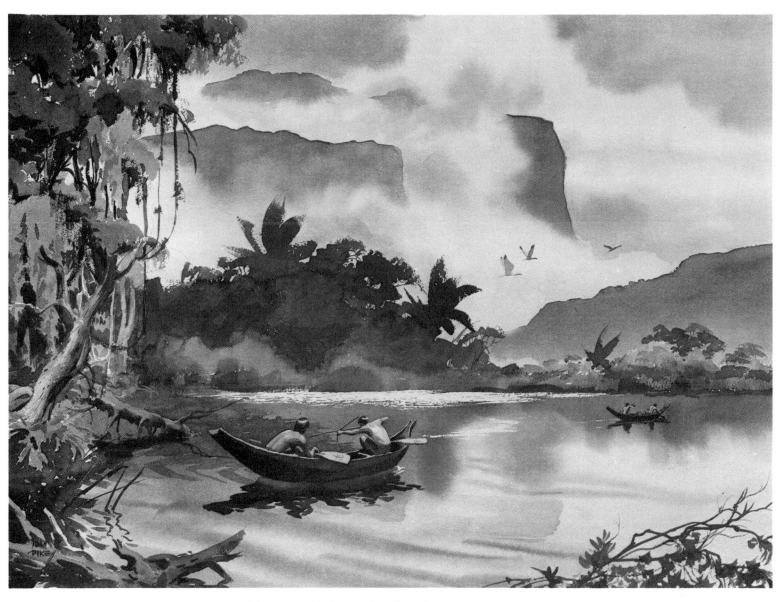

Shooting Fish on the Rio Carrao, Venezuela

22" × 30" (56 × 76 cm), collection of General Tire International

Down the river, a few miles around the bend, are the famous Angel Falls. The name of this 3,700-foot drop has nothing to do with heavenly inhabitants. A few years ago, an extremely skillful American bush pilot was forced to set his light plane down on the high plateau above the waterfall, undiscovered until then. His name was Angel.

I began by wetting the entire upper half of the picture—above the waterline—and immediately painted in the clouds with ultramarine blue and burnt umber, and the blue-green of the sky with phthalocyanine green. When all this was completely dry, I lightly brushed clear water over the sections of the mountains where I wanted the soft clouds. Then I tiptoed in with a mountain blue-gray color, starting with a hard edge at the top and finishing with a soft edge that went into the clean water. Happily, it all turned out as I'd hoped. Now home free! I applied a liquid mask over the figures and over the lights on the shoreline. After I painted the foliage of the middleground shore, I brought a pale blue wash down over the entire water section—going back at once to put in distant reflections and the diagonal swells in the foreground. The windup included removing the mask and painting figures, boats, and the surrounding vegetation.

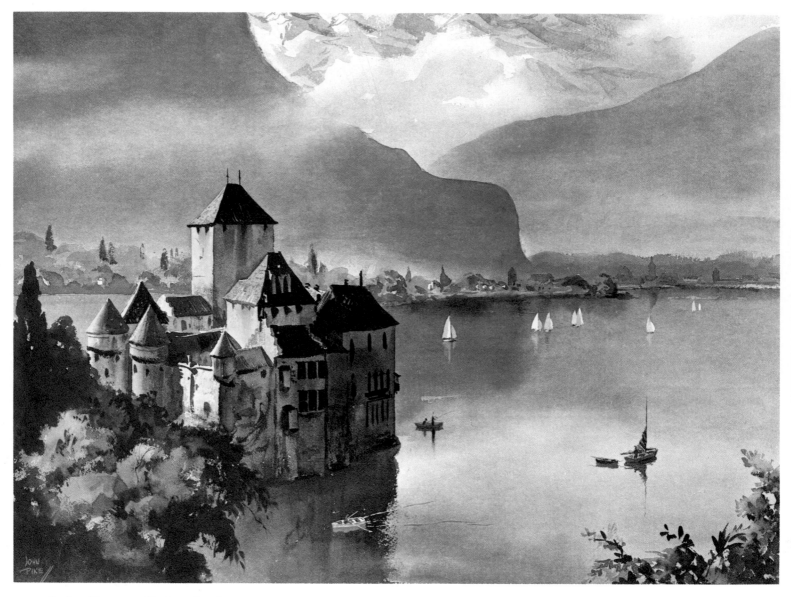

Lake Geneva, Switzerland
22" × 30" (56 × 76 cm), collection of General Tire International

This castle was the setting for Lord Byron's poem, "The Prisoner of Chillon."
I started out with liquid mask on the sunny sides of the castle, the sails in the
distance, and the rowboat in the foreground. I began by painting the lights and
shadows of the most distant mountains just below the top edge of the painting,
bringing the tone right down to the shoreline. When all this dried thoroughly,
I painted the mountain at the right, lightening the tone with water as I moved
downward. Next came the biggest, darkest mountain at the left. This was a little
tricky. I brushed clear water over the area of the mountain where I wanted the
misty effect—and out into the cloud. I carried my dark areas right up to the
edges of the wet, misty area, not splashing around too much; thus the moun-
tain's sharp edge runs right into the mist. If you bring the darks right down into
the wetness, the mist takes care of itself.

Right after I painted the general color of the water, I brushed the soft reflec-
tions into the wetness. The forms along the shoreline were identified with small
strokes. When this was dry, I removed the mask from the castle and the boats.
Then the buildings and the foliage were painted—essentially in two values—
carefully balancing the darks. I was sort of pleased with the dark reflection that
drops down from the right side of the castle: it was a single swipe with a very
broad brush.

Netherlands

22" × 30" (56 × 76 cm), collection of General Tire International

Over hundreds of years, Holland's continuous land reclamation program has produced a network of canals that are used both for irrigation and for cargo highways. This painting is a composite of many aerial photos. It's not one particular place. That's the fun of being a painter—you can build your own towns.

In this watercolor, I pretended that there was a giant cumulus cloud high up in the sunlight, beyond the top of the picture. That cloud—and the light breaking through—could give me a big cloud shadow on the upper landscape, plus a bright reflection on just a few of the canals that made that lovely geometric pattern. I used a liquid mask on these light spots, as well as on the light sides of the buildings and boats, both far and near. I started the dark wash at the top and faded it down to the middleground where the landscape gets lighter and brighter. This kind of aerial view, with its precise pattern of shapes, demands a very careful preliminary pencil drawing. Each canal and each architectural shape needs to be exactly right, and it's got to be in accurate perspective. If you use a ruler for the preliminary pencil drawing, don't follow the lines too exactly when you paint. Swing the brush freely so that the strokes look spontaneous.

Perrine's Bridge

24″ × 40″ (61 × 102 cm), collection of Heritage Bank, Kingston, New York

This painting, along with several others, was commissioned by the Heritage Savings Bank of Kingston, New York. It was fun to paint the oldest covered bridge in New York State, which was originally built in 1844 and then restored in 1969. You can see it from the New York State Thruway.

In planning this picture, I wanted to give strength and solidity to the old bridge. I did this by making the bridge the darkest note in the picture and then continuing that darkness right down into its reflection. The surrounding light areas give these darks greater punch. The sunlit tree in the upper right was painted with John Whorf's old trick of starting with a wash of bright yellow, then placing the greens and browns on top. That tree, which leans into the picture, also keeps the diagonal shape of the bridge from carrying your eye out through the corner.

Rondout Creek

22" × 40" (56 × 102 cm), collection of Heritage Bank, Kingston, New York

This little gem of a building was constructed in the early nineteenth century as the northern terminus of the famous Delaware and Hudson Canal. Every artist I knew feared for the future of this beautiful building, which had stood empty, I would guess, for seventy years or more. Vandalism and time were taking their toll. Then came the saving angel in the form of a fine contractor (and a gentleman of excellent taste) who restored the exterior and made the interior into a beautiful home. The building is actually a lot larger than it looks in this broad landscape.

I wanted to give this painting a high, misty, overcast sky, so I used an old trick. I wetted the sky and water areas with clear water and then dropped in my three primary colors here and there: phthalocyanine blue, alizarin crimson, and new gamboge. While this surface was still wet, I took a large brush and pulled these spots of color together with big, crisscross strokes. Before the surface lost its shine, I then dropped in the grayish distant trees and their reflections. To keep the waterline white, I used some liquid frisket on the middle distance.

Atlas Mountains, Morocco
22" × 30" (56 × 76 cm), collection of General Tire International

Having seen old movies and read second-rate romantic literature, most people (who haven't been there) think of Morocco as a couple of glamorous seaports that open onto the great desert. I was guilty too. It wasn't until a couple of years ago that I found out how wrong I was. There loomed the great, green-covered Atlas Mountains—rugged and high enough in some places to have snow on them most of the year. When you step outside your small government hotel, you go 1,500 years into the past.

It's worthwhile to study how both the shadows and the reflections are handled in this silt-laden stream. All these washes and strokes aren't placed at random, but have a specific relationship to something above. There's a band of shadow on the water directly beneath the bridge, and then there's a reflection below that. The rough masonry of the bridge sits on its own dark reflection, which is a very different tone from the other darks in the water. The blue strokes in the water are picking up the blue of the sky. A few yellow strokes suggest sunlight shining on the lighter patches of water. At the left, the foliage along the riverbank adds its own complicated pattern of reflections.

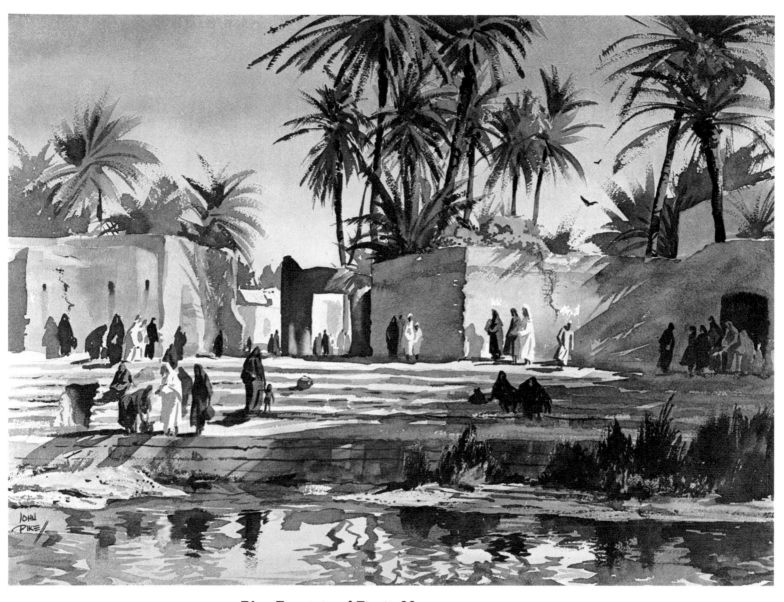

Blue Fountain of Tiznit, Morocco
22" × 30" (56 × 76 cm), collection of General Tire International

Perhaps more crimes have been committed in painting palm trees than in painting all of nature's other kinds of foliage. Ask the neophyte to draw one for you and, almost invariably, he gives you a long trunk, straight or curving, with *banana* leaves on top. Actually, there are lots of different kinds of palm trees, each with its own special character. All the palms are of great benefit to man. The coconut palm offers life-giving food, drink, timber, and clothing. The date palm isn't as attractive as the coconut—but have you *ever* eaten fresh dates with sweetened goat milk cream poured over them? Enough of dreams—on to the painting process at hand.

I brought the sky right down to the tops of the buildings. In the same move, I painted the light blue of the water in the fountain. The large, warm shapes of the sunlit parts of the buildings were painted next. I carried these warm tones pretty much over everything—knowing that the warmth would show through in the cool shadows that would come later. The palm trees were painted right over the blue sky, with strict attention paid to the shapes of the trunks and the foliage. Finally, I added the shadow sides of the buildings—right over the warm undertones—and finished off with the little figures and the darks in the foreground.

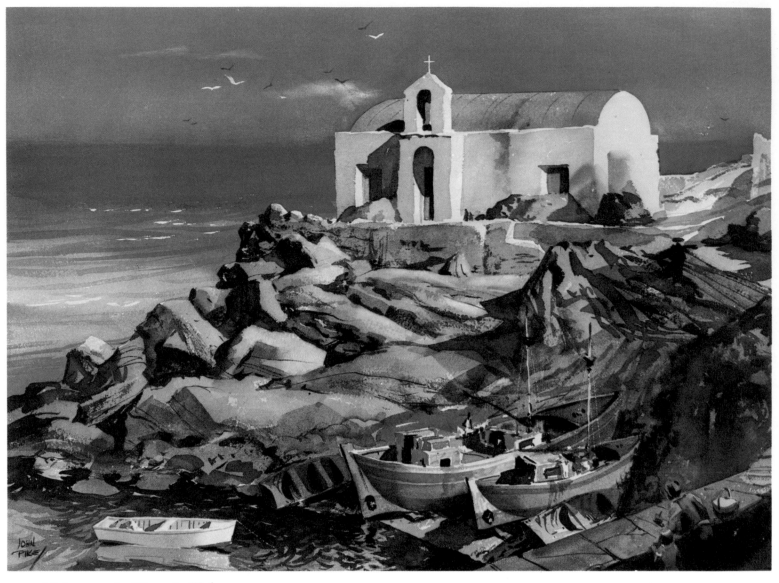

Fisherman's Chapel, Mykonos
22" × 30" (56 × 76 cm), collection of General Tire International

When I was very young and had muscles, I spent a winter in a tent in Provincetown, Massachusetts, where I was a summer student of the great Charles Hawthorne. I had to eat, so I took a short swing at commercial fishing with my old friend Manny. In September, it was magnificent to see the fishing boats going out before dawn. October was not so romantic. By November, I quit. That's when I decided that I'd make painting a full-time job. You don't get any richer. Your hands get just as cold. But you can keep your feet a little drier if you're careful. So my heart saddens when I think of how hard these Greek fishermen work to pull in a few fish each day. However, I doubt if *they* ever thought about how hard it was to sell a few paintings every month.

Blue and orange are complementary colors, of course, which means that they make each other look brighter when you place them side-by-side. That's why the walls of the chapel look so warm, while the distant sea and sky look so cool. This same contrast of complementaries reappears in the more subdued colors of the rocks, which are warm in the lights and cool in the shadows.

Andean Condor Soars Near Cotopaxi, Ecuador
22" × 30" (56 × 76 cm), collection of General Tire International

Although I *have* flown all around Cotopaxi, I have to admit that I didn't sit up there and paint this picture. What looks like a medieval walled city is actually a buildup of volcanic ash and lava about 20,000 feet high. I was eager to paint it, but I had to compose the picture well in order to make it interesting. In planning the painting, I had to consider several elements. I had a little knowledge of cloud formations, based on my fast course in meteorology when I was in flight training. I knew that old cumulo-nimbus, with its anvil top, would climb well above the mountain. For composition, I had to play one blank area against another, and I needed something in that space. How about Andean condors? How high do they fly? A quick call to my favorite researcher, Zellah, who came up with the answer from the encyclopedia: those condors had been sighted at an incredible 26,000 feet!

The painting procedure consisted of three basic steps. First, I masked the light edges of the mountain with liquid frisket. I washed in the clouds, keeping most of the edges soft with clear water, and then removed the mask. Then I painted the big shadows of the mountains with broad strokes that followed the curves of the form, following with smaller strokes and some drybrush for texture—finishing up with two of those magnificent, dumb birds who don't know enough to live at a decent altitude where there's some oxygen!

If I'm allowed to have a "pet," this painting is one of them.

Old Bridge, Toledo, Spain
22" × 30" (56 × 76 cm), collection of General Tire International

It's hard to describe how to capture the "feel" of a place. I remember Mark Twain describing Tom Sawyer lying on his back in a high pasture watching the great white clouds above. The sun beat down and the bees buzzed from clover to clover. Away in a valley, a hound dog let out with a mournful wail. Tom wanted to cry, and didn't know why.

Certainly the atmosphere in this picture owes a lot to the lighting. When I established my composition, I had to figure out where my light source was. In the afternoon, the light came from my left and from behind me. This would have been okay, except that the rugged, rocky lower right was washed out, with no shadows to give the contour I needed. Besides, the sun was hitting flat on the bridge. To make the bridge count, I would have to go too dark in the background—making me lose the feeling of distance. So I switched to early morning with the sun low in the distant sky. This gave me the dark silhouette of the bridge and the tower. And I also got the shadows I needed in the lower right.

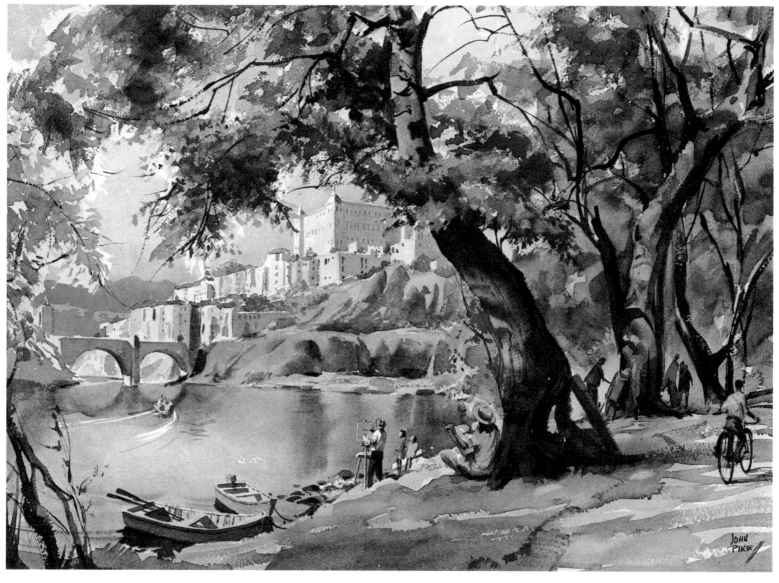

Alcazar at Toledo, Spain
22" × 30" (56 × 76 cm), private collection

This is a charming, informal park on the banks of the Tagus. People come here on Sundays with their kids and their bicycles to have an all-day picnic. There are boat rides if you can find the lad who runs the outboard. Small concession buildings have tables set out on the grass. You can buy delicious sandwiches, wine, and soft drinks. Some of these ancient trees have holes through the base, but they still seem to hold up with the aid of some wire and timber here and there. It's all very beautiful and quiet.

I painted the blue sky, cutting in and around the halolike edges of the trees, around the buildings and the bridge, and down into the water, which becomes darker in the lower left. When the sky tone was dry, I put a pale yellow wash over the trees and on the foregound grass, plus a warm tint on the Alcazar and its surroundings. In painting the shadow sides of the buildings and the bank, I kept in mind the intervening atmosphere; so I kept those shadows cool and in the middle-value range. Then came all the foreground darks: the green of the leaves, the dark trunks, the ground shadows, and all the little figures and other small details.

INDEX

Edited by Connie Buckley
Designed by Bob Fillie
Set in 12 Point Souvenir